W9-DJE-602

THE LITERATURE OF
DEATH AND DYING

This is a volume in the Arno Press collection

THE LITERATURE OF DEATH AND DYING

Advisory Editor
Robert Kastenbaum

Editorial Board
Gordon Geddes
Gerald J. Gruman
Michael Andrew Simpson

*See last pages of this volume
for a complete list of titles*

DEATH
AND
THE VISUAL ARTS

ARNO PRESS

A New York Times Company

New York / 1977

97404

Reprint Edition 1977 by Arno Press Inc.

Copyright © 1977 by Arno Press Inc.

The Dance of Death in the Middle Ages and
the Renaissance was reprinted by permission
of the University of Glasgow, Scotland

Reprinted from copies in the University
 of Illinois Library

THE LITERATURE OF DEATH AND DYING
ISBN for complete set: 0-405-09550-3
See last pages of this volume for titles.

Manufactured in the United States of America

————•————

Library of Congress Cataloging in Publication Data
Main entry under title:

Death and the visual arts.

 (The Literature of death and dying)
 Reprint of the 1950 ed. of The dance of death in
the Middle Ages and the Renaissance by J. M. Clark pub-
lished by Jackson, Glasgow; and of How the ancients re-
presented death, from Selected prose works of G. E.
Lessing, published in 1879 by G. Bell, London.
 1. Dance of death. I. Title. II. Series.
N7720.A1D4 1977 704.94'9'1285 76-19565
ISBN 0-405-09561-9

CONTENTS

GLASGOW UNIVERSITY PUBLICATIONS

LXXXVI

THE DANCE OF DEATH
IN THE MIDDLE AGES AND THE RENAISSANCE

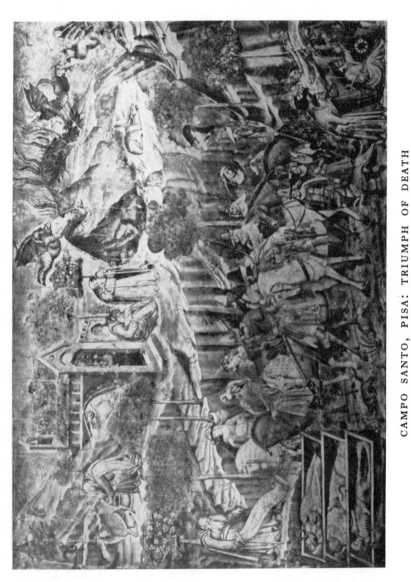

CAMPO SANTO, PISA: TRIUMPH OF DEATH

THE DANCE OF DEATH

IN THE MIDDLE AGES AND
THE RENAISSANCE

by

JAMES M. CLARK, M.A., Ph.D.
LECTURER IN THE UNIVERSITY OF GLASGOW

GLASGOW
JACKSON, SON & COMPANY
PUBLISHERS TO THE UNIVERSITY
1950

97404

PRINTED IN GREAT BRITAIN BY ROBERT MACLEHOSE AND CO. LTD.,
THE UNIVERSITY PRESS, GLASGOW, FOR JACKSON, SON AND CO.
(BOOKSELLERS), LTD., PUBLISHERS TO THE UNIVERSITY, GLASGOW

PREFACE

Since the appearance of Francis Douce's admirable work in 1833, no authoritative account of the Dance of Death as a whole has been published in English. British scholarship was first in the field, but it has lost the lead. There have been excellent monographs on single aspects of the subject, but no comprehensive survey. Even the detailed preface of H. N. Humphreys, with all its merits, does not fill up the gap. This is the more to be regretted as numerous treatises of a general or of a specialized nature have appeared in the last half century in France, Germany, Italy, Spain, Holland, and other European countries. The literary materials for the study of the subject are now scattered through the great libraries of Europe and are in half a dozen languages. The task of undertaking a synthesis, of stating the problem in the light of our present knowledge, cannot be postponed indefinitely. The ravages of time and the devastations of war have destroyed many relics of the Middle Ages, and in our own time we have witnessed a sad shrinkage of the original sources of information.

The average educated Frenchman or German has a clearer conception of the Dance of Death than the average educated Scotsman or Englishman. Hence it might be as well to begin with the argument of the work, with a definition of the theme. When that has been done in an introductory chapter, I propose to build up the story of the Dance of Death from the beginning, taking little or nothing for granted. Instead of developing a programme we shall take part in a quest. The method adopted is that of making Hexham in Northumberland the starting-point, because there we find the most complete mural paintings of our subject that survive in Britain. When sufficient data have been collected, we shall be in a position to investigate the origin and meaning of the Dance.

Among the many works I have consulted, that of Emile Mâle deserves special mention. The name of this distinguished scholar is a household word to all those who have laboured in the field of mediaeval art. The late G. G. Coulton gave me more than once the benefit of his great erudition. Dr. Christopher Woodforde of New College, Oxford, very generously handed over to me the notes he had taken, including unpublished material about the

Norwich example. I have frequently had occasion to apply to Professor W. C. Atkinson of Glasgow University, for advice, particularly with regard to Catalan language and literature, and never have I applied without profit. My thanks are also due to Miss Ivy L. McClelland of the Spanish Department of Glasgow University, Dr. Isopel May of the British Institute in Florence, Miss D. A. Leech, City Archivist, Coventry, and Miss Joan Lancaster of the Institute of Historical Research, for valuable help. I owe many useful suggestions on points of detail to my brother, G. N. Clark, who read the manuscript during the final revision. I should like to take this opportunity of expressing my gratitude to the Publications Standing Committee of the University of Glasgow for including this work in its series of publications, and to the Carnegie Trust for the Universities of Scotland, who made a generous grant towards the expenses incurred in producing and publishing this volume. It is fitting that I should acknowledge my indebtedness to Mr. H. R. Creswick, formerly Librarian of the Bodleian, Mr. H. L. Pink of Cambridge University Library, Dr. K. T. Parker, Director of the Ashmolean Museum, the staff of the Basel Kunstmuseum, the Warburg Institute, and above all the staff of Glasgow University Library, who cheerfully and indefatigably responded to every request for assistance. The present work could not have been completed without the privilege of unrestricted access to the Gemmell Dance of Death collection, which is not the least of the assets of this ancient library.

J. M. C.

GLASGOW, 1950.

ACKNOWLEDGMENTS

Mrs Ollard and Dr Woodeforde generously placed photographs at my disposal. The Phaidon Press very kindly allowed me to use some of the blocks from their publication *The Dance of Death* by Hans Holbein.

Acknowledgments are also made to the following: Mr Walter Scott, Bradford (Hexham Priory); Messrs Hunt & Co., Newark-on-Trent (Newark Parish Church); La Caisse Nationale des Monuments Historiques, Paris (Kermaria, La Chaise-Dieu, Rouen); Mr W. F. Mansell, London (Pisa); The Manchester University Press (La Danse macabre); Direktion, Kunstmuseum Basel (Grossbasel and Kleinbasel).

CONTENTS

97404

ILLUSTRATIONS

I
INTRODUCTION

The terms 'Dance of Death' and 'Danse macabre', with their equivalents in other European languages, have now been in use for over five centuries. They have been applied very loosely to denote a great variety of works of art, spurious or genuine. A musical composition by Saint-Saëns, poems by Walter Scott and Goethe, not to mention countless paintings, etchings, woodcuts and engravings, all pass under the same name. Then there are those works which lack the label, but belong to the same category. There is, for instance, the magnificent poem, *El Estudiante de Salamanca*, by the Spanish Byronic poet Espronceda, whose hero, a modern Don Juan, dances with a corpse. In addition there are innumerable allusions in our own and foreign literatures. We stumble across them in most unexpected places. In *Dombey and Son*, Charles Dickens speaks of 'a skeleton with dart and hour-glass'.[1] To track down these productions and references would be an interminable task. The treatment of death and mortality in literature and art[2] is not the aim of the present work. Only one aspect of the general question is treated, and a definition of this aspect might not be out of place.

By the Dance of Death we understand literary or artistic representations of a procession or dance, in which both the living and the dead take part. The dead may be portrayed by a number of figures, or by a single individual personifying Death. The living members are arranged in some kind of order of precedence, such as pope, cardinal, archbishop, or emperor, king, duke. The dance invariably expresses some allegorical, moral or satirical idea. A single scene depicting a skeleton and a human being is not a Dance of Death,[3] although it may be derived from such a source. The medium employed for the forms of the work varies considerably. There are poems and prose works, manuscripts and printed books, paintings on wood, stone, or canvas, stained glass windows, sculptures, embroidery, tapestry, metal work, engravings on stone or metal, and woodcuts.

[1] In Glasgow University Library there is a copy of Douce's *Dance of Death* with Dickens' book-plate. This shows the source of his information.
[2] For this see the excellent accounts by J. Huizinga and E. Döring-Hirsch.
[3] Such scenes are often called 'Memento mori'.

The Dance of Death has its roots in the Middle Ages. It cannot be traced back to classical antiquity. It is true that the skeleton appears in Greek and Roman art, either on sepulchral monuments or in the function of the 'skeleton at the feast', as a spur to renewed enjoyment.[1] Even the dancing skeleton was not unknown to the ancients, but there was no such thing as the Dance of Death in which both the living and the dead take part. The skeleton or the corpse thinly covered with skin (as in the lemures) represent not Death in the abstract, but an individual. The former was symbolized by a youth with an inverted torch. The soul of the dying was depicted as a butterfly or a bird. In fact the whole treatment of death was euphemistic.

The late mediaeval attitude was entirely different. No longer was Death the brother of Sleep, approaching mortals gently, but with swift pinions, or in the shape of Charon the ferryman on the River Styx. Its terrifying aspect was no longer softened or avoided, but deliberately emphasised. For a time the classical tradition continued: in the most ancient Christian art the youth with the inverted torch is carved on sarcophagi, but this custom died out. In the early Middle Ages the skeleton is never found as a symbol of death. It does not occur till about the beginning of the fifteenth century.

The solemn words 'Memento mori', 'Remember that thou shalt die', now acquire a new significance. To the ancients they meant 'Eat, drink, and be merry', to mediaeval people they were a call to repentance. In classical times the skeleton might seem a comic figure; in the Middle Ages it became awe-inspiring or repellent. The most drastic means were employed to bring home to the public the sense of the impermanence of the physical body and of all earthly things, in order to point a moral lesson. It was not until the Renaissance that the winged goddess Mors appears and it is characteristic that she is first to be seen in Italy, in the frescoes of the Campo Santo at Pisa. But this is no longer the deliverer of ancient tradition, it is the gigantic destroyer of the mediaeval imagination.

The geographical distribution of the Dance of Death is wide. Its various manifestations and countless ramifications can be followed from France northwards to Britain, southwards over the Pyrenees to Spain, eastwards to Germany and Switzerland, across the Alps to Italy. The theme appears in different *milieux* and social settings. It is moulded and modified by friars and scribes, by printers and publishers, by churchmen and laymen, merchants and artists, craftsmen and amateurs. In the great university city of Paris it has a learned stamp; in the Hansa port of Lübeck it receives the impress of a trading community.

[1] See, however, Weber, p. 7.

Our studies are a kind of cross section through late mediaeval and early Renaissance cultural history. We turn over the pages of art and poetry, of drama and painting. We touch on other fields of human activity: we see how the rise of anatomy as an academic discipline affects the drawing of the human form and skeleton.

In the course of our investigations we note the fact that there are two outstanding works: the pictures and verses at Paris and Holbein's engravings. Kermaria, La Chaise-Dieu, Lübeck, the Spanish poem, however great and memorable they may be in themselves, are later than Paris and subsidiary to it. Holbein dominates the latter, as Paris does the former period, and Holbein derives ultimately from Paris. In him the new age lays its stamp on a typically mediaeval form of art, transforms it and recreates it. Between the Middle Ages and the Renaissance stands the 'Death of Basel', which is on the threshold of the new age, inspired by Paris and itself the inspiration of Holbein. The day of mural paintings and didactic poetry comes to a close, and the printed book takes their place as the chief medium of artistic expression.

For the Dance of Death, properly speaking, was essentially a product of the late Middle Ages. Unless we have a sympathetic insight into the spirit of that period we cannot hope to understand our subject. But a history of the Dance of Death that excludes Holbein would be unthinkable. If Holbein marks the culminating point of the development, he also departs so far from the original conception that we might fittingly close with a study of his masterpiece. We cannot ignore Holbein; our story would be incomplete without him, but to pursue our search beyond him into the modern age would have led us too far from our original theme.

Admittedly, the Dance of Death had a new vogue in the nineteenth century, chiefly as the object of learned investigation, but also to a not inconsiderable extent as the theme of creative artistic effort. Why should we not include these productions? However valuable they may be from the artistic point of view, they add little or nothing to what the Middle Ages or the Renaissance had already said and said much better. The inspiration is at second hand; at the best these works are only imitations.

The sphere of investigation is then chiefly the fifteenth and sixteenth centuries. It is not necessary to trace every tributary to its source. It suffices to follow the main stream, and draw the broad line of development. Even when so limited and restricted, logically and chronologically, the field still remained immense and the difficulties formidable. For one has to clear the way through a welter of errors,

misconceptions, and highly speculative theories, the accumulation of centuries.

One has to deal with historians of art who can judge a picture, but have no historical, critical method, with historians who have no aesthetic sense, with pedantic philologists whose primary aim in life is to reconstitute the original text, but who cannot see the wood for the trees, with well-meaning antiquarians, amateurs and dilletantes, who compile assiduously without due investigation, who pertinaciously prefer old error to new truth, or worse still, who delight in new error rather than old truth. Problems and queries continually arise, some solved already, others still awaiting solution, a few perhaps quite insoluble.

In the fifteenth century the commonest form of the Dance of Death was mural paintings. Very few of these now remain. In those parts of Europe that became Protestant, these pictures were in large measure covered over with whitewash or plaster, or destroyed. In the Catholic regions they suffered from the prejudice of the Age of Enlightenment and the rebuilding zeal of the Rococco period. The Middle Ages were regarded as an age of darkness and barbarism, and wall paintings of that period were held in scant esteem. What was spared by destruction decayed as a result of neglect, since constant renovation is required for mural paintings. Those of the Dominican Convent at Basel were made in the fifteenth century, repainted in 1568, and again three times before the beginning of the seventeenth century. Often the representations were in the open air, unprotected from the weather and liable to fade quickly. When they were under a roof they were often affected by damp.

To the small number of surviving examples we may add those attested by reliable witnesses, and even then we have only discovered a fraction of those that once existed. There can be no doubt of the great popularity of the subject in the late Middle Ages. What is the reason for it? Some writers are inclined to think that only a barbarous generation could take pleasure in looking at pictures of corpses or skeletons. This view is one-sided. It takes in the purely negative and destructive attack on life as something ephemeral and worthy of derision. It leaves out the corollary, always implicit, though not always explicit, that the soul of man is immortal.

In the first verse of the English Dance of Death by John Lydgate we read 'O creatures, ye that be reasonable, The lyf desiring wiche is eternal'. And at the end of his poem he repeats the thought. After speaking of man's life on earth which is transitory as a wind, he tells of the victory here over sin, that man may reign in Paradise with glory, 'Happy is he that maketh in hevene his feste

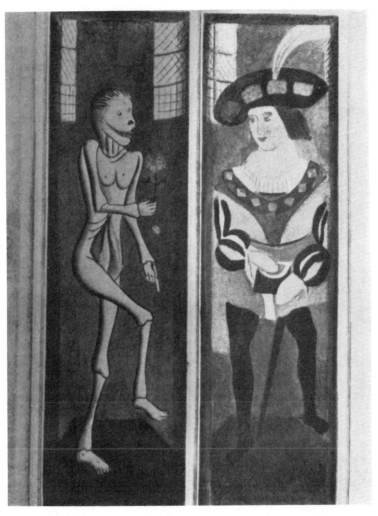

NEWARK PARISH CHURCH: DEATH AND A GALLANT

(i.e. festival)'. The men who painted the pictures and wrote the verses looked to the resurrection of the dead and the life of the world to come. And in the period of the Renaissance, when this faith was somewhat dimmed, Holbein's engravings enjoyed a great vogue. His prints may seem gruesome to a more squeamish generation, but those who collected them may well have regarded these engravings as something conventional, as decorative designs not to be taken too literally. But only a robust age can look death in the face without flinching.

The venerable *Danse macabre* of the Innocents, the mother of so many others, perhaps of all of them, was not the work of one man or of one year. It was the product of a whole generation, or even of an age. It had its roots far back in the past. It summed up so much of mediaeval history and thought. The poet and the painter had wrought the verses and the figures, but they had drawn on many sources. The arrangement of the characters, with the alternation of cleric and layman, speaks to us of scholastic philosophy and Aristotelian logic, with its genius for classification and definition. They depict human society by dividing it and subdividing it into classes and professions. The basis of the community is a universal church, divinely instituted, and a social structure laid on immutable foundations. There is a whole social philosophy underlying the scheme. The moral truths expressed were believed to be eternally valid and unchanging. War and pestilence, fire and sword, left these institutions intact.

We may not share that belief to-day, but we may still find something imposing, even admirable in it, and in this day of bitter feuds and hatreds, we can look back to that former day when Europe collaborated in art and literature, like one great society, one family of nations, which knew something that transcended all frontiers, whether racial or political. We may also gather some little consolation from the spectacle of the co-operation of European scholars, in the last two centuries, who have laboured together to explore the meaning and evolution of the Dance of Death as one phase of our common past. This scholarly work has not been entirely devoid of national prejudice, but on the whole there has been little of it. May it rather be an incentive to friendly rivalry than to unscholarly subjectivity.

We shall follow the course of the Dance of Death in West and Central Europe to the end of the Middle Ages and beyond that period. Until the end of the fifteenth century and to some extent afterwards, the same kind of symbolism is employed to express the same kind of ideas. In different idioms the same conceptions are

expounded in a similar manner. The bulk of this work is anonymous. The identity of the author of the Spanish poem, the finest inspired by our theme, is unknown, just as we do not know the names of the architects of our great cathedrals. The *Danse macabre* at the Innocents cannot be ascribed to any author or artist with certainty.

The mediaeval artist was an artisan, not a celebrity. It is true that in the fourteenth century, in some parts of the Continent, he acquired a somewhat higher status as a result of the favour of princely patrons, but he remained 'a man who ranks in the prince's household with the fool, the minstrel, the tailor.'[1] The donor of the work of art was far more important than the painter. He paid for the work, and his aggrandisement was the thing that mattered. It was very unusal for the artist to sign his work. But when the last word has been said about social conditions, about the fashion of the time, there still remains a final reason. The individual is nothing: he is just the instrument, the vehicle through which truth or beauty is expounded and made manifest. He believed that the work was greater than himself. His motive was in part, and often in the greater part, religious. He laboured *ad majorem Dei gloriam.*

When we come to the age of the Renaissance the outlook is different. The old symbols had lost their meaning. The individuality of the artist begins to assert itself. The *Danse macabre* was not associated with an individual. Holbein's Dance of Death was the work of Holbein, and could have been created by no one else. It is the work of a definite personality. For four centuries the Dance of Death and Holbein have been inseparable ideas.

[1] Renan, quoted by G. G. Coulton, *Art and the Reformation*, Oxford, 1928, pp. 523-524.

II

BRITAIN

Our quest begins at Hexham in Northumberland, a town which combines the advantages of a beautiful natural situation and unusual historic interest. The Priory is a veritable storehouse of ancient remains, ranging from Roman times to the end of the Middle Ages. In spite of much ruthless restoration and wanton destruction, there is still a great variety of mediaeval wood-work and paintings in the church. A magnificent wooden *pulpitum*, known also, though not quite so correctly, as the Rood Screen, divides the choir from the crossing. Passing through this, we see on the north side of the choir a large wooden screen with fine carvings and painted panels. In the upper compartments six bishops of Hexham are depicted. One cannot speak of these pictures as portraits, because there is no attempt at individualization. All the faces are alike: the only differences are in the vestments and attributes.

The main object of our search is, however, in the lower part of the screen, which is divided into eight small panels, measuring 30 inches by 10¼. Half of them are left vacant, but the four on the western side contain pictures, each consisting of a skeleton and a human figure. The outlines are rather hard and the technical skill is inferior to that displayed in the bishops above. The only colours used in the lower panels are light and dark brown, gold, red, black and white. In the course of time the white has acquired a greyish tinge. The background is red; the flowers and floral designs inter-spersed are white and gold. As regards the subjects, we can easily recognize the Cardinal by his red hat, the Pope by his triple crown, the Emperor and King by their royal insignia. Like the bishops above, all the figures have the same features, but the Emperor has a beard. They all face towards the left and the skeletons look towards them, that is to the right.

The series is known traditionally as 'The Dance of Death'; eigh-teenth century authors referred to it as 'Death's Dance'. The name is not inappropriate, because at least one of the skeletons (which evidently signify Death), has its feet raised, as if dancing. Another of them, the partner of the Cardinal, is strangely twisted and con-torted. On the other hand, the human actors in the little drama

have their feet firmly planted on the ground. Each of the skeletons is seizing its victim, dragging him to the dance, as it were. One cannot help feeling that the work is incomplete. How are we to account for the empty panels? If there is a pope and cardinal, why no bishop and priest? Like the clergy, the laity is confined to its two highest representatives; why are there no barons, citizens or peasants?

The screen is certainly not *in situ*, but its original location is unknown. C. C. Hodges, in his description of the Priory (1888), asserted that both the bishops and the Dance of Death were fixed above the Rood Screen, and they were in this position, or at least attached to some part of the Rood Screen, at a much earlier date.[1] The point may seem immaterial, but the different parts of a mediaeval church had their symbolical meanings and hence the exact position of a picture is not without its significance. Hodges mentions five scenes from the Dance of Death, from which it would appear that one was left out when the series was transferred from the *pulpitum* or Rood Screen, presumably because it was in a bad state of preservation. In 1838 Dibdin described the Dance of Death as 'almost obliterated'.

The surviving four panels were revarnished and renovated in modern times; but the work was not particularly well done. One has the impression that both the outlines of the characters and the colours were altered: for instance, one of the skeletons is painted red, the others are white. Part of the crudeness of the pictures is the fault of the restorer, rather than of the original artist. Fortunately we can supplement our knowledge of the series with the help of old drawings and engravings, which reveal many details that are faded or obscured to-day.

There is only one other example of the Dance of Death in England at present: it is in the Parish Church of Newark-on-Trent. Like that of Hexham, it is in the choir of the church and is painted on a screen, but the latter is of stone, not wood. At Newark the panels are inlaid in the open stonework of the Markham Chantry or Sepulchral Chapel, to the south of the high altar. The compartments are longer than at Hexham, but not so wide: they measure $36\frac{1}{2}$ inches by $8\frac{3}{4}$. The extreme narrowness of the space did not allow two figures to be painted in one panel, so that Death occupies one and his partner another. There is only one scene, consisting of Death and a young nobleman. The former is represented by a dancing corpse rather than a skeleton. There are a few loose hairs on the head, there is skin on the face, flesh on the chest and ribs, there

[1] W. Hutchinson, *A View of Northumberland*, Newcastle, 1778, p. 98.

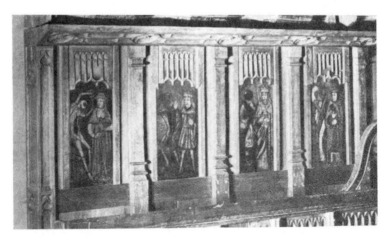

HEXHAM PRIORY: MURAL PAINTING

are eyes in the sockets, but the legs and arms are almost like naked bones. The ape-like face of Death, with its sinister grin, contrasts with the earnest expression of the youth. Death holds a red flower in his hand, with the other he points to the ground. The symbolism of the flower is not quite clear. Is it a rose signifying youth and health? Does Death summon the young noble to the grave, bidding him relinquish the joys of life? Or is the flower a poppy, the emblem of sleep and death? The youth is richly dressed. He wears a hat with a white feather, a red doublet with brown and white slashed sleeves, brown hose and a purse at his girdle. His collar and hat are jewelled: everything about him betokens wealth and high rank. Each of the panels has a window in the background, but it is uncertain whether an interior is meant to be represented or not. At Hexham there were flowers on the ground and the scene of the dance was apparently laid out of doors. At Newark there is no trace of these. The colours used are light and dark brown, red and white, with black for the outlines. The pictures are protected by glass and though slightly faded, are well preserved; they do not appear to have been restored.

Before the subject of the painting was properly understood, some fanciful interpretations were given by antiquarians and local historians.[1] The red flower was linked up with the red rose of Lancaster, and the youth was identified with Lambert Simnel, the pretended Earl of Warwick. This explanation has been rightly abandoned, and it is more reasonable to consider this isolated scene as part of a whole series. For why should all the other compartments have been left empty; and if only one scene was planned, would it have been placed in the bottom corner and not in a more conspicuous position? It is true that there are no traces of paint on the other mullions and transoms of the screen, but the stone has been scraped. As the Rev. L. M. Charles-Edwards, the Vicar of Newark, very kindly informs me, Sir George Gilbert Scott who restored the church, removed all vestiges of paint (except of course in the Dance of Death picture), not even sparing the shields on the south side of the Markham Chapel. If, as seems most likely, the other compartments had pictures originally, we may presume that any scenes containing prelates might have been removed at the Reformation. The pope would scarcely have been left undisturbed. A further motive for the destruction of the pictures would be that of letting more light into the presbytery, since a solid screen would

[1] William Dickinson, *The History and Antiquities of Newark*, Newark, 1816; R. P. Shilton, *History of the Town of Newark-upon-Trent*, Newark, 1820.

obscure the high altar.[1] Perhaps the scene Death and the youth was preserved because of its singular beauty. It is also possible that it had suffered less than the others from the effects of damp and strong light.

There are marked differences in style and treatment between the Hexham Dance of Death and that of Newark; we therefore conclude that they belong to different artists and periods. The Markham Chantry at Newark was founded in 1506, and the costume of the youth is that in vogue between 1485 and 1510: we can confidently place the pictures in the early sixteenth century. There are twenty-four compartments in the south side of the chapel, and if a Dance of Death cycle began in the first compartment, the scene we have been discussing would be the twelfth in the cycle. It should, however, be added that the other screens formed by the walls of the chapel have fourteen compartments, which also may have been filled with painted panels.

Having now dealt with the existing fragments of the Dance of Death in England, we might turn to those examples that are only known to us by contemporary descriptions and reproductions. We are particularly well informed about the pictures formerly in the Hungerford Chapel in Salisbury Cathedral.[2] To the north of the Lady Chapel, Margaret, widow of Lord Hungerford, completed in 1471 the chapel built for her late husband's sepulchre. This part of the cathedral was richly decorated with paintings, but at the time the chapel was demolished they were in a state of decay. There was naturally the figure of St. Christopher, bearing the infant Christ. This was one of the most popular of saints in England, as on the Continent. He was believed to protect travellers from sudden death.

On the south wall was a picture of Death and the gallant: the same theme as we encountered at Newark. The youth was clad in the height of fashion: he wore a doublet with slashed sleeves. His shoes, inordinately long, with pointed toes, were of the type known in France as 'souliers à la poulaine'. He had a feather in his hat and a dagger at his belt. In his right hand he held his staff. Death appeared as a corpse-like figure in a shroud. The background was covered with the initials ihc and m for Jesus and Mary. There were two verses of dialogue, in which the gallant addressing death, bewailed his untimely fate, and death replied that there was no escape

[1] Cornelius Brown, *The Annals of Newark-upon-Trent*, London, 1879, pp. 38-40, 299.
[2] Richard Gough, *Sepulchral Monuments in Great Britain*, London, 1796, vol. II, pp. 187, 189; R. C. Hoare, *The History of Modern Wiltshire*. London, 1843, vol. V, p. 542.

for him. Pointing to the dead bodies he said: 'Behold them well, consider and see, For such as they are, such shalt thou be.' The grave is represented by a coffin on the ground, not by a tomb. This reminds us of the mystery plays, in which this symbolism was common. A coffin or box was a more effective and manageable stage property than a hole in the ground. The costume of the youth is of the same period as the chapel itself, that is of the reign of Henry VI. In 1465 long beaked shoes were forbidden by law, which shows that they must have been very much in vogue at that time.

The drawing was so skilful that it was frequently engraved. The gallant was regarded as a typical example of the fashionable young noble of the reigns of Edward IV and Henry VI. It is apparent from the engravings that at the west end of the chapel, to the left of the door, there was another scene, depicting a man and Death. Of the latter only the two feet and an extended hand were recognizable but the feet distinctly suggest a dancing movement. The other figure was that of a person wearing a doublet with slashed sleeves, pantaloons, and small shoes of moderate length. He had a crucifix at his belt, on which one hand rested, while the other was raised up, as if in protest. The head and shoulders were no longer visible and hence the identification of this figure was difficult. Of the verses part of one line only could be deciphered and that gave no clue to the character of the person concerned.

If our line of reasoning is correct, the paintings at Hexham, Newark and those originally to be found at Salisbury, are all fragments. Where then are we able to find the whole, of which these are the scattered parts? To answer this question we must turn to another source, to old St. Paul's in London. To the north of the cathedral there was a cloister of large dimensions, which surrounded a plot of land known as Pardon Churchyard or Pardon Church-haugh. On the walls of this cloister the Dance of Death was depicted on wooden panels. In 1549 the Protector Somerset ordered the wall to be pulled down. He used the stone for his palace in the Strand, the original Somerset House. The Dance of Death was similar to the one 'which was painted about St. Innocent's cloister at Paris', according to Stow.[1] No pictures of the London Dance of Death survive, nor have we any contemporary description of it. Fortunately, however, the verses which explained the pictures were recorded.[2] John Lydgate, a minor poet and monk of Bury St. y read in French and Italian literature. poem a translator's prologue and an 'en-

London (ed. Kingsford), vol. I, pp. 109, 327. those of E. P. Hammond and Florence Warren.

voy'. In the first he tells us explicitly that he once saw the Dance at Paris, depicted on a wall 'full notably', that he made the acquaintance of French clerks,[1] and took it upon him to translate 'Machabres daunce' out of French. It was on the advice and counsel of the Frenchmen that he carried out the task. He adds that the Dance was portrayed at St. Innocents to show that the world is but a pilgrimage. In the envoy Lydgate says that he rendered the poem 'of intent', not word for word, but following its substance. He apologizes in the conventional manner for the rudeness of his language, pleading that he was not born in France and had little command of French.

There were thirty-six characters at St. Paul's. The whole hierarchy of church and state, from the pope to the clerk in minor orders, from the emperor to the labourer, was represented. At first there was a strict alternation of clergy and laity: pope, emperor, cardinal, king, patriarch, constable, archbishop, baron. But with the addition of the princess after the baron, the regular arrangement was broken. Age, youth and infancy were represented. There were secular and regular clergy, a Carthusian monk and a Franciscan friar. There were three female figures: princess, abbess and gentlewoman. The last character is 'Machabre the doctour', who was regarded as the author of the Dance.

The dialogue form is stressed by the rubrics in Lydgate's poem: 'Death first speaketh unto the Pope, and after to every degree as followeth.' Each of the thirty-six persons answers Death in his turn. They are evidently typical: one pope speaks for all of his rank, one emperor for his class and so on, but there is one curious exception. Between the man-of-law and the person (parson) we find 'Mr. John Rikill, Tregetour'. Surely this very English character could not have been imported from France. We happen to know that this was the name of Henry VI's jester. *Tregetour* means 'juggler'. Why is there a princess but no queen? The king was not betrothed till 1444. In 1440, in which year (or very shortly before it) the poem was translated by Lydgate, Henry VI was still unmarried.

While there is no contemporary account of the Dance of Death at St. Paul's, there is a reference that is not without interest. Sir Thomas More was familiar with the paintings, and speaks of them in his work *The Four Last Things*, in the chapter entitled *The Realm of Death*. A recent writer[2] had this passage in mind when he commented: 'Sir Thomas More had an aversion to the paintings

[1] The Trinity MS. and Tottel's print use the singular, *clerk(e)*; Warr p. 110.
[2] Dr. F. Peyton Rous, *The Modern Dance of Death*.

in St. Paul's, "ye lothly figure of our dead, bony bodies".' Taken from their context, More's reflexions might be so understood, but his meaning is quite different. His observations are an admirable example of his English style, and are quite typical of his trend of thought. They also interpret so well the mediaeval spirit, as expressed in the Dance of Death, that it might be as well to quote them in full. I follow Mr. W. E. Campbell's edition[1] with modernized spelling: 'What profit and commodity cometh unto man's soul by the meditation of death is not only marked of (i.e. observed in) the chosen people of God, but also of such as were the best sort among gentiles and paynims. For some of the old famous philosophers when they were demanded what faculty philosophy was, answered that it was the meditation or exercise of death. For like as death maketh a severance of the body and the soul, when they by course of nature must needs depart asunder, so (said they) doth the study of philosophy labour to sever the soul from the love and affections of the body while they be together. . . . We were never so greatly moved by the beholding of the Dance of Death pictured in Paul's, as we shall feel ourselves stirred and altered by the feeling of that imagination in our hearts. And no marvel. For those pictures express only the loathly figure of our dead, bony bodies, bitten away the flesh; which though it be ugly to behold, yet neither the light thereof, nor the sight of all the dead heads in the charnel house, nor the apparition of a very ghost, is half so grisly as the deep conceived fantasy of death in his nature, by the lively imagination graven in thine own heart.'

H. N. Humphreys called attention to a Dance of Death series in the beautifully sculptured oak-stalls of St. Michael's (now the Cathedral) of Coventry. As this building was almost entirely destroyed in the great raid of December, 1940, the carvings no longer exist. They were the only example of their kind in Britain.

Coventry Cathedral, with its famous spire, was a magnificent specimen of Perpendicular architecture. The north aisle of the choir, known as the Lady Chapel, or Drapers' Chapel, was rich in ancient woodwork. On the west and south sides[2] there was a series of carved stalls with misereres. Although somewhat rough in workmanship, they revealed originality in design. Of the fifteen misereres, twelve still had the mediaeval sculptures, the three others had been destroyed at some previous time by vandals.

On the south side of the Chapel the subjects were the Tree of

[1] *The English Works of Sir Thomas More*, London and New York, 1931, vol. I, pp. 467-468.
[2] The original position is not known.

Jesse, the Last Judgment, the chaining of the Devil, and an angel. The supporters of the second miserere were scenes showing the dead rising from their graves. Against the screen on the west side, there were two pastoral scenes: the first depicted threshing and bat-fowling, the second a shepherd playing on his pipe.[1] Next came the decapitation of a martyr,[2] and the Assumption of the Virgin. To the right of these were three misereres which had a large central corbel and two side subjects in low relief. The central representations were based on three of the Seven Corporal Acts of Mercy: visiting the sick, clothing the naked, and burying the dead. In the first of these a sick man was to be seen, attended by a physician and other persons. In the second a kneeling man was being clothed; beside him a cripple was leaning on a stick. In the third a body in a shroud was being lowered into an open grave; a priest held a torch in one hand and a book in the other. Of his two assistants one seemed to be a monk or a friar. In front of the grave were a mattock and a spade.

The smaller side subjects or supporters were taken from the Dance of Death.[3] As they were somewhat mutilated, their identity was not quite clear, but one appeared to have the triple crown of a pope, and another the mitre of a bishop. It will be noticed that the Dance of Death is not the principal theme, but is added for decorative purposes only. The centre corbels are the main thing, the isolated skeletons and their partners are merely an additional embellishment. There are many subjects that are not suitable for wood carving in high relief, and a long procession of figures is one of them. However, the combination of the Corporal Acts of Mercy with motives from the Dance of Death was quite effective.

It is interesting to note that in the Chester Doomsday Play[4] the idea of the Last Judgment is combined with the Seven Corporal Acts of Mercy, as in Matth. xxv, 31-46. There was moreover a series of characters: pope, emperor, king, queen, justiciary, and merchant, in this play as in the Dance of Death. The Coventry drapers had a Doomsday Play of their own,[5] which may well have resembled the Chester one. If this theory is correct, the four other Acts of Mercy were originally represented by misereres at Coventry.

Coventry Cathedral was not the only church that had an example of the Dance of Death in this particular medium. St. George's

[1] These may represent the seasons: spring and autumn.
[2] Probably St. John the Baptist.
[3] *Birmingham Archaeological Society Transactions*, lii, (1930), Plates v, vi, vii, ix.
[4] *Early English Text Society*, Extra Series, No. lxii (1892).
[5] Harris, *loc. cit.* p. 246.

Chapel, Windsor, has three scenes carved in wood on one of the misereres of the choir. The large central corbel, or roundel, represents a rich man in an arm chair. To his left is a table covered with flagons and tankards. Before the table is a money chest. On his right Death seizes him by the arm. The left-hand corbel shows a labourer digging with his spade. The subject of the right-hand roundel is not quite clear because it is slightly damaged. A bearded man in a jerkin, not unlike the labourer in the opposite corbel, holds a tool of some kind in his left hand. It has been suggested that he is threshing corn and that the implement is a flail.[1] The three skeletons in these scenes are made to resemble the living characters; they are in fact their doubles. The treatment is vigorous and realistic. One would imagine that it is the work of a local craftsman who is treating life as he sees it around him. The late Dr. M. R. James assigned these misereres to the last quarter of the fifteenth century.

The carvings at Coventry perished by enemy action; other examples of the Dance of Death have disappeared as a result of the effects of time or of neglect. Unless wall paintings are frequently renewed they are apt to fade until they become unrecognizable, and they are particularly sensitive to the action of damp, so that the British climate is not favourable to their preservation.

The paintings in the Archiepiscopal Palace at Croydon no longer exist; and there are neither contemporary descriptions nor engravings which would enable us to form an idea of their nature. At Wortley Hall, Gloucestershire, a Dance of Death poem and probably also pictures were formerly to be seen.[2] The verses corresponded to those of Lydgate with some additional characters.[3] In a copy of Leland's *Itinerary*, which belonged to John Stow, the antiquary, there was a manuscript note, in which Stow referred to a Dance of Death in the parish church of Stratford-on-Avon. Douce hazards the conjecture that Shakespeare had this example in mind when he wrote in *Measure for Measure* (Act III, Scene 1):

> Thou art death's fool;
> For him thou labour'st by thy flight to shun,
> And yet runn'st towards him still.

[1] W. H. St. John Hope, *Windsor Castle, An Architectural History*, London, 1913, vol. II, p. 475; M. R. James. *St. George's Chapel*, Windsor, 1933, p. 7. I am much indebted to Mrs Ollard for kind information about these examples.

[2] Douce, p. 53.

[3] The text was published from a manuscript in the British Museum by F. Warren, *The Dance of Death*.

Another literary allusion to the Dance of Death has been suspected in *Piers Plowman*:[1]

> Death came dryving after and al to douste paschte
> Kynges and knyghtes, caysers and popes;
> Lered ne lewide, he lefte no man stande;
> That he hitte evene, sterede never after.
> Many a lovely lady and her lemmanes knyghtes
> Sounede and swelte for sorwe of Deths dyntes.

These vigorous lines, written about 1376, rather suggest a morality play than pictorial representations, and the same thing might be said of the reference in Shakespeare. But one must not read too much into either of these passages. The phrases 'kynges and knyghtes' or 'kynges and keiseres' were stereotyped and occur elsewhere in *Piers Plowman*. They were due to the use of alliteration as the link between the lines of poetry, where we should use rhyme.

A manuscript in the British Museum records 'The second part of the Inventorye of our late sovereigne lord kyng Henry the Eighth, conteynynge his guard-robes, household stuff, etc. etc.' In the list of tapestries in the Tower of London that had belonged to Henry VIII, we read of legendary and biblical subjects, 'the Seven Deadly Sins, the riche history of the Passion, the Stem of Jesse, our Lady and Son, king Solomon, the Woman of Canony, Meleager, and the Dance of Maccabre.'[2] Very few sixteenth century tapestries have survived the ravages of time, and no trace of this particular one can be found.

There is good reason for thinking that the Dance of Death also figured among the subjects of stained glass windows. Francis Douce had in his possession two panes of glass, of which he gave the following description:[3] '1. Three Deaths, that appear to have been placed at the beginning of the Dance. Over them, in a character of the time of Henry VII, these lines:

> . . . ev'ry man to be contented wt his chaunce,
> And when it shall please God to folowe my daunce.

2. Death and the Pope. No verses. Size, upright, 8½ by 7 inches.'

No trace has been found of these examples, but on the other hand one has been discovered in Norwich which compensates us for the loss. In the north aisle of St. Andrew's Church there is a window

[1] *The Vision of William concerning Piers the Ploughman*, ed. W. W. Skeat, Oxford, 1886, vol. I, p. 584, lines 100-105.
[2] MS. *Harley* 1419, fo. 5; see Douce, p. 5, and W. G. Thomson, *A History of Tapestry*, London, 1906, p. 245.
[3] P. 227.

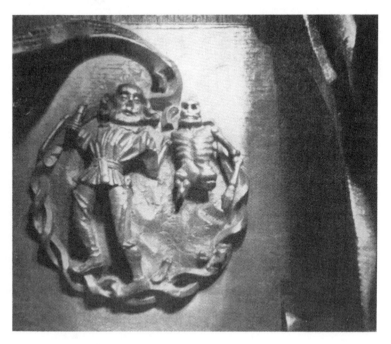

ST. GEORGE'S CHAPEL, WINDSOR: CARVED MISERERE

with a panel depicting a bishop led away by a skeleton. He is shrinking away from his ghostly guide. The bishop wears an albe, a dalmatic and a chasuble. On his hands he has white gloves and in his left he holds a pastoral staff. The figures stand on a black and white tiled floor. A red curtain forms the background. This panel was originally in the north side of the nave clerestory and was still there in 1712. It was later taken away and kept in various places until it was put in its present position about 1913.[1] The date of the glass is not long after 1500. Originally there were 44 panels distributed in 11 windows of 4 panels each. The other scenes were: Death and the emperor, king, pope, cardinal and so on, leading to craftsmen, such as a carpenter, 'and other mechanick trades'.[2] This is all the information we have about the lost panels.

There are some paintings which have been erroneously referred to as Dances of Death, one example is in the rood-loft of Sparham Church, Norfolk. This represents three skeletons only; there are no living persons and hence it is no true Dance of Death. Nor is there any suggestion that the skeletons are dancing; there is no raising of the feet. In the pews of Yoxford Church, Suffolk, fragments of an old screen have relics of pictures in which the figure of Death occurs, but there is nothing to show that it is part of a complete Dance of Death series.

In the magnificent tomb of the Lords De La Warr in Boxgrove Church, Sussex, there are two sculptured figures, known as 'Death and the Lady'.[3] Death is a skeleton with a spade and the Lady has a crown shaped headdress. It is quaint and simple work. This single scene may have been suggested by the Dance of Death, but is only an isolated scene and hence does not fall within the scope of our enquiry.

No pictorial representations of the Dance of Death have been discovered in Scotland. Relatively few Scottish towns or villages possess their pre-Reformation churches, and in those that remain all mural paintings were destroyed or covered over by the Reformers. But, in the domain of stone carving, one fortunate survival more than compensates us for many a grievous loss. Among the architectural treasures of Scotland the ancient Chapel of Rosslyn occupies a high place. It was planned as a collegiate foundation by Earl William St. Clair, a man of vision and energy, but owing to

[1] George A. King, 'The pre-Reformation Painted Glass in St. Andrew's Church, Norwich', *Norfolk Archaeology*, xviii (1911-14), 283-294.
[2] John Kilpatrick, Extracts from Manuscripts, in Norwich Public Library.
[3] Reproduced by Douce, at the end of his book.

the death of the founder, only the choir of the cruciform structure was actually completed. In the variety and exuberance of its ornament it is unsurpassed among Scottish churches.[1]

In this beautiful chapel there are some carvings which are usually designated as a Dance of Death. There are twenty-four subjects, which ornament the sides of the vaulting ribs of the retrochoir. As these sculptured designs are separated from each other and do not form a complete whole, they can scarcely be regarded as a series, and in that sense they fall, strictly speaking, outside the scope of our investigations. Nevertheless, we can safely say that these carvings were inspired by the Dance, and are an offshoot from it. Many of them represent Death with a human figure; in one example Death is found alone; in others there is the human character without Death. Instead of following the conventional pattern, the artist struck out boldly and fashioned something quite new.

Much, if not all, the stone used in building the chapel, is of a friable nature. It lends itself to carving and undercutting, but is very susceptible to weathering and damp. The edifice suffered through vandalism, particularly in 1688. In 1736 the roof was repaired and the windows glazed, but between that date and the careful restoration of 1860, the chapel was allowed to fall into disrepair. When Dorothy Wordsworth visited Rosslyn in 1803, she remarked on the exquisite beauty of the interior, but deplored its ruinous condition, and in 1838, her brother, the poet, apostrophised the building with the words 'The wind is now thy organist'. It is evident that the chapel was not weatherproof, and the Dance of Death carvings are so worn to-day as to be almost undecipherable. One is therefore compelled to rely to a considerable extent on the descriptions of earlier writers, who examined the work before the damage was irreparable.

The composition on the east central pillar is the Fall, which might be logically associated with the idea of death. It is, however, questionable whether it is to be so interpreted here, because there are many other sculptures, such as the Seven Deadly Sins, the Seven Corporal Works of Mercy, the Heavenly Host, scenes relating to the Nativity and the Life of Christ, the Twelve Apostles, the Parable of the Prodigal Son and so on. I think that the Fall belongs to the general scheme rather than to the subjects with which we are specially concerned.

In the Dance of Death the figures are some eight inches in height. They are carved in relief, one subject on each stone, on the sides of

[1] The Rev. G. H. Taylor very kindly gave me special facilities for inspecting the retro-choir of the chapel.

the vaulting ribs. As they are in an awkward position from the point of view of lighting, they can only be seen on a very clear day, and even then the details are difficult to distinguish. This is especially true of the carvings on the south-east corner of the chapel. They are on the rib that springs from the south-east wall corbel and on the opposite one. There are four examples on each rib. The remaining compartments are filled with conventional foliage, and one gets the impression that the work was not completed. According to the description made by Andrew Kerr[1] the subjects are: 'First, a warrior with helmet, sword and spear; second a monk drinking; third, a figure of Death crouched together; fourth, a man with a dress having particularly wide sleeves.' The other groups are said to consist of a queen, a lady seated in a chair, a lady in an attitude of prayer, and finally a warrior.

In the north-east corner of the retro-choir the designs were fully executed and they can be recognized to-day, though with difficulty. It is in this part that we can most clearly trace the original conception of the Dance of Death.[2] The highest figures are those that have precedence: the king is the highest, the lowest is the abbot. There is thus some sign of the hierarchical arrangement that we have met elsewhere. At least the first seven, counting from below, are accompanied by Death. According to the accepted interpretation, the first two subjects are an abbot and an abbess. The wimple of the second figure is still to be seen. The third is decapitated; it seems to be a monk or priest. The fourth is a lady admiring her portrait, or as other writers have it, looking into a mirror. The object in question is oblong, not round. The fifth is very battered; it looks like a prelate; the sixth is a bishop, and the seventh is clearly a cardinal, as his large hat is recognizable. The eighth is a courtier, and the ninth a king. If one might venture a guess as to the identity of the courtier, it seems likely that in a building founded by an earl the nobility would not be left without a representative. In an institution founded for a provost and six prebendaries, one would also expect to find a canon or some similar figure. This may be the explanation of the third scene.

The section just described seems to stand for the court and high ecclesiastics. On the opposite rib there are seven scenes that form a picture of active life, since they include the ploughman with bent

[1] 'The Collegiate Church or Chapel of Rosslyn, its Builders, Architect and Construction.' In *Proceedings of the Society of Antiquaries of Scotland*, vol. XII, Edinburgh, 1878.
[2] See R. W. Billings, *The Baronial and Ecclesiastical Antiquities of Scotland*, Edinburgh, 1845-1852, vol. II, 'Rosslyn', p. 2.

back, the carpenter, the gardener with a spade as emblem, the sportsman, a child, a married couple, and a farmer. The first, the ploughman, has every appearance of having been restored. These and the remaining carvings at Rosslyn raise a host of interesting problems, and there is room for a monograph on the iconography of the chapel. The Dance of Death is unique among the representations in Britain.

The dating of a mediaeval Scottish building is a matter of some difficulty, even for specialists, but we happen to be well informed about Rosslyn Chapel. As far as the present building is concerned, it was begun about 1446 and the work came to an end about 1484.[1] On the outside corbels of the north side an inscription has been discovered with the date 1450. This is approximately the time when the Dance of Death sculptures were carved. The earliness of the date is important. Where the idea came from is not easy to decide. The local tradition has it that Earl William St. Clair, the founder of the Chapel, caused artificers to be brought from other regions and foreign kingdoms. One would naturally think of France. There is no trace of Tudor influence in the architecture of Rosslyn, so that an English source, though not impossible, is unlikely. Some historians of architecture maintain that the ornament recalls Spanish art, but the general view to-day is that the workmanship is largely Scottish, while the inspiration may be partly French.

The Dance of Death left indelible traces on Scottish literature.[2] Lydgate's translation of the *Danse macabre* was known in Scotland, as also was the *Legend of the Three Dead and the Three Living*. We find reminiscences of both in Henryson's poem *The Thre Deid Pollis*, in which three skulls (dead polls) compare the glory of youth and health with the decay of death. All stations alike are subject to this fate:

> The empriour for all his excellenss,
> King and quene, and eik all erdly stait
> Peure and riche, sal be but differenss,
> Turnit in ass,[3] and thus in erd translait.

In the best known of Dunbar's poems *The Lament for the Makaris*, the same theme is treated in verse of haunting beauty.

> Onto the ded gois all Estatis,
> Princis, Prelatis, and Potestatis,
> Baith riche and pur of all degre,
> Timor mortis conturbat me.

[1] David McGibbon and Thomas Ross, *The Ecclesiastical Architecture of Scotland*, Edinburgh, 1897, vol. III, p. 151.

[2] Miss Hammond (*Latin Texts of the Dance of Death*, p. 4) traces the influence of Lydgate's poem on minor English writers. [3] i.e. ash.

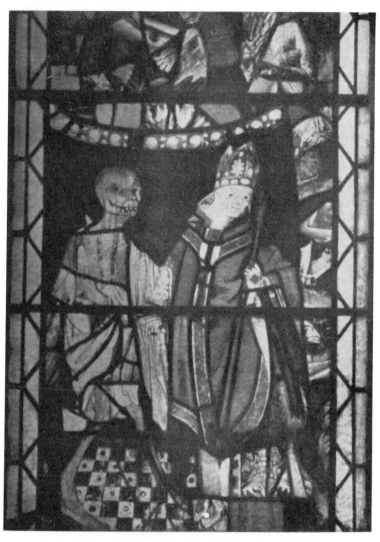

ST. ANDREW'S, NORWICH: STAINED GLASS WINDOW

As the poem proceeds, Dunbar speaks of the knight, victorious in every *mêlée*, but defeated by the arch-destroyer, the *bab* (pope), full of benignity, the captain, the lady in her bower, the lord, the clerk, the leech and finally the *makaris* (poets). All these figure in Lydgate's poem, and among the dead poets whom Dunbar laments is 'The Monk of Bery'.

If we now pass in review the various examples, past and present of which we have any knowledge, we conclude that there are two lines of tradition: the Scottish, as exemplified in Rosslyn, which points to the Continent as its home, and the English, which centres in London, as far as it can be traced to one single source. The paintings at St. Paul's were the authentic and complete Dance of Death, of which the relics at Hexham, Newark, Salisbury, and possibly others, were but mutilated fragments. In consideration of the fact that the London series was undoubtedly the oldest, we may surmise that it was the parent stock from which the others derived. But from St. Paul's the road leads clearly to Paris, and it is there that we must look for the antecedents of the English Dance of Death. Fortunately Lydgate's statements are explicit.

He obtained his inspiration from the Innocents at Paris, and it is there that we must pursue our investigations.

III

FRANCE

Not far from the Halles Centrales, the great Paris market, there is a public garden known as 'Le Square des Innocents'. In the centre stands a fine Renaissance fountain built by Pierre Lescot in 1549. Though it has suffered much at the hands of restorers, it is still considered the most beautiful, and it is doubtless also the oldest of the many fountains of Paris. The park is on the ancient site of the Church of the Holy Innocents and its cemetery.

The place had been used for interments for centuries, perhaps since Roman days. Part of it was reserved for the Church of the Holy Innocents, part for the sick of the Hôtel-Dieu, and the rest for those numerous churches that had no graveyard of their own. The soil was considered sacred. Louis Beaumont de la Forrest, Bishop of Paris, who was not entitled to be buried there, ordered in his will that some earth from the Innocents should be put in his grave.[1] The area was spacious, but it could not meet the needs of the vast city with its high mortality. Until the fourteenth century the mortal remains of the dead lay undisturbed in their graves, awaiting the Last Judgment and the resurrection, but as a result of the overcrowding of mediaeval cities, the custom arose of disinterring the dead and putting their remains in charnel houses to make room for newcomers. There was no respect of persons at the Innocents: rich and poor were treated alike, the one had as short a tenancy as the other. Even the gravestones were taken away and sold from time to time.

There was an ancient churchyard cross, an open-air pulpit, a pillory, and beneath a pent-house a lamp was lit at night to keep away evil spirits and apparitions. Adjoining the church was the cell of a female recluse, who was immured for over forty years. The cemetery was surrounded by high walls with three large gates. Round the walls, galleries, or charnel houses, were built and below them ran a kind of covered walk or cloister. On the southern wall of this cloister the *Danse macabre* was painted, and on the portal of the church the *Legend of the Three Living and the Three Dead* was sculptured.

This then was the awe-inspiring spot that inspired a well-known

[1] *Gallia Christiana*, t. VII, col. 154.

passage in the *Testament* of the poet François Villon. He must have often wandered about in the precincts of the Innocents, reflecting on the vanity of human wishes. The colours of the pictures were still fresh when he gazed on them, and the inscriptions beneath them were legible enough. As he recalls his past life, in the *Testament*, his thoughts turn to anguish and remorse. 'Remember', he says, addressing his boon companions, 'that the time will come when you must die. . . . There is no laughter and no jesting here . . . all these joys come to an end, and the guilt thereof remains. When I consider these skulls, piled up in these charnel houses, they may have been magistrates, at the very least of the Royal Exchequer, or else just street porters; I might as well say one as the other. For all I know, they were either bishops or lamp-lighters. Those heads bowed to each other when they were alive. Some commanded, others feared and obeyed them. They are all jumbled together in a heap now. Their titles have been snatched away from them, none is addressed as clerk or master now.' We may translate the words of the Old French original, but not the music of the verse. The metre of the poem is identical with that of the *Danse macabre*, and Villon shared with the latter the trick of ending a stanza with a proverbial saw or aphorism.

There can be no doubt about the date of the *Danse macabre*, because a contemporary chronicler tells us that it was commenced in August 1424 and completed in mid-lent of the following year.[1] In 1429, as the same informant relates,[2] Friar Richard of the Franciscan Order preached at the Innocents on a high platform, with his back turned to the charnel houses, and facing the wheelwrights' workshops (the modern rue de la Ferronerie), 'at the place of the *Danse macbre*'. The sermons of Friar Richard were apocalyptic. He announced the approaching coming of the Antichrist and the end of the world. Five or six thousand people are said to have flocked to hear him; gaming tables, cards, and women's finery were cast to the flames. Sackcloth and ashes were the order of the day. In 1434 Guillebert de Metz in his *Description de Paris*, writes of the vast cemetery with its houses full of bones and the 'noted paintings of the *Danse macabre* and other things to move people to devotion'.

The place was sombre and full of gloomy associations, but it would be a mistake to think that there was not another side to the picture. It would be easy to describe the sufferings of the times; the long drawn-out agony of the Hundred Years' War, the devastation of the countryside, the disease and famine in the city, round the walls of which wolves prowled, the savage feuds of the Burgundians

[1] *Journal d'un bourgeois de Paris*, Paris, 1881, p. 203. [2] P. 234.

and the Armagnacs, treachery, assassination and mass murder. We might easily convince ourselves that the *Danse macabre* reflected the misery and despair of a dying age. We are apt to forget that besides its didactic value, its message, the work had a practical use. It was intended to decorate the bare walls of the churchyard.

The year 1424 falls in the English occupation of Paris. French historians are fair minded enough to admit that the Duke of Bedford's administration was good. It contrasted favourably with the preceding phase of armed uprisings and massacres. In spite of pestilences and wars, the people of Paris had not entirely forgotten the natural gaiety of their race. The *Danse macabre* was painted in one of the brighter intervals which occur in the most depressing of periods. There had been an excellent harvest. The opening of the Porte Saint-Martin was the signal for a burst of merrymaking. Even the Innocents was not always a place of grief and regret. It was situated in a noisy and gay quarter of Paris: it served at times as a kind of popular promenade. There were small booths below the famous charnel houses, in which books, cloth, and ironmongery were sold. The vendors exposed their wares to the public view on the tombs. We even read of a stag hunt at the Innocents, to celebrate the entry of the nine-year old Henry VI into Paris in 1431.[1]

In 1669 the *Danse macabre*, once reckoned among the sights of the city, but now defaced and forgotten, was destroyed together with the wall on which it was painted. The age of Louis XIV took no interest in the picturesque relics of an earlier day. The road was being widened, and the wall was just an obstruction that had to be removed. But a fortunate circumstance enables us to reconstruct the paintings together with the Old French poem that accompanied them. Two manuscripts in the Bibliothèque nationale[2] contain a dialogue described as 'Les vers de la danse macabre, tels qu'ils sont au cimetière des Innocents'. A comparison with Lydgate's translation shows that here we have the lost inscription.

In 1485 a Paris printer named Guyot Marchant published the first edition of his *Danse macabre* with woodcuts and verses.[3] The latter correspond to the text of the two manuscripts of the Bibliothèque nationale, and there can be no doubt that the illustrations were based on the paintings of the Innocents, though they may not be an exact reproduction. The costumes have been brought up to

[1] Pierre Champion, *La Vie de Paris au Moyen Age. Splendeurs et Misères de Paris*, Paris, 1934, pp. 159, 207.
[2] There is also a MS. at Lisle and one in the British Museum, see Warren, p. 79, Hammond, *English Verse*, pp. 426-427.
[3] Only one copy is preserved, in the library of Grenoble.

97404

GUYOT MARCHANT, 'DANSE MACABRE': POPE AND EMPEROR

date, as was natural, but in many small details the woodcuts follow the text so closely that we feel we have before us a tolerable copy of the *Danse macabre* in its original state. The attitude of the figures, their gestures, even the expression of the face, the attributes that accompany them, all these find their place in the stanzas printed below. The deviations are instructive: the exception proves the rule. One of the most striking instances is that of the sergeant-at-arms. In the woodcut only one of the dead holds him by the arm, whereas in the poem we read 'Je suis pris de ça et de la', which certainly implies that in the *Danse macabre* at the Innocents two figures had seized the sergeant, one on each side. From other unimpeachable evidence[1] we know that this was so. Guyot Marchant groups his characters in fours: one cleric and one layman, each with his 'mort'. Every group is set in an arcading, and pillars separate off one section from the other. Thus there is not an unbroken chain: the sergeant came to be separated from one of his 'morts'. In a printed book one can only see two pages at a time, but at the Innocents the line was continuous, and the chain of figures stretched before the spectator as a unity. There was a division into compartments by means of the arches of the vault, but these would not really interrupt the line as a whole. The ornamental arcading of the woodcuts corresponds to the stone arches in the original.

The general arrangements are already familiar to us from Lydgate's poem. Death addresses one stanza to the pope, who replies, then the emperor is addressed and he answers; and so Death speaks to the living and each in his turn replies. Two curious facts strike us; the usurer is not alone, but accompanied by a poor man, who is, so to speak, the emblem of the money-lender's calling[2] Unlearned folk would readily recognize him as such. But the poor man, who is hardly there at all in his own right, makes a reply to Death. At the end of the Dance proper, the hermit is seized not by one but by two 'morts', one on each side. From a contemporary description[3] we gather that the last arcade of the cloisters contained the last two characters, the clerk and the hermit, followed by the dead king, who is a supernumerary, and the master, who is either the preacher whose sermon includes the whole, or the author of the poem. In the first arcade stood the *acteur* or author, immediately before the pope, who commenced the dance.

[1] Dufour, pp. 65-66.

[2] In later printed versions of the Paris *Danse macabre*, the schoolmaster is similarly accompanied by his pupil.

[3] *L'Epitaphier de Paris*, Collection Clérambault. Cabinet des manuscrits, fonds français, No. 8220.

The first printers came to Paris in 1470; some of them were Frenchmen, others were Germans. They cultivated their craft with enthusiasm and the public responded with alacrity. Some fourteen years later the first illustrated books issued from the printing presses of the French capital. The work was admirably done and among the best examples are those that were produced by Guyot Marchant. His engravings of the *Danse macabre* were drawn and cut by some unknown artist with a skill and delicacy that would do credit to any period. The craftsmanship is that of a man who combined imagination with vigour of execution. The pope and emperor, with their gorgeous robes and appropriate insignia, are full of dignity, but their face and bearing indicate the reluctance of the one and the deep regret of the other. The canon has a face that bespeaks good living. The gestures and look of the parish priest tell of horror, while the labourer has a mien of stolid indifference. He is inured to hardship and want; he has a heavy tread; his knees seem rheumatic, and his weather-beaten face suggests the open air.

An inferior craftsman, faced with the task of drawing thirty-one skeletons or corpses,[1] might have simply repeated his first sketch thirty-one times: not so our artist. Sometimes 'le mort' is naked, in other scenes he has a loin cloth or a shroud loosely draped round him, or he has a spade and pick in his hand or over his shoulder. This is replaced elsewhere by a dart, a scythe, or a coffin lid. Monotony is avoided by these skilful variations. Not only that, but one can say that the gestures of invitation, of scorn or mockery, the dancing steps, are not those of an automaton, but of a being instinct with life. The grotesque grimaces and wild dance of the dead contrast with the slow steps of the living. How could the difference between the host and the unwilling guest be better portrayed? The conventional setting, with its arches and pillars, is of course repeated in the woodcuts, but the lower part of the pictures with grass, plants and flowers has enough variety to be attractive.

Marchant's little book proved to be one of the most popular productions of the time. It sold so well that in the following year, 1486, a second edition appeared. The list of characters was increased by two clerics and an equal number of laymen. Four corpses with musical instruments were engraved on the first page of the new edition as an additional attraction. A rival publisher, Vérard, entered the field in 1492 with a *Danse macabre* which was largely copied from that of Marchant. Provincial printers at Lyons and Troyes produced their versions. The poem inscribed at the Inno-

[1] The mediaeval artist was ignorant of anatomy. His skeletons are not realistically drawn.

cents was translated into English, Low German, Latin (by Pierre Desrey) and Catalan. So popular did the subject become that Books of Hours, or as we should now say, prayer books, began to adopt the Dance of Death among the miniatures with which they were decorated.[1] To pursue the various types of illustrations in these Books of Hours would require a volume in itself. Interesting as the theme would be, it is beyond the scope of the present work to explore it, the more so as these miniatures are all derived from the Paris *Danse macabre*. They add nothing essentially new to the central theme.[2]

In 1486 Marchant produced his *Danse macabre des femmes*. The book was amplified by the addition of the Legend *Des Trois Morts et des Trois Vifs*, and two didactic poems dealing with the subject of death: *Débat du corps et de l'âme* and *La Complainte de l'âme damnée*. Both Dances of Death, that of men and that of women, were painted on the inside walls of the church at Meslay-le-Grenet (Eure-et-Loire) about 1500. They were an uninspired copy of Marchant's work with the original verses. None of the later editions equalled the first in artistic merit. The others, and in particular the *Danse macabre des femmes*, are poor imitations. But the repeated reprints and new editions which follow each other till the eighteenth century afford eloquent testimony to the profound impression created by the *Danse macabre* of Paris and the popularity of Marchant's woodcuts.

Who was the author of the verses inscribed at the Innocents? He was, one would judge, a man of high rank. He knew how to address prelates and princes; he could meet them on an equal footing. He was a churchman and a scholar. He was well versed in law and not ignorant of medicine; he was a theologian. His verse is not musical; he is a didactic not a lyric poet. His strength lies in his terrible irony. He lashes the frailties of mankind with the whip of satire. He is a stern moralist. He does not try to charm the reader with his grace. Beauty is not his forte. When addressing the patriarch he jeers, 'You will never be pope of Rome'. To the portly abbot he says: 'The fattest rot soonest', and to the parish priest: 'You were wont to devour both the living and the dead, but you shall be given to the worms.' Through his mouthpiece, Death, he warns the bailiff that he will have to render an account to the great Judge of all. He mocks the physician who cannot heal himself, the merchant who runs over hill and dale to amass wealth that avails

[1] Douce, pp. 60-74, Langlois, II, pp. 13-28.
[2] This also applies to the printed illustrations in *A Booke of Christian Prayer*, printed at London by John Day in 1578.

him nothing in his hour of need. He has no mercy for hypocrisy or greed. None find favour in his sight save the child that can scarcely speak and the two friars: the Carthusian, to whom he relents somewhat, since he is a man of abstinence among the greedy prelates, and the humble Franciscan, who had often preached of death. All this is criticism of a society in which there were glaring extremes of wealth and poverty, in which the exactions of privilege and rank weighed heavily on penury, an age in which social discontent was rife.

The identity of the poet is unknown. Lydgate called him 'Macabre the doctour', but this must have been a misunderstanding. In 1490 Guyot Marchant printed a Latin translation of the *Danse macabre*. The translator was Pierre Desrey and his version is entitled: 'Chorea ab eximio Macabro versibus alemanicis edita et a Petro Desrey emendata'. Evidently Desrey also believed that the mythical Macabre was the author. The phrase *versibus alemanicis*, 'in German verses', led to the view that the *Dance of Death* originated in Germany and the further conclusion was that Macabre was a German. As a matter of fact *versibus alemanicis* may just refer to the metre, 'in stanzas of the German pattern'. There is not the slightest evidence that the poem was translated from German.

In two manuscripts containing works by Jean Gerson, we find the text of the *Danse macabre*, and for this reason some writers assumed that Gerson wrote it. Incidentally the *Imitation of Christ* was also wrongly attributed to Gerson, who as Chancellor of the University of Paris and dominant personality at the Council of Constance, was a great historical figure. But Gerson left Paris for good in 1415, and in 1424 he was living in voluntary exile. The question is further complicated by a notice in the introduction to Carbonell's translation of the *Danse macabre* into Catalan; 'This Dance of Death was translated into the Catalan language from that [poem] which was composed in the French language by a holy man, a doctor and chancellor of Paris, named Joannes Climachus or Climages, at the request of certain devout French religious . . .'[1] Nicolas de Clemengis was a friend of Gerson. He lectured in 1425 at the Collegium Narbonense at Paris, but he was neither a doctor nor chancellor of the University.[2] In Catalan the word *canceller* does not necessarily mean 'chancellor of the university', but signifies 'an official of a chancery', or one might almost say 'clerk'. But the passage we have just quoted is too late in date to weigh very much as evidence. One of the two manuscripts in the Bibliothèque nationale

[1] *Cançoner de las obretes*, etc., p. 34.
[2] W. Seelmann, p, 393, n. 5.

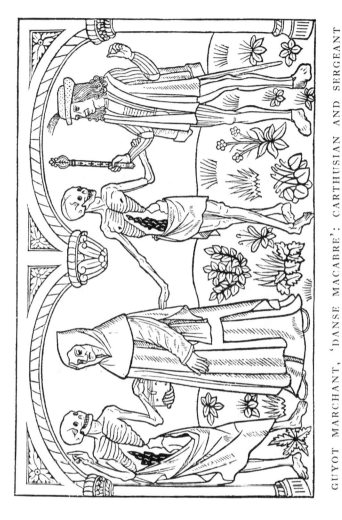

GUYOT MARCHANT, 'DANSE MACABRE': CARTHUSIAN AND SERGEANT

to which we have already referred, as containing the verses of the *Danse macabre* and works by Gerson, also included treatises by Nicolas de Clemengis. The manuscript contains the date 1429. There are, therefore, reasons for supposing that the *Danse macabre* may have been written by someone who belonged to the circle of Gerson's friends, but his exact identity must remain doubtful.

Having dealt with the Paris *Danse macabre* and its derivatives at some length, we might now return for a moment to England. Is there any resemblance between the Hexham pictures and Guyt Marchant's woodcuts? If there is, we have additional proof, should any be needed, that the printed book follows the mural paintings fairly closely. Ovbiously we must not expect too much from this comparison, because there would probably be intervening links between Paris and Hexham, such as the lost paintings at St. Paul's. As it happens, an examination of the two surviving examples reveals several common features, which cannot be due to mere coincidence. These are the floral background, the shape of the skeleton (or figure of Death), and the clothing of the cardinal and the king. The two kings in particular are very similar. Finally, Death has a scythe in the pictures containing the emperor, but not in the other sections. As was to be expected, Hexham betrays a cruder workmanship than Paris. The difference in artistic skill is shown in the drawing of the king and in the floral background. We have the impression that Paris is the original and Hexham an inferior copy.

We are now in a position to compare the Dance of Death at St. Paul's with the work at the Innocents. When we examined Lydgate's poem, we suspected that some changes had been made. Master John Rikill, Tregetour, looked like an addition, and the presence of the princess also gave rise to doubts. We now find that Lydgate (or his patrons) added all the female characters: princess, abbess, gentlewoman. For the French minstrel he substituted Tregetour, and he added the juror, who was absent at the Innocents. The last character at Paris was the *maître*: Lydgate has 'Machabre the doctour', which indicates that the *maître* was believed to be the author of the poem.

It was not only in the French capital that this sombre theme inspired artists and poets. Two remote villages have preserved their mural paintings long after Paris lost hers. One of these is in Brittany, the other in the Auvergne. Let us deal with them in turn.

Brittany is a haunted land. Its ancient churches are steeped in legend and tradition. There is no break between past and present. Prehistoric monoliths and mediaeval churches do not belong to a different age, but blend with the works of yesterday and form part

of the landscape. In a secluded part of Brittany, far from the beaten track, lies the small village of Kermaria. Tourists rarely visit it, as it slumbers in its thoughts of the past. The church in its uncared-for simplicity and slight appearance of want of repair, has been for centuries a place of pilgrimage for the Breton people. Two images stand above the high altar. Both Notre Dame de Kermaria and Notre Dame Isquit have their 'pardon'.

In this village church, decayed with age, austere and stern in its mouldering stone, we see above the nave arcade, on both sides of the building, the *Danse macabre*. On the north wall there is also a very faded representation of the *Legend of the Three Dead and the Three Living*. The *Danse macabre* was covered with plaster, but when this peeled off in 1856, some of the pictures became visible and the rest was carefully uncovered and found to be in a good state of preservation, though it has since suffered somewhat from the damp.

The figures, which are of a greyish colour, are in small compartments formed by a plain upright pillar and a crude, almost horizontal curved head or arch. The framework of pillars and arches is painted yellow. They are represented as being in the open air and stand therefore on the ground, and there is a red background with a floral design, of which a few traces only are visible. As the pillars in the paintings are very thin, they do not really interrupt the line of figures, and the latter seem to form a continuous chain. Some face the spectator, others (particularly the dead) are seen in profile. As at Paris, the dead and the living alternate, but at Kermaria this is not consistently carried through. There are at present forty-seven compartments in all, and thus there are twenty-three living characters, beginning as usual, with the pope and the emperor. Many of the persons represented at Paris are wanting here. The squire, abbot, bailiff, astrologer, and bourgeois were at one time present, but structural alterations have caused their disappearance. The final compartment probably contained the child originally, but there is no trace of it now.

Seven of the figures of the Innocents, namely the canon, merchant, physician, advocate, parish priest, clerk, and hermit are not included. According to Félix Soleil, who discovered the *Danse macabre* of Kermaria, they were omitted because of the limited space available. Beneath the pictures are the verses describing the series in Gothic or mediaeval lettering. Most of them are quite illegible, but some of them were transcribed in 1882, by Soleil. They correspond very closely with the inscription at the Innocents. Were the pictures also related to those at Paris? As far as we can judge

there was some resemblance, but the work at Kermaria was very much inferior to that of Paris.

With one possible exception, the dead are all corpses without emblems: they do not carry a scythe, a spade, or a dart, as at Paris. The only differences between the individuals are in the posture and shape. Some of the corpses have one foot raised, one has crossed knees. The Breton artist added a curious innovation: he gave some of these beings the heads of animals or toads. Mâle surmises that this was done to make them more terrifying, which he rightly considers to be childish. But there is another possibility: the idea may have been suggested by the masks worn by the devils in mystery plays. We read of a Corpus Christi drama performed at Aix-en-Provence in 1462, in which Death was represented by a black figure, with the bones of a skeleton painted on the clothing and with an ugly mask (une laide testiere).[1] Doubtless the artist felt the need for variety, because twenty-four skeletons all alike would present a very monotonous appearance. He did not succeed, as did other craftsmen elsewhere, in imparting an illusion of reality to his figures. They are inclined to be wooden and lifeless.

The painter of the Kermaria series was a man of feeble powers. Did he work from an inferior drawing or from memory? One thing is certain, he lacked inventiveness. He lacked the fertility of imagination of the Paris artist, and did not even attempt to portray the facial expression of the living characters. He is incapable of improving his theme; where he introduces innovations he spoils his work. For instance, at Paris the usurer was accompanied by a poor man, as a kind of lay-figure or emblem. At Kermaria the poor man is treated as a separate subject and has a panel to himself, which makes him meaningless.

Are these paintings older than those of the Innocents? Did the *Danse macabre* originate in Brittany? At first sight it might seem likely. The Bretons, like other Celts, are obsessed with the idea of death. How large a part it plays in their folklore and legend.[2] There is a cult of *Ankou*, older than Christianity and still strong to-day. Small wonder that some scholars should seek in Brittany the source of the Dance of Death. General considerations of this nature are reinforced by more special arguments. It has been urged that the crudeness of the workmanship at Kermaria proves its antiquity as compared with Paris. According to this view, we have at Kermaria the archtype and at the Innocents a later version, ex-

[1] E. H. Langlois, p. 298.
[2] The standard work is Anatole le Braz, *Légendes de la Mort chez les Bretons Armoricains*, 2ᵉ éd., Paris, 1902.

panded by the addition of half a dozen figures that are absent in the older cycle. This chain of reasoning has many flaws. The legendary lore of Brittany tells us a great deal about death, but it affords no clue to the meaning of the *Danse macabre*. If the *genre* had its origin in Kermaria we should expect to find more examples in Brittany than elsewhere, but this is not the case. Kermaria is the only one; the sculptures on ossuaries[1] are late in date and are not true Dances of Death. Nor is the argument from the workmanship at Kermaria relevant to the discussion. Surely the quality of the style is dependent on the skill of the artist as much as on the period. Anyonewho has seen Dol Cathedral, not to speak of a host of smaller churches, will realise that Breton art is not to be judged by the same canons as that of other parts of France.

The mediaeval architecture, sculpture, and painting of Brittany is quaint and picturesque, but it is not beautiful. Throughout this period the Ile de France, that is Paris and the surrounding district, was one of the most highly developed creative centres of Europe, while Brittany was backward and primitive. The Ile de France was the home of Gothic architecture; it was the seat of the greatest university of the Continent, in fact the finest centre of learning since the University of Athens was closed. Is it likely that the rustic artist of Kermaria inspired his talented colleague at the Innocents? The claim that Kermaria is the shorter and hence older series looks plausible enough at first sight, but it will not bear close examination. A short series may be expanded, but it is also possible for a long one to be abridged. We are told that this cycle is the original, excluding as it does the canon, merchant, lawyer, physician, parish priest, and hermit. It is scarcely credible that in a small Breton village the donor or artist of an original cycle of pictures should have included in his list the pope, patriarch, archbishop, bishop, and abbot, but ignored the parish priest. In such a place the *curé* was a much more real person than the patriarch.

One cannot help feeling that the Breton artist copied a model to which he did less than justice. How is it, for example, that at Kermaria the figures mostly face the spectator, except for some of the dead, who are seen in profile, walking either to the left or the right? At Paris, as far as we know, all the persons were advancing to the left, and we shall see later that this is also the case at Basel. At Paris and Basel there is a procession moving in a set direction: that is a symbolism that can be readily understood. But at Kermaria we are left in doubt. Are the figures moving at all, or

[1] See Langlois, pp. 321-322.

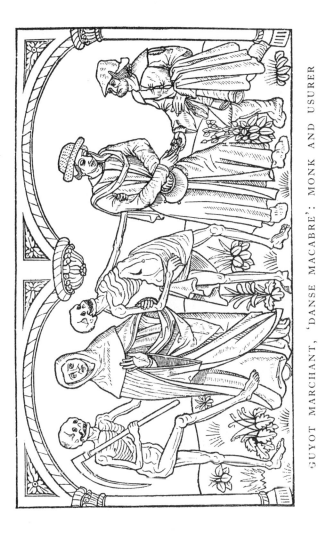

GUYOT MARCHANT, 'DANSE MACABRE': MONK AND USURER

are they dancing in one spot? Is this a chain or a ring of persons? Who can say? If, as we are given to believe, this cycle is older than that of the Innocents, it must have been made before 1424. In the fourteenth or early fifteenth century a poem composed or translated at Kermaria would have been in Breton, not in French, But the verses at Kermaria are in French, and what is more, in the French of Paris! Apart from trifling differences, which may have been due to faulty reading or misunderstanding, they are identical with the verses inscribed at the Innocents. That they are later in date than the Paris version is evident, because the latter has a better text. We cannot possibly believe that the corrupt text of Kermaria came before the Paris verses, which are free from error. In short, Paris came first, both as regards pictures and poem, Kermaria is an imitation and a clumsy one at that.[1]

If we might hazard a conjecture as to the reason why at Kermaria of all places, we should come across a *Danse macabre*, we should suggest that the idea came from the neighbouring abbey of Beauport, which had many links with the outside world and was not so remote in a geographical and cultural sense as Kermaria.

La Chaise-Dieu or Casa Dei, the House of God, is a fit name for the great abbey built on a wind-swept plateau near the borders of Auvergne. It is an austere spot, steeped in memories of the past. The domestic buildings of the once wealthy Benedictine monastery were almost entirely destroyed at the Revolution, but the imposing Gothic church survives. The present structure was erected between 1344 and 1352, largely at the expense of Pope Clement VI, who was a native of the village of La Chaise-Dieu and had been a monk in the abbey. He wished to be buried in the church, which already held the tomb of one of his predecessors, Gregory IX. The magnificent sepulchre of Clement VI, sculptured by François Pierre Royé, was broken open in 1562 by the Protestants. They destroyed the images and burnt the remains of the Pope.

The north aisle of the choir is screened off by a wall which connects the pillars of the choir arcade. The purpose of the wall was to provide support for the stalls. On the north side of the wall, and thus within the aisle, the *Danse macabre* is painted. It is a dark and damp part of the church, which fact has hastened the process of deterioration of the pictures. They cover the wall itself and the four projecting pillars. Do they form a continuous sequence, or is the work on the pillars independent of the Dance proper? A difference in the technique led Langlois to infer that the two sets of paintings

[1] Bégule, p. 56, dates the pictures at Kermaria late fifteenth century.

are not connected. He also claimed that he could detect a difference in style, and drew the conclusion that two artists and two periods were involved. On the pillars the figures were painted on the bare stone, while those on the wall were tinted against a red background. So little is visible to-day that we have to depend very largely on good reproductions and descriptions.

On the first pillar we have Adam and Eve with the serpent, the preacher in his pulpit, and a musician with bagpipes. The second pillar adds two persons and the third two more, together with the skeletons. The fourth has the hermit, a group of three people, and finally the preacher again. It is very doubtful whether the figures on the pillars are integral components of the work. The first looks like a kind of introduction, but it may have been a later addition, inspired by some other model. Beside the second pillar the construction of a pillar destroyed one person and his partner. Some of the figures in the Dance are now no longer recognizable, and the absence of insignia makes the identification of others difficult. The cardinal and patriarch have no cross, the emperor and king have neither sword nor sceptre, the bishop lacks his crosier, the usurer is not accompanied by the poor man, as he is at Paris and Kermaria.

The first scene on the pillar, the Temptation of Adam and Eve did not occur at Paris, but we shall find it again at Rouen and elsewhere. That death is the common lot of mankind, is due to the Fall, and therefore this is fittingly portrayed first. We might wonder why there is no sequel. If the Fall is mentioned, why is there no word of Redemption? We have Paradise Lost, but not Paradise Regained. Subsequent artists approach this problem and try to find a solution, as we shall see later. The final scene is also new and it has puzzled scholars considerably. There are three figures: an old man with a hat, a young man, over whose shoulder a skull is visible, and a woman. These are supernumeraries; they are not arranged in processional order, but are more casually grouped together. It has been suggested that they represent the multitude of persons not expressly included in the Dance. After them comes a priest who appears to be holding a parchment in his hand. He is generally thought to be identical with the preacher who began the series.

When Jubinal discovered the *Danse macabre* of La Chaise-Deu a century ago, much more was visible than is the case to-day. But Jubinal's reproductions[1] are inaccurate and unreliable. His aim was to render the spirit of the original, rather than its exact appearance.

[1] La Danse des Morts. Roll, printed by H. Roux, aîné. (British Museum, there is also a copy in Glasgow University Library. The pictures are also reproduced in Jubinal's *Explication*.)

He ignored the ravages of time, filled in gaps, supplied features that were wanting and took considerable liberties with his subject. His treatment is free and imaginative. It is useful for the average reader or the hurried tourist, but is almost worthless for the purposes of the scholar. For instance, in Jubinal's sketch the labourer has on his shoulder a stick over which a sack or cloth is thrown. At Paris he was carrying a hoe, and at Basel a flail. It seems as if Jubinal, not recognizing the object, made a kind of sack of it; if he had been acquainted with the other examples he would have known to expect some kind of agricultural implement. The drawings of Langlois, which are almost contemporaneous with those of Jubinal, clearly show a hoe. Not that Langlois is always reliable. He adds a beard to his patriarch, while Jubinal rightly makes his patriarch clean-shaven.

Nor are the discrepancies confined to the living. Jubinal makes one of the skeletons a female with pendant breasts, which is not confirmed by the original nor by careful reproductions. To build up elaborate hypotheses on the evidence of Jubinal's drawings alone, as some writers have done, is bound to lead to erroneous or doubtful conclusions. It is curious to note that one such 'authority' cites the female skeleton at La Chaise-Dieu as a proof of his pet theory that the skeletons are not types but individuals! The reproductions of Yperman, made in 1894, and now preserved in the Trocadéro, are faithful to the original and trustworthy.

There has been some controversy about the identity of the figures between the bourgeois and the merchant, the merchant and the sergeant and between the sergeant and the usurer. The characters we should expect here, by analogy with Paris and Kermaria, are the canon, the Carthusian and the monk. The third figure is so indistinct that one cannot be certain whether a monk or a woman was intended, but the other two certainly look like women, and they are generally described as a canonness and a young widow. The dress of the former, with its tassels or pompoms, has quite a feminine appearance. It is possible that the artist substituted women for the canon and the Carthusian, either because he had a poor copy before him or, as has been suggested, as a piece of artistic fantasy or even mischievous humour. Were not women included at St. Paul's, although the Innocents offered no precedent? It is true that the *Danse macabre* of La Chaise Dieu was in the choir of a Benedictine Abbey, to which women were never admitted, whereas the London pictures were in a public cemetery, to which the general public had access, but we cannot exclude the possibility that the French artist, who as so original in his treatment, may have inserted two women in his list.

Unlike his *confrère* at Kermaria, the artist of La Chaise-Dieu was a man of talent. He rapidly sketched his figures and tinted them lightly, using chiefly grey and violet, and colouring the foreground with yellow ochre. It is a brilliant improvisation, not a finished work of art. The characters are at different stages of completeness, for example, the cardinal has received more care than the hasty drawing of the patriarch. Emile Mâle, who saw the pictures when they were clearer than they are now, declared that the whole was the work of one man and that where two sets of lines are discernible we see the original sketch and the artist's later corrections. On the other hand Langlois who also studied the *Danse macabre* on the spot, declares that the first few figures were painted with great care, but were later covered with a new layer of paint in order to make the whole series uniform. He adds that the outlines of all the characters were applied in modern times which had spoilt the effect considerably.

Unless with the aid of science the old pigments can be restored it is improbable that these vexed questions will ever be settled. On one point, however, all critics are agreed: the artist possessed both skill and imagination. He is original in style and treatment. The skeletons, who have more flesh on their bones than those of Marchant's woodcuts, leap and dance with demoniacal energy. They contort and twist themselves and approach their victims with varying gestures. The facial expressions and movements of the living persons are no less varied. One skeleton is seen seizing the sword of the knight, but the constable's sword is already on the ground; it was flung there by his enemy, Death. The sergeant is literally 'pris de ça et de la,' because one grotesque figure is taking him by the arm, while on the other side a second one is pulling out his dagger.[1]

Is there any connection between the paintings of La Chaise-Dieu and those of the Innocents? If we ignore a few doubtful cases, we can say that the same figures occur in both, and in the same order. In points of detail there are many close parallels between the *Danse macabre* of La Chaise-Dieu and Marchant's drawings. The merchant with his wallet, the sergeant with his mace and dagger, the advocate with his *atramentarium* or ink-horn, at his girdle, the minstrel with his instrument thrown to the ground, the parish priest with his book, the labourer with the tool of his trade on his left shoulder, the infant in its swaddling clothes; all these are common to both cycles. At La Chaise-Dieu space was left below the pictures for the verses but they were never added. This is unfortunate, be-

[1] See above, p. 25.

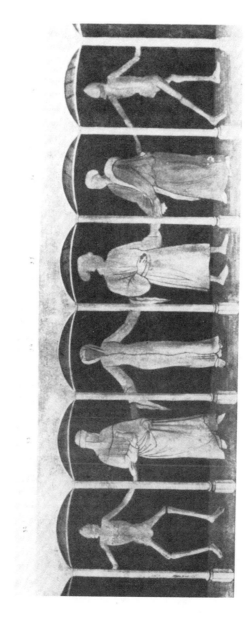

KERMARIA PARISH CHURCH: MURAL PAINTINGS (NORTH SIDE OF NAVE)

cause their presence would clear up many doubtful points, and in particular, the date and the exact position of this series in the evolution of the Dance of Death.

In one important respect this work reminds us of Paris and not of Kermaria. Nearly all the characters look towards the preacher in his pulpit in the opening scene. It is true that this does not apply to the constable, minstrel, labourer and Franciscan friar; they turn to the right, away from the preacher, but the exception proves the rule, because these four characters show their reluctance and resistance to the invitation of Death by this simple but effective means. The majority of the figures face the left and their feet point in this direction. They form a slow procession to the grave. As they walk, the skeletons dance and leap beside them, paying more individual attention to their victims than at Kermaria. The life and variety thus given contrasts with the rigidity that we notice in the Breton *Danse macabre*. At La Chaise-Dieu the line of persons really consists of pairs following each other, because the corpse is invariably at the right hand of his partner, leading, guiding or dragging him forward, as the case may be. The members of the procession are not seen in profile, but stand at an angle to the observer, so that almost the full face can be seen. Thus they seem to form a chain, whereas they are actually arranged in consecutive pairs, as in a stately dance.

Is this place the home of the *Danse macabre*? We might be inclined to think so if we had not already heard about the pictures at the Innocents and if we were not aware of the fact that in southern or central France no other specimen of such antiquity has been found, although there were originally many in the north. We should naturally expect to find most examples in the region where the idea first took tangible shape, just as in botany many plants are commonest where they are indigenous. Two circumstances indicate that La Chaise-Dieu cannot be the *fons et origo*. First, the text is missing, but there is a space in which it was to have been inscribed. Second, it is in the highest degree unlikely that a brilliant, but unfinished sketch in Auvergne would find an imitator in the cultured French capital.

Which of the two Dances is the oldest? All French authorities agree in assigning La Chaise-Dieu to the second half of the fifteenth century, that is to a later date than the paintings at the Innocents. Mâle dates the former about 1460 or 1470, chiefly because of the costumes. There is every reason to believe that it is later than the *Danse macabre* of the Innocents, and that it is derived from the latter, directly or indirectly. If it was a case of direct influence, the

D C.D.D.

artist certainly did not make a slavish copy of the Parisian original. The gestures of some of the figures are quite original. Perhaps the most striking example is the group containing the child. Here Death hides his face, so that the infant will not see him. There is also a subtle touch in the drawing of the merchant, who holds up his hand to his mouth in embarrassment, and in the skeleton who follows the sergeant, which is convulsed with laughter.

There were at one time about a score of other *Danses macabres* in France.[1] The majority of them were in the north. In the cloister of Amiens Cathedral, which enclosed the whole east end of the choir, and was fittingly called Cloître-du-Macabré, there was a pictorial representation of the Dance. It was destroyed in 1817, but Francis Douce saw 'some vestiges of the painting that remained on one of the sides of the building' shortly before the work of demolition was carried out. A fragment of the verses was printed by Langlois. They may have served as an introduction to the poem, but they bear no resemblance to the text of the Innocents. The vestry of the cathedral, which is on the south side of the choir is still called 'La Chapelle des Macchabées'.

The cathedral city of Rouen, the capital of Normandy, is rich in ancient remains. Here Joan of Arc was burnt and here Corneille was born. Here Ruskin loved to wander and dream of the glories of the Middle Ages. The town is so rich in antiquities that even the citizens themselves were not aware of their full extent. In a neglected corner of Rouen, Eustache-Hyacinthe Langlois, the antiquary and engraver, whose name we have already had occasion to mention several times, discovered a long forgotten series of carvings which arrested his attention and caused him to make a serious study of the Dance of Death, in which field he was one of the most distinguished pioneers. In a graveyard attached to the church of Saint-Maclou, the *Danse macabre* was carved on the pillars of a roofed cloister.[2] The walls were commenced in 1526 and the first columns were sculptured in the following year. The style was that of the Renaissance.

The first scene depicts Adam and Eve, as at La Chaise-Dieu. Then follows seven laymen with their skeleton partners, beginning as usual with the emperor, king and constable. The pope, cardinal (?), bishop (?) and four other churchmen complete the list. The last is the Carthusian. The identity of some figures is doubtful, as their emblems have been destroyed. Langlois blames the Calvinists of 1559. Nearly all the dead are decapitated. The carvings are on

[1] A list is given by Douce, pp. 35, 47-48, 221, and Langlois, I, 196-240.
[2] It was entirely destroyed in the Second World War, in 1940.

the north side of the cloister. Opposite them are the Sybils and the seven virtues. It is significant that in the Dance of Death the laymen precede the clerics. This suggests the outlook of humanism. The secular spirit is gaining ground at the expense of the religious. The columns with their fluting and ornate capitals of Corinthian and other types, are very beautifully executed. The figures taken from the Dance of Death are merely ornamental; they are added to the pillars like an accidental adjunct. They are a means, not an end.

Before leaving France to pursue our researches in other countries, we might mention two examples of the later type of the *Danse macabre*. In these we find that carving in wood has taken the place of paintings or sculpture in stone. The larger and more important of the two is to be found in the Musée des Antiquités of Angers and is of the fifteenth century.[1] There are thirty characters, the same number as at the Innocents; they include a pope, a cardinal, two bishops, monks, knights, two women, one of them wearing a crown and the other a hood. Six of these persons are dancing and paying no attention to Death, while the remainder are arranged in a circle around Death and have their bows drawn as if to attack him. Death holds a spade in his left hand and is hurling a javelin with his right. It is evident that here we leave the traditional symbolism. This is no procession of partners composed of the living and the dead, but the embodiment of a new conception of the ancient theme.

The Dance of Death in the cemetery of Montivilliers near Albert, in the Somme Department, is a less ambitious performance.[2] It shows, however, a further stage in the development, since none of the mortals are dancing at all. There is no question of Death dragging off his victims. The burlesque element, the posture of the skeletons, with their characteristic emblems, the scythe and the spade, are reminiscent of the *Danse macabre*. The disintegration of the original idea is due to the site and the medium employed. The statues are carved in wood and decorate the octagonal pillars of a cemetery which has cloisters. Above the pillars is an ossuary. Here again, as at Rouen, the chain was necessarily broken up since the statues were on separate pillars.

The sculptures represent two skeletons and five living persons. Of the latter, one is a woman and the remaining four are men, but their identification is difficult because of lack of detail. One of them appears to be a knight, another is a bearded man clad in a jerkin

[1] Langlois, I, 217.
[2] M. Ch. Roessler, *Aperçu sur les représentations sculptées de Danses Macabres et sur le Cloître du cimetiére de Montivilliers,* Montauban, 1867 (Extrait du Moniteur de l'Archéologue).

and a large cloak, with an alms-bag at his girdle. The discoverer of
the Montivilliers *Danse macabre* judged it to be contemporaneous
with that of S. Maclou at Rouen.

In the three examples we have just considered, we see a new kind
of representation: a series of isolated scenes, not a pageant. The
aim of the sixteenth century artist is to produce a work of art, a
thing of beauty, rather than to 'move the people to devotion' by a
drastic appeal to the emotions, or to instruct them by means of
universal symbols.

The other examples in France have in part been destroyed.
Those that survive are in such imperfect condition that they can
shed no light on our problems. Many of them, in particular the
later ones, are not in the true line of tradition, but belong to some
other, subsidiary category, such as the Triumph of Death, of which
we shall have more to say when dealing with Italian art.

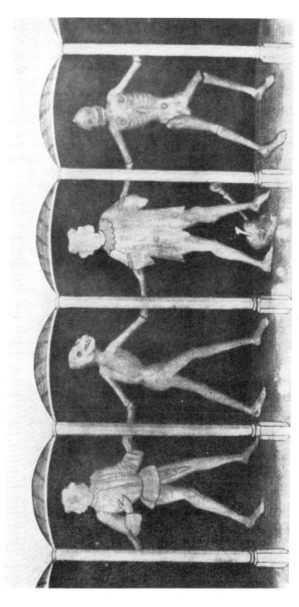

KERMARIA PARISH CHURCH: MURAL PAINTINGS (NORTH SIDE OF NAVE)

IV

SPAIN

At La Chaise-Dieu we saw pictures without a poem, in Spain we find a poem without pictures. This is what we should naturally expect, for mural painting never flourished in the Peninsula as it did in France, Italy, and the Low Countries.[1] Whether this was due to the effects of the Moorish invasion of Spain and the Moslem attitude to pictorial art, we must leave to specialists to decide. The fact remains that in Spain no pictorial representations of the Dance of Death are known to exist, and it is only in literature that any traces of the tradition are to be discovered. It is true that there is a Spanish book of Hours of the Virgin with miniatures depicting the Dance of Death, which is dated 1495. This was, however, published in Paris by Simon Vostre.[2] It appears to be derived from French sources. This book of Hours testifies to the interest shown by Spanish collectors or purchasers of illuminated books in Paris at a time when these were fashionable, but throws no light on the history of the Dance of Death in Spain. The story begins with the *Danza general de la muerte*,[3] a poem in eight-line stanzas in the form of a dialogue between Death and the pope, emperor, cardinal, king, patriarch, duke and so on. There are thirty-three characters in all; clerics and laymen alternate as usual.

The best authorities on Spanish literature are unanimous in placing the *Danza de la muerte* in the fifteenth century.[4] The chief reasons for this view are the metrical form and the maturity of expression. The philologists concur in this opinion: Gottfried Baist speaks of it as 'A Dance of Death of about the middle of the fifteenth century, which was formerly dated much too early'.[5] Wolf found in the same manuscript the date 1420, which he interpreted as meaning A.D. 1382, overlooking the fact that the Spanish era was

[1] S. C. Kaines Smith, *Spanish Painting* (In *Spain. A Companion to Spanish Studies*. Ed. E. Allison Peers, London, 1929), pp. 186, 189, 192.

[2] Douce, p. 61.

[3] Printed in Ticknor, III, pp. 422-436; also in *Poemas castellaños anteriores al siglo* XV, pp. 379-385, and by Carl Appel.

[4] The mistaken view that it was written in 1360 was refuted by Seelmann, p. 64.

[5] In *Grundriss der romanischen Philologie*, Strassburg, 1897, 2. Band, 2. Abteilung, S. 428.

abolished in Aragon in 1350 and in Castile in 1393.[1] A great deal depends on the date of the poem, as will become apparent later.

The experts also agree (a happy, though not a universal state of affairs) that the *Danza* is not an original work, but an adaptation of a French work. All the ascertained facts point in this direction. The stanza is French; it is used by the Troubadours. Literary influences round about this time flow from France to Spain not *vice versa*; moreover Spanish art of this period lags behind that of Italy and France. The fact that there are no pictorial representations of the Dance of Death in Spain is not irrelevant.[2] At Paris the verses explain the paintings; in Spain there are verses alone. If there are traces of French influence in the *Danza*, there is nothing Spanish in the *Danse macabre*.

The French poem is homogeneous, the Spanish version is not free from contradictions and inconsistencies, such as we almost invariably find in derived as opposed to original texts. One example may be given which does not appear to have been pointed out before. In the introductory part of the *Danza* there is the usual reference to the friar who preaches about death, and he makes a personal appearance as 'the preacher'. Death expressly confirms his remarks. On the other hand, when the friar enters the stage as one of the actors, he is received with derision. In the *Danse macabre* it is the Minorite who is extolled and the monk who is condemned. We assume that, from a *milieu* in which the friar was regarded as the representative of religion pure and undefiled, the Dance passed to an environment in which the friar was regarded as a less worthy type, and the older monastic orders were held in favour. Was the Spanish poet himself a Benedictine, or Black Monk? It is not unlikely.

Is the *Danza de la muerte* derived from the French poem, or is it an independent work? The connection between them is clear. If we eliminate the typically Spanish characters: the Jewish Rabbi, the Muhammedan Alfaqui and the Santero, or custodian of a sanctuary, and in addition the two damsels in the introduction, thirty persons remain. There were thirty at Paris. Apart from a few minor differences which can be easily explained, the characters of both poems are identical. The alternation of church and state, the eight-line stanzas, the main tendency of the thought, is common to both.

[1] J. J. Bond, *Handy-Book for Verifying Dates*, London, 1889, p. 203.
[2] Neither the statue of a skeleton with a scythe in Toledo Cathedral, nor the painting in the monastery of St. Ildefonso in Burgos, the work of the sixteenth century Netherlander, Hieronymus Bosch, is a true Dance of Death (Ellissen, p. 90; Douce, p. 50).

They are in the same line of tradition, and one work may well be based directly or indirectly on the other. In the short prose introductory passage prefixed to the Spanish poem, which looks like the work of the scribe rather than the poet, the word *trasladaçion* occurs. This has led some writers rather rashly to conclude that it is a translation from the French, or as one scholar would have us believe, from the Latin.

But the Spanish word does not necessarily mean 'translation'; it may be equivalent to 'copy' and even if we take it in the former sense, it need not be taken literally. The *Danza de la muerte* does not look like a borrowed product. The stanzas allotted to the Rabbi and the Alfaqui do not seem to be interpolations: they are integral parts of the work. It is not a mere Spanish version of the *Danse macabre*, it is a homogeneous poem. It will be admitted that a great poet, a Chaucer or a Spenser, can so translate and interpolate that the elements of which his work are composed, the original and the alien, are fused together in a perfect unity. The Spanish poet undoubtedly had this gift. If his inspiration came from France, he made something new out of his material. There is not a single line that corresponds textually with a line of the French poem. There are some points in common and some verbal parallels. Thus *La muerte* says 'Dance, fat abbot with the tonsure'. *La mort* speaks of 'L'abbaye qui gros et gras vous a nourry' and concludes with the words 'Le plus gras est premier pourry'. The French squire says 'Adieu dames' while his Spanish counterpart cries 'Matrons and maids, take pity on me'. But such resemblances are very general and lie in the nature of the subject.

The originality of the poet leads to further conclusions. At the close of the *Danza* there is no trace of the dead king of the French version, but instead there is an exhortation addressed to 'all those whom I have not counted, of whatever kind or estate or condition'. They are summoned to join the dance and are told that 'those who have done well shall ever have glory, those who have done the opposite shall have damnation'. Then comes the reply on the part of 'those who have to pass by death'. Had the poet before him a text in which the dead king figured and did he feel it illogical that a corpse should speak and so was led to substitute his new stanzas? It may be remembered that at La Chaise-Dieu the dance ends with some unidentified persons. There is a tendency among scholars to explain these as supernumeraries, representatives of those classes who have not been mentioned before in the dance proper. In other words they are taken to be the same persons as those at the end of the Spanish work. This does not follow and it is not safe to build up

a theory on such a slender foundation. There is no reason to think that the affiliations of the *Danza* are with La Chaise-Dieu rather than with Paris.

The poet does not plunge *in medias res*, but being a Spaniard, he approaches his theme with grave, leisurely ease, avoiding indecent haste. He indulges in lengthy preliminary remarks and builds up a rambling prologue, complete with characters and moral reflections. After the argument of the poem has been set forth in prose, Death appears and announces that none can escape his onslaught. Next the preacher (el predicador) appeals to the Scriptures which say that every man is destined to die, be he pope or king, consecrated bishop, cardinal or duke, illustrious count or emperor. Then Good Counsel (sano consejo) calls upon his hearers to do good works and not to trust to wealth or high estate. They are to repent and seek pardon for their iniquities, without delay. Death speaks again and informs two damsels that they must join his retinue. Turning to the pope, he summons him as head of the church to lead the dance.

In contrast with the diffuse introductory passage, the main body of the poem is constructed in strictly symmetrical pattern and with a certain terseness and vigour. The ecclesiastical hierarchy is drawn up with strict correctness, which in addition to the whole tone of the work, strengthens our belief that the author was a churchman.

There are a few lines in which the sense is sacrificed to the rhyme, but this is not surprising in the work of a poet unaccustomed to a foreign stanza. He was, after all a pioneer; he had to find his own technique and invent his own rhymes. But on the whole the poem is at a high artistic level. There is a plaintive lyrical beauty in the verses that refer to the two maidens, to which Ticknor's translation[1] scarcely does full justice. There is great poetic vigour in the taunts and sneers of Death to those who have been sinners in this life. His caustic irony lashes their failings. No one finds favour in his sight. The Benedictine monk and the labourer come off best perhaps, but they receive no commendation. Death merely holds out to them the hope of eternal life if they have done their duty. 'If thou didst follow the holy Rule of the Benedictine monk in all respects without any other desire, believe steadfastly that thou art written in the book of life, according to my belief, but if thou didst those things that I see others do who walk outside the Rule, they shall give thee a life that shall be blacker'; blacker, that is, than the monk's own black habit.

The friar, the 'famous master, learned and ingenious' is not spared the taunts of the stern tyrant. As we should expect, the

[1] I, 83.

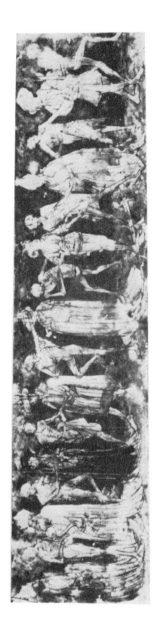 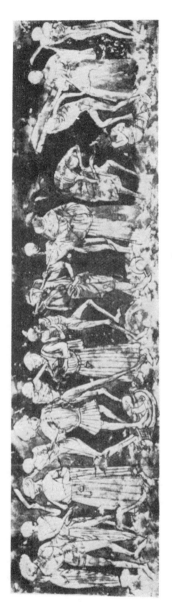

LA CHAISE-DIEU: DANCE OF DEATH

advocate receives short shrift: 'Sir lawyer, false and cunning, who didst extort a fee from both parties, remember how shamelessly thou didst turn thy coat for another antagonist.' But the usurer naturally fares worst: his fate is certain. 'Traitrous usurer of evil conscience, now shalt thou see what I am wont to do: into eternal fire without respite I shall consign thy grief-laden soul.'

In a poem of this kind, in which one figure speaks to a long series of persons, summoning them all to follow him, an inferior writer cannot avoid repeating himself. Where the same situation recurs two or three dozen times he uses the same phrases. But in the Spanish *Danza* there is no monotony in the speeches of Death. Now he is suave and sly, now vehement in his denunciation. He can threaten, cajole, and mock. He is a master of irony and of satire. The attitude of the victims reveals the same skill in treatment. Some of them say farewell to their companions, or call their friends to their aid, others again lament, implore, plead for delay, or submit with a good grace, as the case may be.

The author of the *Danza de la muerte* was a poet of no mean order. He was also a scholar. His physician mentions Avicenna; he is conversant with Galen and Hippocrates, with gargles, potions and dietaries. His Death speaks of swollen glands and carbuncles. The Spanish lawyer is told to leave the *Digest* and to expect no help from Cino and Bartolo, two eminent fourteenth century Italian jurists, of whom the former is better known to most of us as the sonnet writer Cino da Pistoja. His Rabbi studies the *Talmud* and uses a Hebrew form of benediction. All this is not the language of an amateur, but of an expert.

In 1520 a new version of the *Danza de la muerte* was printed at Seville.[1] It is the old poem lengthened by the addition of new characters to 136 stanzas.

The Catalan Dance of Death,[2] has sometimes been incorrectly described as a translation of the *Danza de la muerte*. As we have already seen, however, the source is not to be found in Castilian, but in French literature. This is what we should naturally expect, because the culture of Catalonia has closer affinities with France than with Spain. The translator of the Catalan poem was Pere Miquel Carbonell (1437-1517). He was a scribe and royal archivist. His version is derived from the *Danse macabre* in its shorter form. There are the same thirty characters, beginning with the pope and

[1] Reprinted by Amador de los Rios, *Historia crítica de la literatura española*, Madrid, 1863, t. IV, pp. 507-540.
[2] Printed in *Cançoner de las obretes en nostra lengua materna mes divulgadas*, etc.

the emperor, and ending with the clerk and the hermit. Carbonell inserted after the hermit five additional figures: maiden, widow, monk, matron, and notary, concluding with the dead king, as in the French version. It will be noticed that Carbonell, like the unknown author of the Spanish Dance, included female characters in the list. The former is responsible for the maiden and matron, as the latter is for the 'dos donsellas' or two damsels of the prologue. This is one of the usual methods of enlarging the circle, so that it does not necessarily imply direct influence; in other words, it does not prove that Carbonell was acquainted with the *Danza de la muerte*.

Carbonell keeps pretty close to the original, often reproducing whole lines literally. The exigencies of the rhyme force him to alter some passages, but this is done without departing from the general sense of the *Danse macabre*. A careful comparison of the Catalan poem with the French verses written at the Innocents reveals two striking differences. At Paris the living and the dead alternated in the pictures; in the poem inscribed below, the dialogue closely followed the line of figures painted above. Death addressed a stanza to the figure on his left, and the latter replied in the next stanza. Twice this rule was broken. Instead of speaking to one person only, Death on two occasions first addressed a few words to the figure at his right, then turning to the next comer, spoke to him for the rest of the stanza. Thus, *le mort* divides his attention between the merchant and the Carthusian, between the labourer and the Franciscan. In the first printed edition of the *Danse macabre* this procedure is followed exactly.

In Carbonell's translation there are no broken stanzas. Death invariably speaks to one character during the whole of each strophe. He has no Parthian thrust for the merchant or the labourer. Eight lines are devoted to the Carthusian, and eight to the Franciscan, which involves an adaptation of the original verses intended for the merchant and the labourer. As long as the pictures and the text were combined no headings were needed. It was quite clear by whom each stanza was spoken. But when the words appeared without illustrations, headings were necessary, such as: 'Death speaks to the Emperor', or 'The Emperor replies'. The rubric 'Death speaks to the Carthusian' was anomalous when the opening lines of the speech apostrophize the merchant. The strophe had to be remodelled. We should give Carbonell the credit for the new departure, were it not for the fact that some editions of the *Danse macabre* had introduced it. But it is quite possible that Carbonell and the Paris editors acted independently. It was only a question of changing

'merchant' to 'Carthusian' at the beginning of the stanza and making alterations in the following lines. The second deviation occurs at the point where Death converses with the usurer. At Paris the latter was accompanied by a poor man, to whom he was doling out money, so that the illiterate would know that he was a money-lender. The poor man was a kind of trademark. The king had his crown, the bishop his mitre and crosier, and the usurer his money bag and his debtor. The poor man made a little speech on the evils of usury. At the Innocents, and also in the *Editio Princeps* of 1485, these words were written below the picture of the poor man. In the Catalan translation the passage was misunderstood. The words of the debtor are placed in the mouth of Death, and the heading runs 'Parla la mort mes avant contra lo usurer' (Death speaks further to the usurer). The conclusion is that Carbonell did not know the paintings in the cemetery of the Innocents. His source was a printed book or a manuscript, and his translation was made in or before 1497, in which year Carbonell wrote his continuation of the Dance of Death.

After the translation of the French poem there is a sequel consisting of fifty-one stanzas, with twenty-four new characters, or groups, because some of the headings are in the plural, for instance: 'chaplains and choirboys', 'jurists and judges', 'youth and age'. An introductory passage describes the work as 'a poem by Peter Michael Carbonell, scribe and royal archivist, concerning the dreadful Dance of hideous Death, composed on the Feast of the Nativity of our Lord Jesus Christ, in the year of our Salvation 1497, while the inconstant multitude was busy playing dice'. The association of dicing and Christmas was not altogether fortuitous, to judge by a Turin statute of the year 1360:[1] 'Regarding the prohibition of playing dice: . . . save that on the day of the Nativity of Our Lord and the two following days, according to custom, the game is permitted without penalty.'

In a short verse prologue the author tells us why he wrote the continuation: 'I, Carbonell, valuing life but little, for my remembrance and for that of the royal house, put in the Dance the people who remained in my mind, seeing that Death summons us. We shall be wise if each one of us prepares himself by doing good and eschewing evil, since our wealth and the royal offices (we hold), and all that exists, is taken away and divided by Death.' The new characters are largely made up of court or government officials and servants, from the viceroy and chancellor to the artisan and porter. In fact they are drawn from the environment in which a scribe and

[1] Ducange, *Glossarium mediæ et infimæ Latinitatis*, s.v. *Taxilli*.

archivist of the King of Aragon would live, move and have his being. And so we bid farewell to the worthy man, sitting at his task on Christmas Day five years after Columbus landed in America. As he looked out of his window and saw the mob gambling on that sacred day, one wonders if his thoughts would go back to that other day, over fourteen and a half centuries before his time, when unruly men had thrown their dice at the foot of the Cross?

The *Danza de la muerte* has some of the characteristics of true drama, and for this reason historians of Spanish literature used to include it among the sources of mystery plays in Spain, but there is no evidence that it was ever produced on the stage. Nor can we trace any connection between the Spanish poem and the later Corpus Christi plays. On this great church festival, the most popular of all in Spain, itinerant players went from place to place, acting a drama derived from the Dance of Death, showing in allegorical fashion the equality of all in death and the salvation of mankind through Christ. Thus, in the middle of the sixteenth century a certain sheep-shearer named Juan de Pedraza produced his *Farsa llamada Danza de la muerte*.[1] The work, which was printed in 1551, was written at the request of the town council of Segovia to be performed outside the church. *Farsa* in Old Spanish meant simply a play, and the title is noteworthy as showing that the tradition of the dance still persisted, although it was no longer the central idea of the drama.

Juan de Pedraza's work is not an adaptation or translation of any known poem on the Dance of Death, but quite a different kind of composition. It is a pleasant little work written in eight-line stanzas. The characters are Death, the pope, king, lady, shepherd, and the allegorical figures of Reason, Anger and Understanding. The play begins with the inevitable *Loa* or prologue, spoken by the shepherd (pastor). There are ten short scenes, arranged in pairs. The first four pairs consist of a monologue spoken by one of the human persons followed by a conversation between this person and Death. They make their exit together. Scenes 1 and 2 are a soliloquy of the pope, who congratulates himself on the greatness of his power upon earth, and a dialogue with Death, who admits the powers of the supreme pontiff, but observes that in the presence of the great Leveller all are equal. Next comes the monologue of the king who boasts of his valour and his conquests, but when confronted with Death, asks

[1] Ed. Ferdinand Wolf, *Ein spanisches Frohnleichnamsspiel*, Wien, 1852, and by Gonzales Pedroso (*Biblioteca de autores españoles*, Madrid, 1884, t. 58. See J. Fitzmaurice-Kelly, *A New History of Spanish Literature*, Oxford, 1926.

ROUEN: CEMETERY OF SAINT-MACLOU

for a respite to make amends for his sins. The fifth and sixth scenes contain the monologue of the lady, who proclaims her wit and beauty, and a conversation with Death who drags her off with him unceremoniously. The shepherd also indulges in a soliloquy and then in a dialogue with Death. These two characters remain on the stage; in scene 9 they are joined by Reason, in the last scene by Anger and Understanding. The gist of the last two scenes is that the defeat of evil passions, symbolized by Anger, and of benighted human intelligence, represented by Understanding, leads to the liberation of man by Reason, inspired by divine revelation. By participation in the sacraments man is redeemed. Even the humble and simple believer (typified by the shepherd) can attain this goal. The play ends with an invitation to those present to venerate the sacrament. This links up the drama with the institution of Corpus Christi Day, on which the *autos sacramentales* were performed.

The popularity of the Corpus Christi plays did not diminish. Half a century later the greatest of Spanish novelists immortalized them in Don Quixote. The episode is full of interest and might be quoted *in extenso*[1].

'Don Quixote would have replied to Sancho Panza, but he was interrupted by a cart which came out across the road, freighted with divers of the strangest shapes that could be conceived. He who drove the mules and acted as charioteer was a hideous demon. The waggon itself was open to the sky, without tilt or covering. The first figure that presented itself before Don Quixote's eyes was that of Death himself with human face; next to him was an angel with large painted wings. At one side was an Emperor with a crown, seemingly of gold, on his head. At the feet of Death was the god whom they call Cupid, without the bandage over his eyes, but with his bow, quiver, and arrows. There was also a Knight armed *cap-à-pie*, except that he wore no helmet or head-piece, but a hat decked with plumes of divers colours. With these were other persons, of various attire and visage. All this, beheld of a sudden, discomposed Don Quixote in some measure and struck terror into the heart of Sancho; but presently Don Quixote was gladdened, believing that some new and perilous adventure was being presented; and in this conceit, and with a soul disposed to encounter any danger soever, he planted himself in front of the cart, and cried in a loud and menacing voice:

[1] *The Ingenious Gentleman Don Quixote de la Mancha.* By Miguel de Cervantes Saarvedra. Done into English by H. E. Watts, London, 1895, Part 2, Chapter ii, pp. 116-118. For the original, see F. R. Marin's critical edition, Madrid, 1916, t. IV, pp. 234-235.

"Charioteer, driver or devil, or what thou art! Delay not to tell me who thou art, whither thou goest, and who are the people thou art carrying in thy coach, which looks rather like the bark of Charon than the ordinary cart."

To which the Devil, stopping his cart, politely replied:

"Sir, we are players of Angulo el Malo, his company, and have been acting this morning in a village which lies beyond yon hill, for it is the Octave of Corpus Christi, the piece of the Assembly of Death, and we have to perform this evening in that village which you see from here; and because it is close at hand, and to save ourselves the trouble of undressing and dressing again, we go attired in the costumes we play in. That youth there goes as Death; the other as an angel; that woman, who is the manager's wife, is the Queen; another one is a soldier; that one is an Emperor, and I am the Devil; and I am one of the principal characters in the play, for in this company I take the leading parts. If there is anything else your worship wishes to know about us, enquire of me, and I will be able to answer with all exactness, for, being the Devil, I am up to everything."

This mild answer turned aside the wrath of Don Quixote, who courteously offered his assistance, declaring "For from my boyhood I was ever a lover of masques, and in my youth had much longing for comedy" '

The drama which Cervantes had in mind seems to be the *Loa y auto sacramental de las cortes de la muerte* (Prologue and Mystery of the Court of Death); the *Prologue* was written by Mira de Amescua and the *Mystery Play* by the famous dramatist Lope de Vega.[1] The characters are Death, represented by a skeleton with a scythe, Sin (a queen with a death mask), Folly, Time, Man (an emperor), the Divine Child, an Angel, Envy and Cupid. These correspond to the figures mentioned in Don Quixote. Incidentally, in the play we find in the list of *dramatis personae* a guardian angel 'with large painted wings', and finally 'the god whom they call Cupid', which recalls the exact words used by Cervantes.

[1] *Obras de Lope de Vega publicadas por la Real Academia Española*, Tomo III, p. 592, Madrid, 1893. According to Buchheit, p. 18, Cervantes' source was the *Cortes de la muerte* by Caravagal (1557).

V
ITALY

The total absence of Dance of Death paintings in Spain contrasts strongly with the position in Italy. The Spanish contribution is entirely in the literary sphere, but in Italy frescoes predominate. It is significant that all the Italian examples are to be found in the North, which was more open to transalpine influences than the centre and the south of the peninsula. At Clusone,[1] in the Province of Bergamo, on the external wall of the Chiesa dei Disciplini, there is a fresco which is attributed to a Florentine artist of the late fifteenth century. Italian authorities give the date as 1485. The work is divided into two large compartments with numerous figures. The upper one contains in the left hand corner a representation of the *Legend of the Three Living and the Three Dead*.[2] Only the living, however, are depicted. They are to be recognized by the fact that they are noblemen in rich attire on horseback; they are hunting with hounds, and their falcon is flying away. There is no sign of the conventional cross or the hermit, but part of the fresco to the right of these figures is effaced and it is not known what filled in the gap originally.

In the centre there is a large tomb containing the bodies of a pope and an emperor, with worms and snakes crawling over them, while toads hop round. On the edge of the tomb stands a huge figure of Death in the shape of a skeleton, clad in a gorgeous mantle and with a crown on its skull. At each side of this presiding genius stands a smaller skeleton; that on the left is shooting arrows from a bow, while that on the right, which is standing on the body of the emperor, is taking aim with a harquebus and apparently firing it. Some of his bullets have already found their mark. To the left of the sarcophagus is a group of suppliants, and among them a bishop with cope and mitre, who is offering a bowl full of coins to Death.

On the opposite side there is a group of kneeling clergy, led by a pope, who is holding up a goblet full of money. His retinue consists of cardinals, bishops, and monks. In the very centre of the picture, and in front of the tomb, lie several bodies transfixed by the arrows of Death, while four kneeling figures await their fate. The central

[1] The chief authorities are G. Vallardi and Astorre Pellegrini.
[2] See below, p. 95 *seq.*

person in this party is a king who is busy purchasing a precious stone from a Jew, in order to propitiate Death. Other persons are offering dishes of money and a duke holds up his crown.

Karl Künstle conjectured that the three skeletons standing on the tomb should be taken in conjunction with the three horsemen on the extreme left and that they are like the three riders, a reminiscence of the *Legend of the Three Living and the Three Dead.* I do not think that this is justified. The central figure is Death triumphant and the other two skeletons are evidently his assistants; the former is passive, the latter are active. The whole picture is a variant of the familiar Italian theme of the Triumph of Death and the *Legend* has supplied an incident to the main conception.

Our main concern is, however, with the lower part of the triangular fresco, which alone can be styled a Dance of Death, since it portrays a procession of figures, each attended by a skeleton. The living are led by the left hand and they give their right to the following partner. They thus form a continuous chain which is moving towards the right of the spectator. To the extreme left is a doorway, in which other figures can be seen. Curiously enough, all the persons in the upper compartment are princes, prelates, monks, or priests. In the lower section the characters are of the middle class or even humbler station, except the first and last, whose costume is that of the nobility. Even these two persons, a nobleman and a lady, are much more simply dressed than those above. It must be admitted that at the extreme right the fresco has suffered so much from weathering that any figures it contained are no longer visible. It is therefore possible that the nobleman who leads the procession was preceded by a king, a prince, or a duke. There is also some uncertainty about the tenth figure. It is a hooded man in white, whom Vallardi describes as a Flagellant, while other writers consider him to be a sexton or gravedigger. In times of plague the gravediggers often covered the face to avoid contagion. One has the impression that the lower compartment contains commoners only (apart from the two persons already mentioned), and the upper division the higher ranks of society. Wealth and power reign in the triumph of Death, industry and simplicity characterize the procession below.

It is not clear what connection, if any, exists between the two compartments. If the artist intended them to form a logical unity, as he presumably did, he may have wished to signify that the persons, eleven in number, who form the Dance of Death proper, have already been dealt with by the arch destroyer. The nobles and clergy have the privilege of dying last. This explanation does not

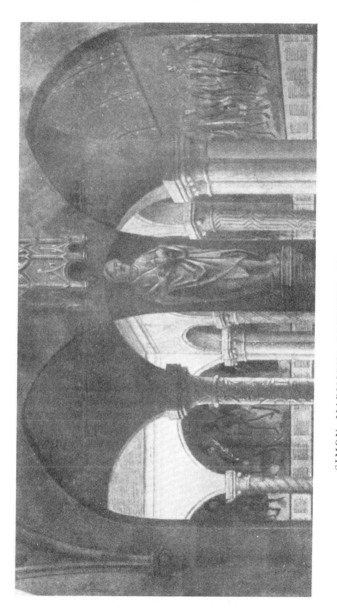

SIMON MARMION: CLOISTER OF A MONASTERY

square with the usual moral of the Dance of Death, and Künstle, who invented it, does not tell us why anyone should have ascribed such an improbable privilege to these classes. In the scroll held by Mors Imperator in this fresco, Death claims that in him is equality. Künstle's explanation has a further drawback. It leaves out of account one important circumstance: the persons in the upper compartment are not all slain, some are in the process of being killed. Further, they are offering their coins and jewels to Death, whereas in the lower part there is no sign of avarice or of bribery. Is it not more reasonable to assume that the two pictures give two different symbols of death, the arrow above, the dance below? Is it not also evident that the wealthy look like wicked people and the bourgeois like decent folk? The rich fear Death and try to appease it, the others know no fear. The skeletons that lead them along have a kindly and friendly demeanour. In short, it is a case of social satire and anti-papal or Ghibelline politics.

There is no explanatory text, but in the Triumph the dominant figure holds a scroll with a verse of four lines in Italian, in which Death calls upon the mortals to join him, declaring that he wants their lives and not their riches, and boasting his regal power. There is also a short verse inscription[1] over the procession in the lower part, affirming the inevitability of death and inviting those who have served God wholeheartedly to approach without fear and to 'join the dance': the phrase is significant.

The salient feature of this fresco is the originality of the artist's conception. He borrowed ideas from abroad, but the details are his own. In addition, this is, as far as we know, the oldest Dance of Death in which real skeletons appear. They are not correctly drawn but there is at least a genuine attempt to reproduce the bones without flesh. We must remember that Italy was in advance of Northern Europe in medical science in the late Middle Ages. The separations of nobles and commoners (with the reservations made on this point) and the offering of money to appease Death are also innovations.

In a fresco at Pisogne (in the Brescian Alps, on the shore of the Lago d'Isco), the second of these motives occurs again. The church of Pisogne, which is dedicated to the Madonna of the Snows, has a façade with mural paintings forming two large oblong compartments. Both of these are divided by small columns into three sections. Each of the compartments has a procession of the living without partners, each moves towards a skeleton.

In one of the two main divisions there is a chain of persons mov-

[1] See F. Saxl, 'A Spiritual Encyclopaedia of the Later Middle Ages,' *Journal of the Warburg and Courtauld Institutes*, V (1942), p. 97, n. 2.

ing from south to north towards Death, which has a crown on its head and is armed with a bow and arrows. This line of figures consists of three groups; in the first we see a pope, two cardinals, two bishops, and two deacons; in the second and third there are noblemen and high born ladies together with two monks. In all these groups the characters are carrying money or jewels to offer to Death triumphant. This might seem a pagan, rather than a Christian conception, but it is balanced by a companion piece, in which the victory of Christ over Death is portrayed. For in this section there is a second skeleton, with a shattered bow and no arrows. The idea of the artist is highly original, and by means of the two compartments and the two figures of Death, first as victor and then as vanquished, he subordinates the triumph of Death to the triumph of Faith.

In the second compartment a group of mortals is seen moving from north to south towards vanquished Death. Like the first procession, this is divided into three sections, and is headed by Jesus, leading the Virgin Mary by the arm, followed by five saints with haloes, bearing scrolls with inscriptions which appear to be in German. In the second group are a king, princes and nobles, who instead of offerings of money or jewels, bear a small banner, on which were doubtless recorded the virtues of these persons. In the third party there are, according to Vallardi, Christian converts from pagan countries, among whom are a Turk, a Kalmuck and a Moor.[1] The symbolism of the fresco is evident. Christ and those who follow Him have subjugated Death, which is shown by the shattered bow. They are passing from north to south, that is, from death to life. The other procession includes those who are subject to death. They are advancing towards the north, which symbolizes darkness and death. As the ecclesiastical authorities belong to the first, and the highest secular rulers to the latter category, the sentiment of the whole work is frankly Ghibelline.

The third example is at Pinzolo in the Southern Tyrol. This district belonged to Austria till 1918, but in language and culture it is Italian. The fresco adorns the southern façade of the chapel of San Virgilio.[2] It is a solemn procession rather than a lively dance. There are first three skeletons with trumpets. Next comes a crucifixion scene. The pope leads a group of five churchmen, the emperor and queen follow with eight laymen (including the physician, who is generally to be found among the clergy). Finally there is a

[1] I think these characters were suggested by Basel or Berne.

[2] There is a small reproduction in *Mittheilungen der k.k. Central-Commission, Neue Folge*, 12 (1886), p. xxii. See Vigo, p. 29.

nun, a woman, and a woman with a child. Each of these persons is transfixed by an arrow, and each has a dead partner carrying a weapon or other emblem. The text runs beneath the figures. Both the artist and the date are recorded: the work was executed in 1539 by Simone Baschenis, perhaps with the aid of his son Filippo. This cycle, with its skeleton musicians, crucifix, queen, cripple, mother and child, is reminiscent of Basel rather than of any other Dance of Death north of the Alps, but the copious use of arrows recalls Berne.

A commission set up by the Austrian government inspected the ancient churches of Tyrol. In their report[1] they mention a Dance of Death in the hamlet of Rendena, not far from Pinzolo. The date is given as 1519. Beyond the fact that the work is still extant, that the characters are arranged according to their rank, and that they form a long strip, no further information is forthcoming.

On the exterior wall of the church of San Lazzaro near Como, there was, a century ago, a fresco with life-size characters. This work no longer exists but thanks to the careful description and drawings of Zardetti we are well informed about it. San Lazzaro was a hospital, owned by the Humiliati, but later it passed under the control of the local bishop. Seven figures and fragments of an eighth were visible in Zardetti's time. Three of them had fragmentary Latin inscriptions in mediaeval characters. A few words only could be deciphered. The first person is a herald, dressed in green and holding a green flag. He is followed by a gentleman dressed in light blue and by what appears to be a merchant. Then come three ladies, of whom the second seems to be a queen. A youth is the last figure. They are all attended by their partners, some of whom are skeletons, others are emaciated corpses; the dead raise their feet as if to dance, but the living do not do this. There are no clergy in the procession and none of the dead has musical instruments. Historians assigned the fresco to the second half of the fifteenth century.

At one time Ferrara possessed two Dances of Death.[2] We read of a representation in the Palazzo della Ragione by Bernardino dei Flori painted in 1520. But beyond the fact that 'diverse conditions of persons, with several skeletons' were led to the dance, we know nothing of the characters. Another artist, Lodovigo da Modena,

[1] *Mittheilungen der k.k. Central-Commission, Neue Folge*, 16 (1890), p. 112.

[2] Barotti, *Pitture e scolture di Ferrara*, Ferrara, 1770; Cittadella, *Notizie relative a Ferrara*, Ferrara, 1864, and the same author's *Documenti risg. la storia artistica ferrarese*, 1868.

was commissioned to paint a Dance of Death for the church of St. Benedict in 1499.

The best known Italian allegorical representation of the ravages of Death is the Trionfo della Morte at Pisa. It is painted on the wall of a covered gallery of the Campo Santo, or cemetery. It is, strictly speaking, neither a Dance of Death, nor a Triumph of the Renaissance type; one of the sources of the artist's inspiration is the *Legend of the Three Living and the Three Dead*. This fresco, which has undoubted artistic merit, was formerly attributed to Pietro Lorenzetti of Siena, but experts now ascribe it to one of his pupils. On the left hand side of the picture a cavalcade of nobles and ladies is proceeding through a narrow valley. Among them are a king, a queen, and an emperor. They are returning from the chase with their menservants, one of whom has a greyhound on the leash, while the other carries the game. Suddenly the riders see on the ground before them three open coffins with dead bodies. In the first is a skeleton, in the second the corpse of a prince, his head resting on a crown, and in the third the body of a nobleman, swollen hideously by decomposition. Snakes coil round the corpse. The lords and ladies look at each other with horror, the king holds his nose, the horses snuffle with fear. This part is evidently based on the *Legend*, but the dead are in their coffins instead of standing upright and addressing the living. Nor is the hermit absent: he plays a double part, since he acts as spokesman for the silent dead, besides being present in his own right. The scroll he holds in his hands contains a warning to his hearer against pride and boastfulness.

With great skill the artist manages to convey the spirit of the scene without striking a grotesque or grisly note. The road turns and twists, ascending the rocky hillside towards a chapel round which we see a small community of recluses reading, meditating, milking a goat. Animals and birds rest peacefully round them. From the top of a neighbouring mountain the flames of hell are issuing from cracks in the rock. Devils are thrusting the souls of the damned into the fires.

On the right hand side the artist depicts a sylvan idyll. Lords and ladies are dallying away the time in converse, listening to sweet strains of music. One of the lords has his hawk at his wrist, his lady has her pet dog on her lap. Cupids with lighted torches fly overhead. They are sitting in an orange grove; there is green grass in the foreground with wild flowers. In this *dolce far niente* they do not see the gigantic figure of Death menacing them from above, in female form with long flowing white hair, with talons instead of hands and feet, with large bat-like wings, brandishing a huge scythe.

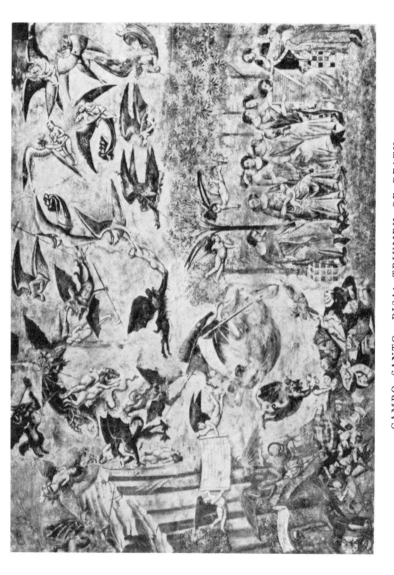

CAMPO SANTO, PISA: TRIUMPH OF DEATH

Between the two scenes of hunting and dalliance, in a nook carpeted with thorns there is a party of poor wretches, maimed, crippled, broken men, calling upon Death to release them from their sufferings. But she is deaf to their entreaties, and turns to attack wealth rather than poverty. At the feet of Death is a heap of the dead, a pope and an emperor, prelates and nobles, monks and nuns, the victims of the arch destroyer. Their souls are issuing from their mouths, looking like small naked babies, and are either the prey of the devils on the left, or they are rescued by the angels on the right. Behind Death the two armies of light and darkness are engaged in combat, contending for the souls of the dying. There is no trace here of the old symbolism: the dead are not the partners of the living. There is no allegorical dance. Death appears in a new guise.[1] There is a note of solemn warning. Death does not deliver those who implore her to come, but pounces unaware on those who are carefree and happy. The ever-present threat of sudden death and the danger of eternal damnation is the theme, tempered by the thought that there is salvation for the godly. The next fresco in the gallery represents the Last Judgment and forms the sequel to the Triumph of Death.

The Hungarian composer Liszt was in Pisa in 1838 and 1839.[2] He told his biographer Lina Ramann that while he was looking at the frescoes in the Campo Santo, the music of the hymn *Dies Irae* came into his mind and his composition *Danse macabre* took shape. This work, vast in conception and revolutionary in technique, has always been considered one of Liszt's most remarkable pianoforte productions. It is the most outstanding performance relating to the Dance of Death in the musical sphere.

In the Accademia di Belle Arti at Siena[3] there is a Triumph of Death which has many similar features, although the *Legend of the Three Living and the Three Dead* is less in evidence. On the left-hand side the Fall of Man is depicted: Adam and Eve are being expelled from Eden, led by Death. Next comes the murder of Abel and after this the Triumph proper. As at Pisa, there is a heap of bodies slain by Death, a pope and an emperor, clergy and knights

[1] A possible source for this female Death is Petrarch, who in his *Trionfo della Morte*, wrote of 'una donna involta in veste negra'.

[2] L. Ramann, *Franz Liszt als Künstler und Mensch*, Leipzig, 1894, II, 341-345.

[3] André Michel, *Histoire de l'Art*, Paris, 1906, t. II, 2ᵉ partie, p. 876. For the artist see Bernhard Berenson, *Florentine Painters of the Renaissance*, New York and London, 1909, p. 171; Raimond van Marle, *The Development of the Italian Schools of Painting*, The Hague, 1938, vol. XIII, p. 453.

in armour. Christ on the Cross is seen above them. Death with black wings raises a threatening scythe against Him. Three figures, a prophet, a hermit and a master of arts, hold a scroll that must have pointed the inevitable moral, but the words are now obliterated. A party of lords and ladies face the corpses on the ground with horrified looks and there is a second group of old beggars. On the right there is a representation of the Last Judgment. This is a variation of the subject treated at Pisa.

Italian art of the late Middle Ages and the Renaissance is a world of amazing richness and beauty. We are sorely tempted to linger here for a while, but we have already strayed too far from our main theme, to which we must now return. The Dance of Death, suitably modified and adapted, appealed to the Italians in its pictorial form. The poem had little attraction for them. One isolated example is the *Ballo de la morte*, the manuscript of which is in the Riccardiana Library at Florence. It was edited by Vigo, the historian of the Dance of Death in Italy,[1] who allots it to the late fifteenth or early sixteenth century.

It is neither a translation nor even a free rendering of any known version of the Dance of Death. It has every appearance of being the work of a poet who had originality and imagination. But he was not responsible for the general idea. The framework of the poem, the names of the characters and some of the details are taken from the French *Danse macabre*. Apart from minor changes, the first twenty figures in both works are identical. We can equate the French *baillif* and the Italian *potestas*.[2] The French *Chartreux* is replaced by the Italian *monachus* and the Italian poet inserts the poor man (pauper) between the bishop and the squire. He may be the equivalent of the French *laboureur*. As a result of this innovation, the strict sequence of laymen and cleric was interrupted in the *Ballo de la morte*. It is highly significant that this poem has at the end the king lying in a tomb, which is one of the distinguishing characteristics of the French series. Moreover, the Italian usurer has his debtor beside him, as has the usurer at Paris. There are a few additions in the latter part of the Italian work, in the shape of two women; an abbess and a female lover (amorosa). There is also a senator, which suggests the Italian city environment, and a *prepositus*. To make room for them the minstrel and the parish priest drop out. The number of characters is thirty-three, whereas at the Innocents there

<hr/>

[1] As an appendix to his book, *Le Danze macabre in Italia*.
[2] The names of characters in the *Ballo de la Morte* are a barbarous mixture of Latin and Italian. The Latin forms have the advantage of being correct, the venacular ones are corrupt.

were only thirty. The author appears at the beginning and the end of the poem, which circumstance reminds us of the Parisian work. The most striking feature of the *Ballo de la morte* is the strong Franciscan tendency: one might almost call it blatant propaganda. The archbishop, who believed himself to be a saint, is summarily consigned to hell. Death tells him with brutal frankness that benefices are now granted in order that prelates may lead a dissolute life. (Or sono e' prelati conceduti Perchè e' prelati vivin dissoluti.) Even the patriarch is not immune from castigation. Death roundly upbraids him for his sinful life and threatens him with the words: 'And Satan already shows his open tusks.' The abbot has saved many souls, but Death sternly declares: 'Nevertheless I would rather be the least of the Friars Minor in the congregation,' and adds: 'I will never leave what is certain for what is uncertain.' The abbot agrees wholeheartedly: 'How truly you speak,' and flings himself on the mercy of God. How differently the Franciscan is treated! Death greets him as the 'servant of Christ', assuring him that Paradise will be his portion. The elimination of the Carthusian shows that the author, who was certainly a Minorite, had no great respect for the older monastic orders. But how far we are from the spirit of the gentle, humble founder of the Franciscan Order!

Religious dramas loosely connected with the Dance of Death were acted in Italy. Among them was a translation of the Spanish Corpus Christi play performed at Segovia in 1551, by Juan de Pedraza, to which reference has already been made. The Italian translator was a certain Maurizio Monte.[1]

[1] Vigo, pp. 112-114.

VI

SWITZERLAND

Of all the pictorial representations of the Dance of Death none was more famous than that of Basel. It became proverbial; many are the allusions to it in prose and verse. It was imitated at Berne, Lucerne, in Alsace, Italy and Austria. The city of Basel stands in the elbow of the Rhine at a point where the swift-flowing river turns sharply to the north on its long journey from the Alps to the sea. The Rhine divides Basel into two halves. The southern part is the larger and more beautiful part of the town; it contains all the fine public buildings, such as the Cathedral and Town Hall, while the northern part contains the industrial quarter. The southern half is known as Grossbasel or Greater Basel, and the suburb on the right bank of the Rhine is Kleinbasel or Lesser Basel.

At one time both the city and its northern suburb possessed a Dance of Death, known respectively as the Grossbasel *Totentanz* and the Kleinbasel *Totentanz*. The former was in the Dominican churchyard. The latter was in the convent of Augustinian nuns in the district of Klingenthal. As long as the convent was occupied by a religious community, the general public had no opportunity of seeing the Dance of Death and they may not even have known of its existence. But in 1480 the inmates were ejected by order of the Dominican friars, who were their spiritual superiors. It is highly probable that the Grossbasel paintings owe their origin to this circumstance. The departure of the nuns drew attention to the *Totentanz* in the convent and the friars wished to have a Dance of Death of their own in the friary churchyard.

It is surprising enough to find that there were two Dances of Death cycles in one town, but it is still more extraordinary to learn that they had so much in common. Both had the same number of figures, namely forty, arranged in the same order, with similar features and gestures. The merchant at Kleinbasel had a right hand attached to his left arm, and his counterpart at Grossbasel had the same physical defect. The first few persons in one series are not so tall as those which follow, and this peculiarity is duly reproduced in the other cycle. As regards the figures in the two paintings there are only two differences that really matter: Greater Basel has the queen and the pedlar (Krämer): instead of these, Lesser Basel has the patriarch and the beguine.

The Kleinbasel work included pictures of the abbess, the maiden,

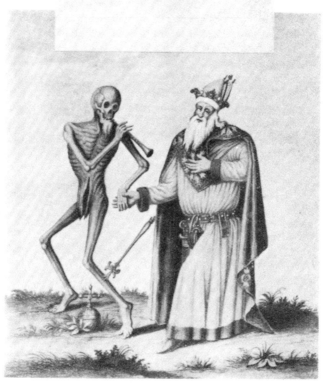

BASEL, DANCE OF DEATH: TWO EMPERORS

the beguine, and the pagan woman, but there is no monk or friar, whereas in Paris and Kermaria there is both a monk and a friar, but no women at all. It is, therefore, safe to conclude that this *Totentanz* was specially intended for a nunnery. At Grossbasel the beguine was omitted, which lends additional weight to the view that the Dance of Death was copied after the nuns had been sent away for their scandalous behaviour. The nunnery came to be used as a granary and then as a salt warehouse: windows were broken through the wall of the cloister; later the wall was reconstructed and the mural paintings suffered considerably by demolition and neglect. Only half of them were visible in a state of advanced disintegration in 1847.

The Grossbasel *Totentanz*, which adorned a cemetery in one of the busiest parts of the town, was better cared for. It was frequently renovated and ultimately protected against weathering by a roof. The fame of the 'Death of Basel' spread far and wide. Travelling journeyman, traders, and tourists flocked to see it as they entered Switzerland by the Golden Gate on their way further south. Englishmen of fashion passing through Basel on the Grand Tour did not fail to visit the Dominican cemetery and the other sights of the place. Few of them recorded their impressions for the benefit of posterity, but that prolific writer, Gilbert Burnet, gave a description of the Dance of Death as he saw it in 1685.[1]

'There is another longer *Dance*,' he tells us, 'that runneth all along the side of the *Convent* of the *Augustinians*, which is now the *French Church*, which is *Death's Dance*; there are above threescore *Figures* in it at full length; of *Persons* of all ranks, from *Popes*, *Emperours* and *Kings*, down to the meanest sorts of *People*, and of all *Ages* and *Professions*, to whom *Death* appeareth in an insolent and surprizing posture; and the several Passions that they express, are so well set out, that this was certainly a great design. But the *Fresco* being exposed to the Air, this was so worn out some time ago, that they ordered the best *Painter* they had to lay new colours on it; but this was so ill done, that we had rather see the dead shadows of *Holben's Pencil* than this course work.'

Apparently Burnet's informants were to blame for connecting the Dance of Death with Holbein (whom Burnet consistently calls 'Holben'), and perhaps they were also responsible for the confusion of the Dominicans with the Augustinians. Burnet was struck by the 'great design', but deplored the 'course work' of the renovator. We

[1] *Some Letters containing an Account of what seemed most Remarkable in Travelling through Switzerland, Italy, some parts of Germany*, etc., London, 1689, p. 272.

may paraphrase this by saying that he noted the vigour of conception and imaginative power of the *Totentanz*, but disliked the crude technique. It is the 'new colours' that called forth his condemnation. It was quite in the Basel tradition to use very bright paint or oils, as we can see to this day by the gaudy roofs of the Cathedral and the Town Hall. From this and other accounts of the Dance of Death at Grossbasel we conclude that the overwhelming mastery of Death was portrayed with great force and considerable skill, but with a kind of realism which might offend those who preferred conventional art. We also note in this description the reference to the insolence of Death and the various passions depicted in the other characters in the cycle.

Small wonder that the citizens of that quarter of the town were very attached to their *Totentanz* in the Dominican cemetery, with its beautiful linden trees. When the Council brought forward new building plans in 1805, which involved the destruction of the cemetery wall, the local residents protested violently. So great was the opposition that the work of demolition had to be done secretly by night. Local patriots rallied to the spot afterwards and picked up the remaining fragments of the Dance of Death. These were carefully preserved in various private houses. The relics are now to be seen in the old Franciscan Church (Barfüsserkirche), which is used as a Historical Museum.

Between 1767 and 1773 a master baker named Büchel labouriously copied both the Dances of Death of his native city.[1] In his day the Klingenthal pictures were faded and badly damaged; he felt that it was high time to preserve them from complete disappearance. The Grossbasel *Totentanz* had been better looked after. We read, for example, that in 1578 the Council entrusted the task of renovation to a Netherlander named Kluber or Klauber, who settled down in Basel and joined the local guild. Kluber added his own portrait with that of his wife and child at the end of the Dance, together with a rhymed stanza, in which Death calls upon him by name to abandon his painting. This is a new feature: the artist becomes a member of the Dance and is summoned to his fate in his own workshop. As Kluber's portrait and name were to be seen on the walls of the cemetery, it was naturally thought that he was the creator of the whole series. This legend was duly propagated by later writers and the confusion about the date of the Dance[2] was thus still further confounded.

[1] There are two copies in the Basel Museum and one in the University Library. These different sets were made for different patrons.

[2] See below, p. 64.

Kluber carried out his task conscientiously. He contented himself with renovating the main scenes, and apart from the group in which he himself figured, he made few additions of any kind. The only alteration of note was in the physician scene. It is astonishing to see in Merian's engravings, which reproduce with remarkable fidelity the details of the Grossbasel pictures, one single well-drawn skeleton among the long series of the dead. In the rest of the cycle Death is portrayed as an emaciated body with a skull for a head. Some of the skulls have hair attached; some of the bodies show signs of decay, but most of them are quite intact. Their sex is recognizable: the partner of the queen is seen from the pendant breasts to be a female. Here, however, beside the physician we find a complete skeleton. This part of the Dance cannot be original. In the fifteenth century anatomy was in its infancy. It was chiefly studied from the works of Galen, who was regarded as an infallible authority. The dissection of the human body, though occasionally practised in Italy, was almost unknown north of the Alps. Hence articulated skeletons were not to be found in Central Europe before the middle of the sixteenth century. Kluber came on the scene when Vesalius, the father of modern anatomy, had opened out new vistas for the science of medicine.

It is significant that in the second half of the sixteenth century the University of Basel reached the highest point of its development; and not the least of its glories was its famous medical faculty. In 1453 Vesalius arrived in Basel from Padua with the manuscript of his epoch-making work *De Humani Corporis Fabrica*. He arranged for its publication by the press of Andreas Oporinus, who was himself a physician and a student of the great Paracelsus. Kluber's drawing and the accompanying inscription have a certain historic interest. The skeleton, if not an exact replica of an engraving in Vesalius' work,[1] is at least closely modelled on it.[2] The verse addressed by Death to the Physician is in the language of the sixteenth century, and is hence more modern than the other stanzas. 'Doctor,' he exclaims, 'observe my anatomy, whether it is rightly made, for you have executed many a one, who now looks just like me.' It is a little satirical tilt at the medical profession.

When Büchel set to work, the Grossbasel pictures were practically unchanged, apart from the periodical renovation of the paint.

[1] P. 165, cf. also p. 164.
[2] Dr. Warthin (p. 17) considers the resemblances superficial and accidental. In his view the model was 'primarily' the physician in the Kleinbasel series. But Kluber was an artist, not an anatomist; he would not consider it a crime to miss out a rib, or to put the sacrum a few inches too high.

On this point he is quite definite. He did his work well; he even reproduced the exact colours of the original and the anatomical errors to which we have referred, not to mention the blemishes due to weathering and neglect. Büchel recognized that the Kleinbasel paintings were older than the others. This fact has been questioned since, but later investigations have corroborated the worthy baker's observations. Not only has it been proved conclusively that the pictures at Grossbasel were a copy of those at Kleinbasel, the priority of the Kleinbasel text has also been definitely established.[1] Those who maintain that Grossbasel is the earlier or that the two cycles are contemporaneous, have not made themselves acquainted with the literature of the subject. Even in 1928 an eminent historian of art blandly asserted that the two Basel *Totentänze* were of the same date and probably by the same artist.[2] Dr. Daniel Burckhardt's attempt to prove that only a few years separated the two works, and that the later one was painted by Konrad Witz is quite unconvincing.

In this important question Büchel anticipated the results of modern scholarship, but in another he fell into error. He saw a date on the Kleinbasel series which he read as 1312. Uncritical writers kept on copying this mistake from their predecessors. Büchel subsequently corrected his error: the date should have been 1512, and it could only refer to a renovation of the Dance of Death, not to its inception. But the harm was done and the legend continued to circulate. A century was to elapse before the true facts were brought to light, for the manuscript which contained Büchel's recantation was not discovered and published till 1876.[3]

According to tradition, the Grossbasel pictures were produced at the time of the Council of Basel (1443-1449), at the suggestion of some of the prelates who took part, and as a memorial of the plague of 1439, which carried away several of the ecclesiastical dignitaries who were then resident in the town. But it is more likely that the idea emanated from the Basel Dominicans. The extreme care with which the pictures were copied from those of Kleinbasel suggests that local men were responsible. The foreign churchmen would probably have recommended some model known to them at home in their own countries. The pronounced satirical and anti-clerical features that were added at Grossbasel suggest the late fifteenth century rather than 1440. The popular tradition may have been right

[1] Alexander Goette (p. 145) deals with the pictures, and Wilhelm Fehse, *Der oberdeutsche vierzeilige Totentanztext*, p. 81, with the verses.
[2] Karl Künstle, *Ikonographie der christlichen Kunst*, Freiburg i, B., 1928, Band I, S. 213.
[3] Th. Burckhardt-Biedermann, in *Beiträge zur vaterländischen Geschichte*, Band VI, Basel, 1882, pp. 44-48.

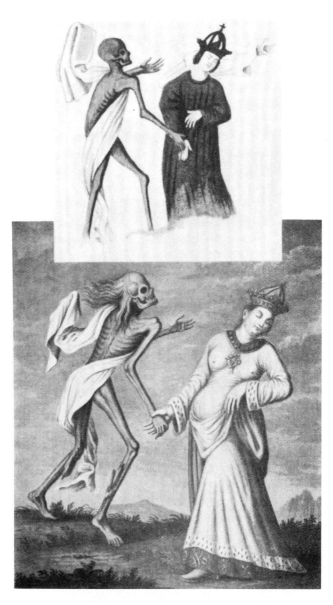

BASEL, DANCE OF DEATH: TWO EMPRESSES

in associating a *Totentanz* with the plague of 1439, but if so there is a confusion of Kleinbasel with Grossbasel. It is a mistake that is easily understood. The people of the town were themselves scarcely aware of the existence of the Klingenthal *Totentanz*. The convent was not open to the public. Even in the second half of the eighteenth century the pictures were almost unknown. Francis Douce himself, the greatest English authority on our subject, derived his information about Klingenthal from a guidebook, although he had actually visited Basel in person. The old tradition that a Dance of Death had been painted at the time of the Council would naturally be understood to refer to the pictures in Greater Basel, which were extremely well-known when those of Klingenthal were forgotten. Emile Mâle, the learned historian of French mediaeval art, states that the costumes of the Kleinbasel pictures date from about 1450. The Klingenthal convent was destroyed between 1850 and 1860.

There are further clues to the dates of the two *Totentänze*. Besides the reproductions of Büchel, there are the drawings of Matthieu Merian, made in 1616 and published in the form of engravings five years later. Büchel dealt with both Dances of Death, whereas Merian devoted his attention to that of Grossbasel only. Merian records a local tradition that almost all the figures were drawn from life in the costumes of the day (which would give support to Mâle's method of fixing the date). We are told that the pope depicted was Felix V, who was elected by the Council to succeed the deposed Eugene; the emperor was Sigismund, who died in 1437; the king was Albrecht II, King of the Romans (1438-1439). This sounds reasonable enough: all these persons were present at the Council of Basel. At Paris the Emperor was a foreigner; but at Basel, which was an imperial city, subject only to the jurisdiction of the Emperor, Sigismund was a well-known figure. He was more than the Holy Roman Emperor: he was the feudal overlord and protector of the citizens. I have carefully compared the Emperor's face in Merian's engravings with the image on contemporary coins and seals and find that there is a certain similarity. How different, for example, are the portraits of Maximilian I! The features of the King in Merian are not dissimilar to those of Albrecht II, as found in an old portrait. It is true that Merian did not know, as we know to-day, that the Grossbasel pictures were copied from the older *Totentanz* at Klingenthal. But there is nothing unreasonable in thinking that the people of Basel would point out to visitors the portraits in the more famous Dance of Death long after the original at Klingenthal was forgotten.

One curious circumstance about the later work seems to have escaped attention. The Empress is represented as a pregnant woman in the Grossbasel pictures, but in them alone. What would be more natural than to think of Elisabeth, the daughter of Emperor Sigismund, who lost her husband, Albrecht II, in October 1439, and gave birth to a child in the following February? Her tragic fate made her the object of general sympathy.

We have found a motive for the omission of the nun or beguine at Grossbasel, why should the queen be included here, but absent at Kleinbasel? Massmann throws out a hint, but it is nothing more, that this fact might throw light on the date of the *Totentanz*. The problem, as he sees it, is that of the absence of the queen at Kleinbasel. As a matter of fact, it is not really a case of omitting the queen at all. The Paris *Danse macabre*, the Lübeck *Totentanz* and the Spanish *Danza general*, all lack the queen, who first appears at Grossbasel. Even the empress was absent at Paris and in the Spanish poem, and is an evident addition at Lübeck. I think that the solution of Massmann's problem is to be found in the fact that Frederick II ascended the throne as a young man in 1440 and did not marry till 1452, so that there was a king, but no queen in Germany in this period. Basel joined the Swiss Confederation in 1501, but belonged to the Empire, nominally at least, in the fifteenth century.

There is one further piece of information that may help us to fix the date of the Klingenthal *Totentanz*. The cloister in which it was painted was built, entirely or in part,[1] in 1437. The unknown artist was perhaps a native of the Netherlands; in the poem that accompanied the pictures some Low German (or Dutch) forms are to be found.

The popularity of the 'Death of Basel' in the Dominican cemetery was not undeserved. From the drawings of Büchel, the engravings of Merian, and the surviving fragments in the Historical Museum, we can form a very good idea of the lost work. There were obvious defects, but it was powerfully conceived and well executed. It was the creation of an artist whose one aim was to develop to the full the possibilities of the subject. With what skill the figure of Death is varied. The queen is led away by a female risen from the grave, the count by an old man, the knight by an enemy holding a sword, while the knight himself has only the empty scabbard. The noblewoman has her back to Death, but sees him in the mirror. He creeps behind the merchant and seizes his scales. When accosting the lame beggar, Death has a forked stick which supports his mutilated leg.

[1] Goette, p. 88, thinks that only part of the cloister was built in 1437.

The painter was fortunate in having a good model to follow, but faithful as he was to the original at Kleinbasel, he improved it by countless deft touches. He gave greater individuality to the human figures and to their partners. He heightened the effect in all kinds of ways. Here he made Death more ruthless, or vigorous, elsewhere more roguish and sly. By raising the arms and legs of the figures he accentuates the dance motive. All this is done without changing the gestures, the facial expression, the colours and the costume of the model. In the older and also in the later cycle, one finds an important peculiarity already encountered at Paris and La Chaise-Dieu, but here more strongly accentuated. The long chain of dancing and walking figures clearly consist of a series of pairs. This feature prepared the way for Holbein.

One scene in the Kleinbasel cycle has attracted little attention. Büchel observed that after the picture of the cripple there came the corner of the cloisters. He described the sacred monogram *ihs* over the door and the name *Maria*. Next was a very faded representation of the Crucifixion, with the Virgin Mary, St. John and two kneeling nuns with their coats of arms. Then followed the hermit and the remaining figures. Büchel evidently did not consider the crucifixion scene to be part of the Dance of Death. But it came exactly in the middle of the series: thirty-five paces from the mortuary at the beginning and thirty-five paces from the mother of the child at the end. This can scarcely have been a mere coincidence.

The figure of Christ on the Cross formed an integral part of the whole. At La Chaise-Dieu the *Danse macabre* commences with the Fall, and so does Holbein's Dance of Death. The Kleinbasel series contains in the very centre the picture of the Passion, which symbolizes the salvation of man and the victory of Christ over Death. The inevitability of Death is not a Christian theme, unless it is completed by some reference to the resurrection or the redemption of man. The underlying thought of the Dance of Death was that man in his fallen state is a prey to death, but man redeemed inherits eternal life. If one aspect of this twofold truth was expressed pictorially, the other aspect would doubtless be emphazised in the sermon of which the pictures are the object lesson. For in the first scene at Grossbasel the preacher was depicted in his pulpit; at Kleinbasel this part of the pictures was missing in Büchel's time, but it is almost certain that it did exist. The last scene also contained the preacher, as far as we can gather. When the Kleinbasel cycle was renovated, the Crucifixion scene was not repainted; consequently it faded and seemed to be of a different date from the rest. This circumstance misled scholars to think that the scene did

not form part of the Dance of Death. When we come to examine the Berlin *Totentanz*, we shall find the Crucifixion scene again in the middle of the series.

What was the model of the Klingenthal pictures? Seelmann[1] conjectured that it was the *Danse macabre* of Dijon, which was made in or before 1436. Dijon is the nearest French town of any size to Basel and there were close relations between the two places in matters of art, as is shown by the fact that in 1418 the Basel Council ordered an artist named Hans Tieffenthal to paint a chapel (Die Kapelle des elenden Kreuzes) on the model of one in Dijon. As far as we are aware, few pictorial representations of the Dance of Death existed in 1440, and there were none in Germany. It is therefore natural to look to France for the inspiration of the Basel work. But the latter is very different from the *Danse macabre* of the Innocents. Points held in common are few, divergences are very numerous and far-reaching. If the ultimate source of Basel was Paris, there must have been intermediate links.

Under the two cycles at Basel there were two sets of verses, which apart from differences of dialect, are almost identical.[2] Here again, as in the paintings, Grossbasel copied Kleinbasel. The poem in question has no great literary merit. It is rough in places and the rhymes are often forced. It is journeyman's work, not literature. But nevertheless there is a certain vigour and freshness in this verse that must have harmonized well with the pictures above. The verses are of four lines each: one quatrain is assigned to each character and the partner also receives one. The mortals announce their names and stations in life, with some such phrase as 'I am' or 'I have', just as if they are telling us what the pictures represent. The verses serve as the titles of each scene.

A few specimens will make the procedure clear: 'I was named a holy pope', 'I have ruled powerfully as a king', 'I was by papal election a cardinal of Holy Church', 'I have borne the double cross' (patriarch). The speeches of the partners vary the theme: 'You must join the circle', 'You must dance with the dead', 'I will lend you a hand', 'I will lead you by the hand in the dance of the black brothers', 'You also must dance with the apes'. Much speculation has been caused by the phrases 'black brothers' and 'apes'. Were the 'brethren' the Dominicans, whose association with the Dance

[1] This remains a conjecture, because we know nothing whatever about the *Danse macabre* of Dijon, apart from its date. But there were other links between Basel and Burgundy.

[2] At Kleinbasel the local dialect is used, at Grossbasel the literary form (Kanzleisprache). This is a further proof that there was a gap of some forty years between the two works.

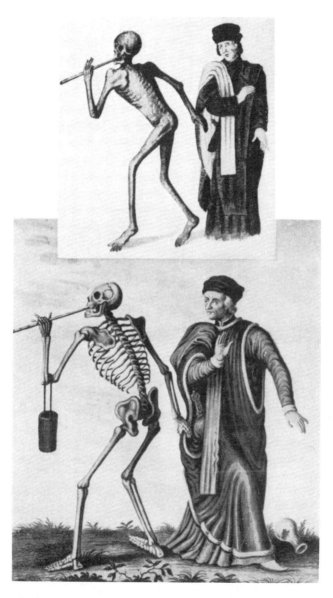

BASEL, DANCE OF DEATH: TWO PHYSICIANS
[KLEINBASEL ABOVE, GROSSBASEL BELOW]

is historically clear, or is it a reference to a drama in which the speaker was disguised as a devil or a skeleton? What are we to make of the word 'apes'? The German word *Affen* rhymes with *Pfaffen* (priests), and there is no need to take it too literally. It means probably 'evil ones', 'misshapen fellows'.

It was in Basel that the most famous of all representations of the Dance of Death took shape, the woodcuts of Hans Holbein the Younger. In 1515 this famous artist left his native Augsburg and arrived in Basel. In the German city competition was so keen that he had had the greatest difficulty in earning a livelihood. Basel was a smaller and less populous town; it could not boast the presence of the emperor; it lacked the opulence of the great merchant centre of Augsburg. But it was a free republic, and in an atmosphere of civic and intellectual liberty, learning and art were able to develop without hindrance. A group of scholars had assembled at the university, among whom the great Erasmus felt at home. The renowned printing presses of this city offered steady employment for a skilful craftsman.

It is more than likely that Holbein was familiar with the Dance of Death when he came to Basel. Augsburg possessed a *Totentanz*, though not a particularly good one, and the blockbooks with woodcuts of the Dance of Death were well-known and widely diffused in South Germany. In any case the pictures in the Dominican churchyard must have made a profound impression on the young artist's mind, for when he treated the subject, and he did so several times, he borrowed many motifs from the famous Dance of Death.

Among Holbein's most attractive works is a sketch for a silver dagger sheath, now preserved in the Basel Museum.[1] The design elaborated for this purpose was particularly suitable for an instrument of sudden death. With great skill the artist made the most of the limited space at his disposal and cleverly filled up the tapering shape of the sheath, drawing his inspiration from the Basel mural paintings. There are six pairs only: king, queen, mercenary, matron, mendicant friar, each with his ghostly companion.

In 1524 and the following years Holbein drew an Alphabet with interwoven figures taken from the Dance of Death. This alphabet was engraved by Lützelburger, as is attested by his signature. It was a preliminary sketch or study for Holbein's greatest work in the sphere of woodcuts, which is often called the *Grosser Totentanz*, or Great Dance of Death, in order to distinguish it from the dagger

[1] The date is unkown; Waetzold thinks that it was the latest of the works inspired by the Dance of Death. The workmanship is certainly very mature and finished.

sheath and the alphabet. The connection between the latter and the Great Dance of Death is closer than would appear at first sight. Nine of the scenes in each of these works have the same theme in the same order. First comes the dance of the dead (or 'bones of the dead'), and then follow pope, emperor, king, cardinal, empress, queen, bishop, and duke. In the following subjects of the Alphabet Holbein departs from the usual order. The bishop (H), the monk (O), and the soldier (P) clearly foreshadow the woodcuts of the later work. To a lesser extent this may be seen in the figure of the fool (R). The influence of the Grossbasel series is evident in the hermit (W).

It is not known exactly when the drawings for the Great Dance of Death were made, but the majority of them were certainly in existence before 1527. For several years Holbein seems to have allowed the plan to mature in his mind. We know from a letter written by Erasmus in 1524 that Holbein had recently gone to France. He took with him a portrait of Erasmus as a present to Bonifatius Amerbach of Basel, who was then studying at Avignon. Holbein would pass through Lyons on his way to Avignon, and it was perhaps on this occasion that he got into touch with Melchior and Gaspar Trechsel, who were printers in that city.

It is, however, equally possible that Holbein made the designs for the woodcuts and then handed them over to Lützelburger, who negotiated with the printers himself. For Melchior Trechsel laid claim to the blocks in settlement of a debt owed to him by Lützelburger, and Holbein was not involved in the transaction at all. The first Lyons edition appeared in 1538. A Basel edition seems to have been contemplated, but it was never produced, but two sets of proof impressions were made in Basel with German headings and no descriptions. The older set may be seen in the British Museum, the Bibliothèque nationale at Paris, and the Museums of Basel, Karlsruhe and Berlin. There is also a complete set at the Albertina, Vienna.[1] There are forty woodcuts with headings in cursive writing. Of the second set the only complete copy in existence is in the Bibliothèque nationale. It consisted originally of forty-one prints, the additional one being the Astrologer (Sternsecher). The headings are in German with Gothic lettering.

None of Holbein's works is so well-known and none displays such imaginative power and originality as the Dance of Death. The secret of his success was the combination of Holbein as artist and Lützelburger as craftsman. The former drew the designs and the

[1] One subject, the Preacher (Predicant) may be from one of the later printed editions.

latter cut the wooden blocks. This partnership had a unique quality. When Holbein had other collaborators the results were noticeably inferior. The title of the series is rather misleading, because it is not really a dance at all, but a series of groups, each complete in itself. The artist and the publisher were not responsible for the title which posterity gave to the work. It was published as 'Les simulachres et historiees faces de la mort', and this description, 'Images and storied aspects of Death', is much more appropriate. Holbein's woodcuts of the Dance of Death are his greatest performance in this medium. They are, moreover, by far the greatest achievement in the history of our subject. Not only did it reach its culminating point in his work, but nearly all subsequent efforts were dominated by his influence.[1]

Switzerland is a land of competent craftsmen rather than of artists, and this is particularly true of the Swiss capital, in which we find little of that ancient culture that distinguishes Basel, the city of Erasmus and Holbein. Berne produced fine soldiers, who served with distinction on many a foreign field, it also bred excellent bailiffs, governors and magistrates, but it held itself aloof from the great movements of European philosophy and learning. It had no humanists, no scholars. Nicolas Manuel, the greatest of Swiss artists, was born at Berne, but he had to go to Basel to learn his craft. He was one of those versatile personalities that we associate with the age of the Renaissance. As a soldier he took part in the Italian campaign of 1522, serving with the Swiss mercenaries who fought for Francis I of France. Manuel's literary work includes satires, Shrovetide plays and polemical writings. He was a diplomat and statesman. He was one of the leaders of public opinion chiefly responsible for the introduction of the Reformation in the town and canton of Berne. Thanks to his restraint and tolerance the transition from the old faith to the new was effected without disorder or bloodshed. As an artist Manuel produced altar pieces, portraits, drawings and woodcuts, in various styles. His famous work was the Dance of Death on the cemetery walls of the Dominican convent of Berne. It was carried out between 1515 and 1520 and destroyed in 1660 or earlier. It is known to us by two water colour copies, now in the Berne Historical Museum, and by two rather inferior lithographs executed in 1823 and between 1832 and 1838 respectively.

Manuel never studied under a master of eminence. The story that makes him a pupil of Titian is apocryphal. He was largely self-

[1] For further details see J. M. Clark, *The Dance of Death by Hans Holbein*.

taught and received his inspiration from many sources. During several visits to Italy he had become acquainted with the spirit of the Renaissance. He had travelled widely and with an observant eye. He loved the landscape of his native district, the Alpine chain, the foothills of the Alps, the lakes of Neuchâtel, Biel and Thun, the old castles and villages, the meadows, orchards and vineyards of the canton of Berne. It cannot be doubted that he was familiar with the Grossbasel Dance of Death and with the verses inscribed below it. There are good reasons for supposing that he also knew other examples, perhaps the French woodcuts among them. But from these various sources he only derived the general idea of his pictures and poem. His work is very original both in form and in subject matter. It bears the imprint of a vigorous personality.

In his verses he does on one occasion take over two lines bodily from Basel, but for the rest he gives us not an adaptation, but a new poem. It is not written in literary German, in the *Kanzleisprache* which Luther used in his Bible and Hymn-book, but in the homely idiom of the Bernese peasantry, the Swiss dialect which was Manuel's mother tongue. It is not very elegant or polished poetry. It was written in an age of fierce controversy, of scurrilous invective and mordant satire. There are savage attacks on the prelates and monks. The bishop confesses: 'Like a wolf I have devoured the flock, and now I suffer the punishment.' 'You are ravening wolves in sheep's clothing' cries Death to the group of monks. The same satirical tendency is seen in the pictures. As the pope is carried in the sedia gestatoria, Death snatches away the tiara and stole. He leads the patriarch by a cord, like a beast to the slaughter; he chucks the abbot under the chin. The Reformation had not yet arrived in full force, but the time was ripe for its introduction. A Protestant character appears in the pictures: the Preacher of the Word.

The work belongs entirely to the sixteenth century, the old mediaeval traditions have been left behind. Far-reaching changes have been made in the Dance of Death. The original alternation of laymen and clerics was interrupted at Basel by the addition of the empress and by other later innovations. The Berne artist boldly abandoned it altogether. He separated clergy and laity entirely and made many other alterations. The strict hierarchical arrangement of society had ceased to mean anything. We have the impression that the work reflects the urban environment, whereas the Paris *Danse macabre* grew in an ecclesiastical *milieu*. At Berne the church still has the precedence and the secular persons follow: that is a survival or a concession, but the layfolk by far outnumber the churchmen.

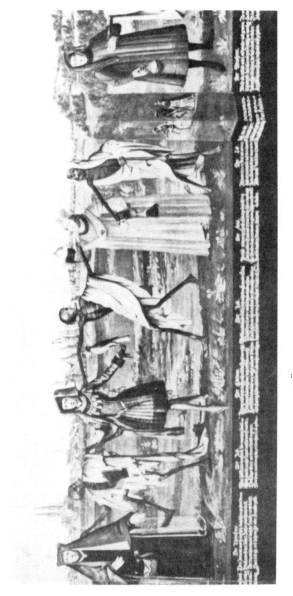

LÜBECK: DANCE OF DEATH

The profession of arms is well represented by the man-at-arms and two knights (one of them is a member of a religious and military order and has a cross on his breast, the other is a secular). The usurer has been dropped; would his presence have been regarded as a reflection on the integrity of the traders of Berne? In his stead we find the merchant, who with the pedlar, citizen and journeyman form the middle class section. Grossbasel had a jurist and a councillor; Berne has whole faculty of law, consisting of a jurist, an advocate, a mayor (or chief magistrate), a councillor and a judge, as was fitting in a centre of government and lawgiving.

The scheme is organized as a whole; the characters appear in groups, not singly. The pope and cardinal are together, as are the emperor and the king, the empress and the queen. The widow and the bawd personify virtue and vice. The introductory scenes lack the preacher, but he appears at the close of the series. Four scenes form the introduction: the Fall, the reception of the Ten Commandments by Moses, the Redemption, and the Resurrection. The traditional symbols are not left intact. In the Redemption the Cross stands in the middle of the picture, and the Virgin is in her usual place at the left, but at the right, where we should expect St. John, there is a skeleton. The Resurrection takes the form of four skeletons, in a mortuary, one of whom is playing the bagpipes while the others have trumpets. They are sounding the last trump, unlike the ghostly musicians at Basel, who were inviting the living to join the dance.

The final scene is new in the history of the subject. Death stands with a scythe in one hand, while in the other he holds a cross-bow. He has a quiver full of arrows. Before him lie on the the ground a score of persons of both sexes and all ages, including a small naked child, all transfixed by arrows. On the left-hand side there is a large tree, partly severed by an axe, which, regardless of the laws of gravity, is placed in the cleft. From the branches of the tree people are dropping to the ground. At the right is a preacher in his pulpit, holding a skull in his hand. The background is a Swiss landscape. The effect of all these mixed and even contradictory allegories is curious rather than pleasing.

There is, however, real artistic skill in the composition of the warrior priest in his coat of mail, holding his long spear. The skeleton stands behind him and is partly hidden, so that there is little of the grotesque effect. The two figures fill a double section. In another scene there is on the right a group of four monks with Death, and on the right there is Death and the abbess, carrying her crosier. The features of the characters are strongly individualized and they

may well be portraits of contemporaries. One of them certainly is: over the picture of the duke is the coat of arms of the Mülinen family and the duke has the features of Kaspar von Mülinen. Above each of the sections there are coats of arms, for the Republican Bernese were as proud of their pedigrees as any peer of the realm in a monarchy.

The strangest portrait of all occurs in the last scene of the series proper. On the left are Jews and heathens, and to the right, complete with brush, maulstick and palette, dressed in the mode of the day, stands the artist himself, with the features of Nicolas Manuel! He is seen putting the finishing touches to his great work. Death creeps along with the hour-glass on his back and grasps the maulstick, interrupting the painter in his studio. There is a touch of genius in the idea and it did not pass unnoticed. It is not unlikely that Hans Hug Kluber owed to Manuel the idea of adding his picture to the Grossbasel *Totentanz* which he was ordered to renovate.

Here for the first time we have a Dance of Death of which the painter is known to us by name. Mediaeval architects, sculptors and painters are usually anonymous. No one knows who produced the *Danse macabre* of the Innocents or the Basel *Totentanz*, nor has the utmost ingenuity and industry of scholars succeeded in discovering the author of the accompanying poems. At Berne we are not left in any doubt. Manuel was responsible for both the pictures and the verses. He added his own portrait by way of signature, and thus made himself one of the characters of his own work. We think of St. Paul's Cathedral as the work of Christopher Wren, but who was the architect of Salisbury, or the nave of York Minster, or the choir of Ely? At the time of the Renaissance more stress was laid on personality, and the artist was more conscious of his own importance. The mediaeval master was more humble and modest; he thought less of himself and more of his work. He was one link in a chain of tradition, one of the many workers whose collective labour resulted in a great cathedral or abbey. His own dignity and worth was less important than the vast masterpiece of which he is fashioning the whole or a part.

We have called the Berne pictures a Dance of Death, but the term is not altogether appropriate. The old symbolism is not consistently carried out. It is true that in the poem many references to the dance appear. For example, Death cries to the monks: 'You must dance with us, whether you will or no.' This is a survival, but in the pictures the old conception of a procession is no longer in evidence. In the original Dance of Death each of the living characters was engaged in a dialogue with his partner, and so they filed past

the spectator. No such convention was adopted at Berne. Here the illustrations are almost independent of each other and some of them are more like separate groups. In the great majority of scenes Death confronts a single person, but in one there are four victims. Death attacks and on occasion drags away his prey, but he does not attempt to dance with many of them. He approaches them as individuals and his method of approach varies according to circumstances. There is no unbroken chain of dancing pairs. In some of the scenes Death comes upon a man unawares as he is engaged in his typical occupation. The mercenary is arrested when he is on the point of receiving stolen poultry. The physician, here as elsewhere, is scrutinizing his urine glass. The fool alone struggles with Death and this is his crowning act of folly, but the knight (Ordensritter) meets his fate with calm courage and dignity.

Manuel departs somewhat from the conventional manner of drawing Death. His skeletons have strips of decaying flesh hanging from their bones, and their heads are in various stages of decay. Some are bearded, others have long hair. They appear in some simple disguise: to the duke with the gestures of a valet, to the count in the guise of a messenger, doffing his hat, to the youth he comes as a falconer with hawk on wrist, to the infant he plays enticing music on his flute. With a pike over his shoulder and clad in a coat of mail, he gives his arm to the mercenary; beside the judge who had condemned so many men to death he points to the open grave. The instruments on which the skeletons play are ingeniously varied: they comprise the lute, viol, flute and bagpipes. How can symmetry and unity be created among so much diversity? It is done by means of the framework. The figures are arranged below round arches on marble pillars. The idea, though not the detail, of the arcading, reminds us of the French woodcuts. In the background, between the arches there are landscapes: lakes with sailing ships, mountains, castles, vineyards.

When Manuel executed his Dance of Death at Berne the Reformation had not been officially introduced, but its spirit was in the air. The councillor is treated with great respect, as befitted one of the rulers of the little republic, and the mordant satire is directed against the prelates, clergy and monks. The anti-clerical element was carried a stage further in a printed *Totentanz* which was published in 1650 at Zurich. The authors, Rudolf and Konrad Meyer, begin with a parody of the Basel poem, in which the pope is addressed as 'Heiliger Vater'. The Zurich brothers substitute 'Scheinheiliger Vater' (sanctimonious father). The passions aroused by the Reformation had not subsided, but it is noteworthy that in

a later edition printed at Hamburg in 1759 this and other objectionable outbursts had been eliminated.

Lucerne alone among Swiss towns can now boast of a well preserved Dance of Death *in situ*.[1] It is unique in its position, being on a bridge. Besides the five modern bridges which connect the two banks of the River Reuss as it flows out of the Lake of Four Cantons, Lucerne has two mediaeval wooden ones, the Kapellbrücke (or Chapel Bridge) and the Mühlbrücke (also called the Spreuerbrücke). Both are roofed over and decorated with paintings. The Chapel Bridge is devoted to the heroic deeds of the old Swiss and the lives of the two patron saints of the town, St. Leodegar and St. Mauritius. The Mühlbrücke (or Mill Bridge) contains the Dance of Death, painted by Kasper Meglinger, a local craftsman, between 1625 and 1635. In the short period of prosperity that preceded the Thirty Years' War the Council of Lucerne planned to decorate the Mill Bridge with pictures of a gay and cheerful nature. The war intervened, driving large numbers of undesirable refugees into Switzerland. Besides the imminent danger of invasion, there was a severe outbreak of the plague which did not spare Lucerne. Fearing the corruption of public morals which such upheavals often bring in their train, the city fathers abandoned their original scheme and decided to have paintings which would turn the thoughts of the people to higher things. The appearance of Merian's engravings in 1621 supplied the theme, and the Lucerne Dance of Death was the result.

The Mill Bridge was once known in Lucerne as the 'Portraitsbrücke', because the models of the figures were well known to the public. Pope and cardinal, king and emperor all bore the likeness of some local worthy, and so we have the astonishing spectacle of a pope with a beard celebrating mass at the altar, while a little further we have a bishop with a moustache. There was no satirical intention, for this is in the strictly orthodox Catholic town of Lucerne. The anti-clerical tendency of Manuel is entirely absent. Not content with giving his own portrait, the artist, Meglinger, adds those of his eight colleagues of the painters' guild, all in seventeenth century costume, complete with trim beards, ruffs, doublets and knee-hose. The middle classes, trades and handicrafts are strongly represented.

In this series the process of substituting individual scenes for the long chain of figures has been carried to its logical consequences. The setting varies: sometimes the little scene is enacted

[1] The paintings at Chur are not original, being based on Holbein's woodcuts.

out of doors, sometimes we see an interior. The forty-six surviving panels[1] (twenty-two have been removed or destroyed) are delightful *tableux de genre*. We see the good citizens of Lucerne at work or play, driving in a carriage to take the air and hunt with the falcon, feasting with their friends to the sound of music. We enter the council chamber to see the magistrates in session; in another public room a judge is condemning a malefactor. In one panel the painters are depicted in their studio; in others a watchmaker, or masons, sculptors or goldsmiths are at work. It may not be a great masterpiece, but it is a valuable historical document. Even the violence of party warfare that characterized local politics has left its mark on the pictures, if we are to believe the Lucerne gossip. The worthy Meglinger is said to have depicted his friends in heaven and his political opponents in purgatory or hell in the final scene of the Last Judgment.

Lucerne possesses a second example, which is earlier than that on the Mill Bridge. In the present Regierungsgebäude (government buildings), there is a series of mural paintings of the Dance of Death by the local painter Jakob von Wyl (1586-1621). This building was formerly the Jesuit College.[2]

[1] Eleven of them are now in the Städtisches Archiv.
[2] For other Dances of Death in Switzerland, see Douce, 148; Buchheit, 186; Seelmann, 48-53; Dürrwächter, 2.

VII

GERMANY

'The ancient paintings of the Macaber Dance next demand our attention. Of these, the oldest on record was that of Minden in Westphalia, with the date 1383, and mentioned by Fabricius in his *Biblioth. med. et infimae aetatis*, tom. v, p. 2. It is to be wished that this statement had been accompanied with some authority but the whole of this article is extremely careless and inaccurate.' The doubts here expressed by Douce a century ago were justified; and subsequent research has demonstrated the untrustworthiness of Fabricius' remarks. Unfortunately this entry received so much publicity that it took a long time to clear up the error. We know now definitely that this work mentioned by Fabricius is not a Dance of Death, but a *Memento mori*; it is not in Minden, nor even in Westphalia. Minden, the scene of the Anglo-Hanoverian victory over the French in 1759, has been confused with a smaller place called Münden, in Hanover. The so-called *Totentanz* is a flag, on one side of which is the figure of a woman richly dressed; on the reverse side there is a skeleton. It bears the date 1383 and the inscription 'Vanitas vanitatum'.[1]

The Dance of Death of Lübeck had a better claim to be considered the oldest in Germany. It was certainly the most important. It decorated the walls of a chapel in the north transept of the Marienkirche. The original painting dated from 1463,[2] or slightly earlier, and was executed in water colours on wooden panels. It was replaced in 1701 by another *Totentanz* painted in oils on canvas.[3] The original work was carefully copied by Anton Wortmann: he retained the fifteenth century costumes. The Low German text was partly illegible, but Jakob Melle, the pastor of the Marienkirche, transcribed such portions of it as could be deciphered when the restoration took place. A new poem in High German was put in place of the fifteenth century verses.

At this time the pictures must have been in a bad state of preservation, for the first scene had disappeared. We know from other

[1] Seelmann, p. 4.
[2] Ibid, p. 44; Fehse, in *Zeitschrift für deutsche Philologie*, Bd. 42, 271.
[3] This was destroyed in 1942. The figures were life-size, and the whole series was twenty-two metres long.

evidence that the subject was the preacher in his pulpit and a musician with bagpipes. Wortmann substituted for it Death playing on his pipe. The background was a panorama of Lübeck with its churches, towers, its ships on the River Trave and the wooded surroundings of the town. We must remember that when the first pictures were painted, Lübeck was the capital of the Hanseatic League, which was then at the zenith of its importance. The scenic background of the *Totentanz* testifies to the citizens' pride in their town. The same motive accounts for the insertion of the burgomaster among the figures in the pictures. He immediately follows the nobleman and the canon, and thus leads the line of commoners. There is no archbishop, because Lübeck was not an archiepiscopal see. The patriarch conveyed nothing to the North Germans so he was also dropped.

The figures stand on a foreground of grass and flowers. They are twenty-four in number, alternately clergy and laity. They are provided with the conventional symbols: the pope with his tiara and cross, the emperor with sword and globe, the bishop with mitre and cross (not a crosier), the abbot has a crosier, the noble his hawk, the usurer his wallet, the physician his urine glass, and the infant is in its cradle. But the poor man does not accompany the usurer, and there is no Franciscan, which indicates that the friars are not the dominating influence here. The living with their rich robes contrast with their dead counterparts. The skeletons have no emblems, except the first, the pope's partner, who carries a coffin, and the last, who has a scythe. They are all draped in a white shroud and differ only in their gestures. They are conventional and stereotyped; and the living figures, though differentiated in shape and colour, are somewhat lifeless. The characters all face the spectator; they stand in a row and do not form a procession. While the skeletons leap, most of the living stand where they are. Many of the former hold two of their partners by the hand. No arcading or other device breaks up the chain.

There are twenty-four characters: twelve are laymen and twelve are ecclesiastics. Anyone who is familiar with the mediaeval symbolism of numbers will recognize that this is not a mere accident. The number twelve had a profound significance in the art of the time. There were twelve signs of the zodiac, twelve months of the year, twelve prophets, twelve apostles, and twelve Sybills. Human society, divided into the two chief sections, was also presented in this shape. At Lübeck was preserved what we may well believe to have been the primitive type of the Dance of Death. The thirty figures at the Innocents are an amplification of the original scheme.

The division of society into twelve classes shows the influence of scholasticism, with its passion for defining, classifying, dividing sub-dividing into a symmetrical scheme. The Lübeck *Totentanz* was replaced by the work of a later artist. How do we know that he made a careful copy of the original? How do we know that he retained the figures, adding nothing and taking nothing away? Strange as it may seem, there exists an almost exact copy of the Lübeck pictures at Reval (Tailinn) in Estonia. It is painted in oil on canvas in the Nicolaikirche. The preacher in the pulpit, musician with bagpipes, and the first few characters: pope, emperor, empress, cardinal and king, each with his partner and the appropriate verses, are still to be seen, all the rest has disappeared. Apart from slight alterations, especially in the background, the artist reproduced the Lübeck paintings faithfully. It is very likely that the work was done in Lübeck, because otherwise this degree of accuracy would be unnecessary. The foreground, with the River Trave and the outline of Lübeck is put in. As the Reval copy was made before the restoration of the original by Wortmann, it is an excellent guide for purposes of comparison.

Is there any connection between the *Totentanz* of Lübeck and the *Danse macabre* of Paris? At Lübeck the text begins 'Och redelike creatuer', which is the exact equivalent of the words 'O creature raysonnable', with which the Paris poem commenced. There is another parallel passage, which runs in French: 'La danse macabre sappelle Que chascun a danser apprant', and in the Low German: 'Tho dessem Danse rope ick alghemene'. But here the resemblances stop. The two poems seem to be not different versions of one work, but two entirely different works, as regards the text. They also offer a marked contrast as far as the tone and spirit are concerned. At Paris the Dance of Death was under the entire influence of the Church, and it reflects a stern and ascetic view of life. At Lübeck we are in a different kind of *milieu*. The work bears the impress of a wealthy merchant community. At both places the doomed characters express remorse, they regret their ill-spent life. There is a definite didactic purpose: to call sinners to repentance.

In the free city of Lübeck the verses are redolent of genial intolerance or smug optimisim and self-satisfaction. The words addressed to the physician savour of official praise or of obituary notices: 'Thou shalt receive great reward for the work which thou hast done; God will recompense thee a thousand times and crown thee with eternal life.' With a vague and perfunctory exhortation to repentance, Death then orders the physician to follow. Some persons are severely

dealt with at Lübeck, for example the canon, the usurer, the chaplain, and the maiden. We do not know who wrote the *Danse macabre* of the Innocents, but we can at least say that he was a scholar and a cleric. The psychology of the poem admits subtle shades of meaning. The psychology of the Lübeck poem is more superficial. The parts are not all particularly appropriate to the speaker. We could easily reverse the roles of the usurer and the chaplain. Death addresses them in almost identical terms, and their replies are very similar. The French poet was a priest and a pessimist. He had looked deep into the heart of man and found it full of sin and vanity. The Lübeck poet was a layman; he condemns evil where he sees it, but he is an optimist. He sees avarice and oppression around him, but he thinks there are plenty of decent, hard-working, honest people in the world.

We should infer that the Lübeck verses are the work of a local writer, who adopted ideas from elsewhere, but his poem is largely an original performance. What of the pictures? There is a certain family likeness between the figures at Lübeck and those of the Paris *Danse macabre*. The alternation of clergy and laity, the use of graveclothes to drape the dead, are common to both series, as also are the physician with his urine glass, the pose of the hermit between two skeletons. There were no women at the Innocents; there are only two at Lübeck, the empress and the maiden, who are an addition. In North Germany the emperor's writ ran, but it did not run in the North of France. As regards the other characters, the archbishop, patriarch, and constable are found at Paris only; the burgomaster is peculiar to Lübeck. The two series had a common source, and in view of the dates Paris would seem to be the original of Lübeck, unless both are derived from some older model.

Evidently there is a close connection between the Dance of Death of Paris and that of Lübeck. Is there any connecting link between these and the Spanish poem? Are all three related to each other? The verbal similarities between Paris and Lübeck find no parallel in the *Danza general*. It is a new and original text that differs from the other two in detail and in general spirit. Unlike his Lübeck confrère, the Spanish poet was a man of learning. In the *Danza general* the physician is a scholar; he speaks of the Arabic writer Avicenna, he is conversant with Galen and Hippocrates, with gargles, potions and dietaries. The Lübeck doctor knows nothing of these things. The Spanish hermit gives expression to mystical devotion; the recluse of the Hanseatic port is prosaic and uninspiring. In the *Danza general* Death informs the peasant that if he has led a guileless and honest life, Paradise will be his portion. One cannot be more non-

committal than this. But the German poem assumes the rustic's righteousness and assures him of future blessedness.

The introductory passage: 'A la danca mortel venit los nascidos, Que en el mundo soes de qualquiera estado' reminds us of the preliminary verses at Paris and Lübeck. The Spanish poem, like that of Lübeck, is in stanzas of eight lines, divided at the seventh. It is true that all the eight lines placed in the mouth of Death are spoken to the same person, but the break is clearly marked and the final line is often a command. Thus at Lübeck we have Death addressing the canon: 'Step hither to the dance'; to the physician he says: 'Follow me, sir doctor'; to the usurer, 'Usurer, follow me at once', and again, 'Sir chaplain, reach me thy hand'. These passages remind us at once of the Spanish version. The alternation of clergy and the absence of women (the empress and the maiden at Lübeck being exceptions) are common to both poems. A common source is therefore to be regarded as certain.

Some writers are of the opinion that details of costume at Lübeck, apart from those of persons of the highest rank, such as the pope and emperor, suggest the Flemish fashion of the time. In other ways also the Lübeck *Totentanz* seems to point to the Netherlands. The text has traces of Dutch mixed with the Low German. Considering the close economic relations between the Hansa ports of the Baltic and the Low Countries, this is quite a likely proposition. If it is correct, it would indicate the location of the missing link between Paris and Lübeck. Having regard to the great popularity of the Dance of Death in France and Germany it seems strange that no early pictorial representations have been discovered in Holland[1] or Belgium. The reason for this may be sought in the fact that art was then at its zenith in this region and was an article of export rather than an import.[2]

In Lübeck, as in Paris, the Dance of Death first appears on the scene in the form of paintings with an explanatory text and then passes into the next phase of printed books with illustrations. The Lübeck pictures of 1463 were succeeded by the printed *Totentanz* of 1489, with excellent woodcuts. A second edition appeared in 1496. The poem which accompanies the pictures is inordinately long; it runs to 1686 lines, which is easily a record for a Dance of Death in verse. The explanation is that it was written for a book

[1] See, however, J. G. Schultz Jacobi.

[2] Holbein's woodcuts enjoyed considerable popularity in the Low Countries, and in 1730 *De Algemeyne Doodenspiegel* was printed at Brussels. For references to the Dance of Death in Dutch literature, see G. A. Nauta in *Romania*, 24, 588.

and not for a mural painting. It is the work of an excellent poet. We do not know his name, but he was also the author of the Low German version of *Reinke Vos* (or Reynard the Fox), that vigorous satire which enjoyed such a great vogue in the Netherlands and Germany. Another *Totentanz* with woodcuts was published at Lübeck in 1520. The poem is much shorter than in the earlier work, running as it does to a mere 424 lines. This second Dance of Death is a new edition of a lost work printed between 1487 and 1489. All these books, including those of 1489 and 1496, have the same illustrations, so they must have been based on the same cuts. In the Royal Library of Copenhagen there is a defective printed book of 1536 or earlier, which contains a Danish translation of the Lübeck *Totentanz* of 1520 with the woodcuts. This was reprinted at Copenhagen in modernized spelling in 1862.[1] There is no record of any further development of the Dance of Death in Denmark.

Like Lübeck, Berlin had its *Totentanz*, and it was also in a church dedicated to the Virgin, the Marienkirche. It was painted in the fifteenth century, according to some authorities between 1460 and 1470, but it was not discovered beneath the whitewash till 1860. After restoration it was fairly complete, but the verses were not so well preserved. The Berlin Dance of Death is of simple design and execution. The figures are very much alike in attitude and form. As the same type is repeated over and over again, the general impression is monotonous. There is no shading and no skilful use of colour; the artist relies for his effect on line drawing. It may seem strange that in Berlin the standard of taste was so much lower than in the town of Lübeck, but it must be remembered that in the late Middle Ages the Hanseatic port was a place of great wealth and a centre of culture of the first rank. It was linked up with a hundred commercial towns; it was governed by a merchant class of taste and vast resources. Lübeck was able to commission the best artists of the Netherlands to adorn her churches: Hans Memling himself painted the altar pieces in the cathedral. At this time, in fact until the middle of the seventeenth century, Berlin was an insignificant town, inferior in importance to Brandenburg, the capital of the Mark. It was backward in the arts and sciences and could not command the local or the imported talent which was at the disposal of Lübeck.

But if inferior from the aesthetic point of view, the Berlin *Totentanz* is not without interest. The arrangement of the figures is original. The extreme left is occupied by the preacher in the pulpit,

[1] By C. J. Brandt. There is a later edition (1896) with reproductions of the woodcuts by Raphael Meyer, entitled 'Den gamle danske Dødedans' (the Old Danish Dance of Death).

who is a Franciscan friar; at the foot of the pulpit are two devils, one of whom is blowing on the bagpipes. To the right of the preacher stretches the line of the clergy, from the sacristan to the pope, rising in hierarchical dignity till we reach the centre of the series. This is taken up by a crucifixion scene. To the right of this, the laymen follow in a descending scale, beginning with the imperial pair, the king, duke, and knight, and ending with the fool. Originally the mother and child seem to have completed the cycle. There were fourteen clerics and the same number of laymen.

Among the art treasures of Berlin one relic deserves our particular attention. In the Kaiser Friedrich Museum there are two large shutters from the reredos of the abbey Church of St. Omer.[1] They were formerly part of the collection of the Princess of Wied and passed into the possession of the Berlin Museum in 1906. Two smaller shutters from the reredos are in the London National Gallery.[2]

The paintings represent scenes from the life of St. Bertin, the patron of the Abbey of St. Omer. Originally they were attributed to Hans Memling, but the researches of Deshaines have made it practically certain that they are the work of Simon Marmion, a Frenchman of the Flemish School. We are not concerned here with the two panels at London, but with those in the Berlin Museum, two of which contain a picture of the Dance of Death. The external portion of these has paintings of the Annunciation, the Evangelists and the Prophets, while the internal compartments depict the Legend of St. Bertin. The first shutter contains the youth of the saint, and the second his life as abbot of St. Omer. In the second panel there are two scenes representing the profession of Count Waldbert and that of four noblemen. In the following compartments the subjects are first, the temptation of St. Bertin and the miraculous intervention of St. Martin, and second, the death of the saint.

The subject of the second panel has been misunderstood. For instance in the official catalogue of the Berlin Museum it is described as a sermon. We see in the panel on the left a tonsured figure kneeling and taking his vows as a monk. In the right-hand picture four novices are making their profession in the same way. The place where they are taking part in the ceremony is adjacent to a cloister on the walls of which the Dance of Death is to be seen. There are verses beneath the pictures. The details are not very clear because of the small scale. Two figures only are recognizable: a knight in

[1] *Beschreibendes Verzeichnis der Gemälde im Kaiser-Friedrich Museum,* Berlin, 1912, pp. 254-255; André Michel, *Histoire de l'Art,* Paris, 1912, tome V, 1ᵉ partie, p. 204.
[2] *The National Gallery,* ed. E. J. Poynter, London, 1899, vol. II, p. 16.

ADAM AND EVE IN PARADISE

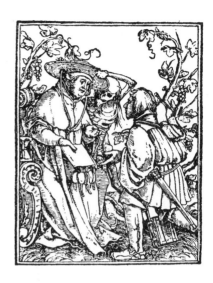

THE CARDINAL

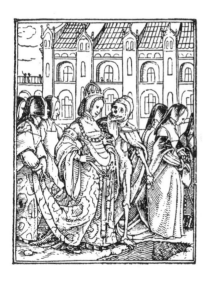

THE EMPRESS

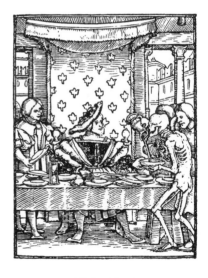

THE KING

plate armour of the fifteenth century type, and a musician playing the sackbut.

Which Dance of Death had the artist in mind? The cloister is too small to be meant for the Innocents. It is attached to a church. Marmion was a native of Amiens, which had a Dance of Death. He painted a picture in the town hall of Amiens in 1454. One would naturally suppose that he had in mind the *Danse macabre* of his native town when he did this work. We know that the reredos of the Abbey Church of St. Bertin at Omer was executed in Valenciennes between 1455 and 1459. There is also documentary evidence that Marmion was at Valenciennes in 1458. This gives us an approximate date for the painting. If our assumptions are correct, it would also help us to fix the date of the Amiens *Danse macabre*. This is the only instance that we have yet discovered of a musician with a sackbut in a Dance of Death. Hitherto we have met the viol or the lute. The sackbut was a wind instrument and the ancestor of the modern trombone.

Although printing with movable type was introduced by Gutenberg in 1455, printed books had already been in use in Germany at that time for about half a century. These are known as Blockbooks, and are so called because the whole page, letter-press and illustrations, was printed from one single wooden block. The workmanship was rather crude and clumsy. After the new technique in printing had been established, the old-fashioned blockbooks still continued to be produced. Two books contain Dance of Death poems and illustrations. Neither of them bears the date or name of the printer. They are both entitled *Der Doten dantz mit figuren*.

Opinions differ as to the origin of the first. It has been assigned to the press of Johann Zainer of Ulm (fl. 1473-1499), and also to that of Heinrich Knoblochzer of Heidelberg (fl. 1485-1495). Five copies are in existence, in the libraries of Karlsruhe, Darmstadt, Wolfenbüttel, Berlin, and Munich.[1] Two others are mentioned by Schramm, but he was unable to state their location. There are forty-two woodcuts.

The second book has the same number of woodcuts printed from the same blocks, but they are in a different order. There is general agreement as to its origin. It issued from the famous printing press of Jacob Meydenbach at Mainz, between 1491 and 1495. Three copies are known: one is in the British Museum,[2] a second in the

[1] Reprinted in facsimile by Albert Schramm, Leipzig, 1921.
[2] The press mark is I B 357; see *Catalogue of Books printed in the fifteenth century now in the British Museum*, Part I, p. 45 (London, 1908). See also Voullième, *Die deutschen Drucker des 15. Jahrhunderts*, p. 52.

C.D.D.

Berlin Kupferstichkabinett, the third in the Munich Staatabiblio-thek. To judge by the dialect and to a reference to 'The host of Bingen', the original from which these two books are derived came from the neighbourhood of that town. The text is in eight-line stanzas.

A poem christened by its editor[1] *Totentanzsprüche* (c. 1496) is an abbreviated version of the eight-line text, and rather a clumsy one at that. For in spite of general roughness, the verses of the *Doten dantz* have real literary power. The *Totentanzsprüche* are in four-line stanzas. The nun ends the list of characters and the manuscript has every appearance of being written for use in a convent. The com-piler of the poem used other materials: he borrowed with slight alteration the stanza spoken by the empress in the Quatrain poem,[2] and the opening address of Death to the same lady. He also took over almost unchanged a fourteenth century poem about the Last Judgment, entitled *The Prophecy of the Sybil.*

The *Doten dantz* poem is not in any way related to the Quatrain text. In the former Death addresses the individual and he answers with a lament, such as 'Alas!' or 'Shall and must I die?' He makes his protest or asks for a respite. Thus, Death accuses the parish priest of neglecting his flock and the priest sadly admits the truth of the charge. The poem was evidently planned and written as a dialogue, unlike the Quatrain poem, which grew out of a series of monologues.

Rieger's[3] attempt to reconstruct the primitive form of the *Doden dantz* was unsuccessful. He considered that there were originally twenty-one characters arranged in three groups: seven clerics, seven nobles, and seven bourgeois. But in order to arrive at this list we have to omit, *inter alia*, the abbot, physician, usurer, citizen, child, the two monks and the friar. It is difficult to conceive of a *Totentanz* which lacked these persons, but included the scribe, the journey-man, and his wife. There is nothing in the verses allotted to the abbot and the physician that suggests that they are interpolations. On the contrary, they have every appearance of being original. It is precisely in these verses that we find parallels to the *Danse ma-cabre*, and one is inclined to think that they are among the oldest parts of the poem.

One of the most striking peculiarities of the *Doten dantz* is to be found in the arrangement of the characters; the clerics and laymen are separated. No other German text of the fifteenth century has

[1] Schröer, in *Germania*, XII (1867), 284-309.
[2] See above, pp. 68-69.
[3] In *Germania* XIX (1874), 257-280.

this feature, although it occurs in later works (Berne, Dresden, Holbein). Unlike the great majority of German representations from the Quatrain poem to Holbein's Dance of Death, the *Doten dantz* has no empress, and the female characters are placed at the end, after the men. These characteristics are shared by the *Grande Danse macabre*. There can be no doubt that the artist had before him a French original because the king has on his banner the fleur-de-lys, and the same emblem decorates the end of the sceptre. It is quite possible that other models were used in addition, and in any case the poet and the illustrator made free adaptations, not slavish imitations. But that Marchant was one of the sources becomes almost a certainty when we compare one of the woodcuts, that of the physician holding his urine glass in his right hand, with the corresponding illustration of the printed *Danse macabre* of 1486. The parallels in the text are numerous and striking.

In another respect the *Doten dantz* is unique among German *Totentänze*: at the end it has the representatives of all the classes that have not been mentioned, under the title 'Von allem stait' (of all stations). Elsewhere this section is only found at La Chaise-Dieu (if we accept this interpretation of the group), in the Spanish poem, and in Carbonell's work. What is still more remarkable is the similarity between the two passages in the *Danza de la muerte* and the *Doten dantz*, more particularly in the verse spoken by Death.

Finally the engravings in the *Doten dantz* are characterized by the number and variety of musical instruments with which the skeletons are provided. One might almost speak of an orchestration of Death. Whether this was a local innovation or introduced from abroad is a question that is undecided.

There is in the University Library of Heidelberg a blockbook[1] which is claimed to be even earlier in date than the *Doten dantz*. It was originally the property of the Elector Palatine Otto Heinrich; in 1623 it found its way to Rome, but was returned by Pope Pius VII. The text is that of the Quatrain poem, with the addition of one new character, the Apothecary. The skeletons resemble those of Marchant's woodcuts, but the drawing is much cruder.

After the commencement of the sixteenth century the printed book with its woodcuts dominates the development of the Dance of Death, but older types do not entirely disappear in Germany. At the end of the sixteenth century the Jesuits in Bavaria produced Dance of Death plays. The traditional texts in verse continued to

[1] Cod. pal. germ. 438, dated 1465 by W. L. Schreiber, *Der Totentanz-blockbuch von etwa 1465*, Leipzig, 1900. For this and other incunabula, see Humphreys, 19-21.

be produced, and in out of the way corners of Bavaria and Swabia, in the districts that remained Catholic, paintings on wood or stone continued to be made, as they did in Switzerland. These are rustic productions and of slight artistic merit, but they are interesting enough to the local historian. Their story has not yet been told.[1] The chief attention of scholars has been paid to the great representations and after Holbein's time it is the further development of his woodcuts that monopolizes the scene.

The Dance of Death is almost unknown in Austria.[2] This is due to the fact that in the late Middle Ages and Renaissance there were few political or cultural links between Austria and France or Germany. Vienna received its artistic impulses rather from Italy than from the north or west at this time. The only Austrian Dance of Death, as far as I am aware, is that of Metnitz in Carinthia.[3] According to the Austrian Central Commission report, it was painted between 1490 and 1500, and ran right round the outer wall of the mortuary in the churchyard, forming a broad frieze. Under the pictures were German verses, now obliterated. The figures were half life-size. As usual, the preacher heads the list. In front of the pulpit a pope, emperor and cardinal sit as congregation. Next come the jaws of hell with the damned and the devil in chains. The procession begins with emperor, empress and king, and ends with the mother and child in the cradle. A second preacher with a small group of women as audience, completes the list. The figures are almost identical with those of the German quatrain poem, as far as they are recognizable: six cannot be identified. The German source of this *Totentanz* is thus evident. The characters stand against a background of mountain scenery. A knight in complete armour is a striking figure. One of the dead has a drum. They form a line, not a procession, since they face the spectator. The pictures have no great artistic value, but have a certain pleasing naïveté.[4]

There is no evidence that the Dance of Death was propagated in Slavonic countries. The one solitary instance in Poland is late in date, and it came into existence after Poland had lost her independence. It is a painting in oils on canvas in the Bernardine monastery of

[1] There are some general indications in Dürrwächter, pp. 11-13; see also the same writer's monograph, *Der Füssener Totentanz und sein Fortleben*, in *Jahrbuch des Historischen Vereins für Schwaben und Neuburg*, 1899.

[2] The so-called Vienna *Totentanz*, mentioned by Douce, pp. 48, 51, and Langlois, I, 229-230, is not a true Dance of Death at all. See Seelmann, p. 41. For a later seventeenth century example at Kukuksbad, in Bohemia, see Ellissen, p. 90.

[3] Seelmann, p. 52.

[4] For Tyrolese examples in wood-carving, see E. C. Williams, p. 246.

Cracow. In the central picture nine women of various classes and nine skeletons are seen dancing round a coffin; in twelve smaller compartments there are pairs of living and dead with Polish verses. The work is said to be based on an etching by Johann Elias Ridinger made in 1795.[1]

[1] Seelmann, p. 63, attributes the etching to Johann Jacob Ridinger, which is a mistake; it was the work of his father. See Ch. le Blanc, *Manuel de l'amateur d'estampes*, Paris, 1854-1888, t. III, p. 334.

VIII

THE ORIGIN AND MEANING OF
THE DANCE OF DEATH

In the sphere of our investigations all roads lead back to Paris, to the cloisters of the Innocents. Whether our starting-point is in England, France, Germany, Switzerland, Denmark, Italy or Spain, we find all the sign-posts pointing in the same direction. Here surely, if anywhere, we must seek the home of the Dance of Death. As far as our present results are concerned, we have found nothing more ancient than the paintings in Paris and the verses that accompanied them. Which of the two came first? Are the pictures illustrations of a poem already written, or are the words an explanation of a work of art? Was the poet or the artist the initiator?

We often find in the Middle Ages that mural paintings are described or explained by Latin inscriptions, called *tituli*, that is 'titles', or 'a written programme'. But it would be difficult to find an instance of a picture inspired by a contemporary poem. A careful study of the Paris *Danse macabre* leads to the conclusion that the pictures came first and that the text, in the form in which we know it, was given to elucidate or amplify their meaning. Naturally this does not exclude the possibility that the poet who expounded the paintings may have known earlier poems on the subject of the inevitability of death, and may have made use of such poems in his stanzas.

The characters are, as is usual in the Middle Ages, made recognizable by their attributes, the pope by his triple crown, the emperor by his sword and globe, and so on. When the artist comes to draw the usurer he gives him a large purse and puts beside him a poor man who is soliciting a loan. These are his characteristic emblems and an illiterate person would at once understand them. However, the poet, not content with writing one stanza for Death and a second for the usurer, adds a third for the poor man, who exclaims: 'This man, who feels the approach of death . . . is lending me at interest even the money which he counts out in my hand.' This is as much as saying: 'Look at this scene, which shows you how inveterate a vice avarice is.' No one would maintain that the poem came first in this case.

Why should Death address two stanzas to the hermit who, with

90

the exception of 'le roy mort', is the last person in the Dance? The illustrations show that the hermit is between two skeletons, each of whom is clutching at him. The introductory words of death: 'You who live will assuredly dance in this manner (ainsi), however much it may be delayed,' and the final comment of the dead king: 'You who see in these figures various estates of men dancing', these and a number of small touches, all point clearly enough to the pre-existence of the pictures.

Were the paintings the oldest phase? Is it possible by some kind of historical reconstruction to go further back? Is there any clue to guide us on our way? There were kings before Agamemnon, was there a Dance of Death before that of the Innocents? The question is highly controversial. Most authorities would, nevertheless, agree that the great Paris *Dance macabre* had its antecedents. It is when we come to the nature of these antecedents that opinions differ and doctors disagree.

There is, however, the indisputable fact that long before 1424 the term *danse macabre* was in use. In, or soon after 1376, the poet Jean Lefèvre wrote in his poem *Le Respit de mort*:

Je fis de Macabre la danse,
Qui tout gent maine a sa trace
E a la fosse les adresse.

Everything hangs on the interpretation of the first line. Some critics, and among them Gaston Paris, took it to mean that Lefèvre wrote a poem on the Dance of Death. Nothing is known of such a poem. What we do know is that Lefèvre wrote *Le Respit de mort* soon after a serious illness. It is, therefore, reasonable to suppose, and many writers share this view, that the poet is referring in this passage to his recent illness, and means that he had a narrow escape from death. Gaston Paris objected that the phrase cannot mean 'to escape death', but only 'to die', and quoted two other mediaeval poets in support of his contention. The whole passage is rather obscure and involved. But poetic licence must be taken into account. Lefèvre may quite well have used an expression that usually and properly meant 'to die' in the sense 'to be at the point of death', 'to suffer the agonies of death', just as St. Paul could say, 'I die daily'. Incidentally this is the earliest example of the word *macabre*. The essential thing is that Jean Lefèvre was familiar with the phrase. He knew that such a thing existed and took it for granted that his readers would understand him, though there is some difference of opinion as to what he himself understood by it.

The second point that might be emphasized is that the three Dance of Death poems written respectively at Paris, Lübeck and

in Spain all have elements in common. It is highly probable, though not absolutely certain, that they had a common origin, which would be older than 1424, the date of the pictures and the poem of the Innocents. The hypothetical source of these three works was in French, but it was not necessarily a didactic poem. It may have been a drama.

There are various references in France and elsewhere to a drama of death. Two of these are sufficiently well known. The oldest runs as follows: 'To Nicaise de Cambray, painter, living in the town of Douai, to help him to defray his expenses in the month of September of the year 1449, in the town of Bruges, where he acted before the aforesaid lord, in his mansion, with his other companions, a certain play, history and morality relating to the fact of the *Danse macabre*, 8 francs.' This passage occurs in the accounts of the Dukes of Burgundy.[1]

Four years later we hear of a performance at Besançon.[2] It is once more an item in an account book that provides the information: 'That the seneschal has to pay to Jean de Calais sacrist of St. Jean, for four gallons of wine, furnished by the said sacrist to those who on the tenth of July last, after the hour of mass, performed the Dance of Death (Chorea Machabæorum) in the church of St. John the Evangelist, on the occasion of the Provincial Chapter of the Friars Minor.' At Besançon the play was produced under ecclesiastical, not under secular auspices, and the entry is in Latin, not in French. The generous allowance of wine suggests a fairly large number of actors.

These references do not take us back beyond the middle of the fifteenth century.[3] If this were all, we should not be entitled to assume that there was a Dance of Death drama before this time. Evidence drawn from English literature is incomplete, but it is important to note that 'Of the half dozen extant English morality plays which can with any plausibility be assigned to the fifteenth century, two are based on a motive akin to that of the Dance of Death.'[4] One of these, the *Pride of Life*, was written early in the fifteenth century; the other, *Everyman*, is of later date.[5] Death also appears in the miracle play cycle which goes under the name of *Ludus Coven-*

[1] Langlois, I, 292.
[2] Carpentier in Ducange, *Glossarium Mediæ et Infimæ Latinitatis*, Paris, 1845, t. IV, p. 158, s.v. *Machabaeorum Chorea*.
[3] The Corpus Christi play at Aix-en-Provence was a little later (1462); see Langlois, p. 298.
[4] E. K. Chambers, *The Mediaeval Stage*, II, 153.
[5] It is interesting to note that there was an *Everyman* in Dutch and French before the English version.

triae: as 'God's messenger' he intervenes with tremendous effect to slay the unsuspecting King Herod in his 'pompe and pryde'. Morality and miracle plays do not necessarily originate in drama; the pictures at St. Paul's or elsewhere may have suggested the death motive. But if, as we have good reason to suppose, the original text of the *Ludus Coventriae* was of the fourteenth century, the figure of Death was seen on the English stage before it became a subject for the painter.

There is a short passage in Mâle's monumental history of French mediaeval art which has scarcely received the attention it deserves. The Abbé Miette, who studied the antiquities of Normandy before the French Revolution, discovered among the archives of the church of Caudebec a brief, all too brief, description of a drama performed in the church in 1393. 'Les acteurs représentaient tous les états depuis le sceptre jusqu'à la houlette. A chaque tour il en sortait un, pour marquer que tout prenait fin, roi comme berger. Cette danse sans doute . . . n'est autre que la fameuse danse macabre.' Two characters only are explicitly mentioned: the king and the shepherd, with their emblems, the sceptre and the crook. Were there no clerics among the *dramatis personae*? Did Death play an active role? To all these and similar questions we seek in vain for a reply. But it is clear that in the late fourteenth century some kind of a play resembling the Dance of Death was actually performed in Normandy.

Nor is this the earliest instance. At the wedding of Alexander III of Scotland to Yolande, the daughter of the Count of Dreux in Champagne, a Dance of Death masque or *tableau vivant* was produced at Jedburgh in 1285. It is recorded in an old Scottish chronicle in the following words: 'When the royal nuptials had been duly solemnized, a strange semblance of a play was acted, by means of a procession among the company of spectators. Those preceded who were skilled in the art, with all kinds of musical instruments, and after them in turn and intermingled were others, performing a military dance in a splendid manner. There followed one, of whom it might almost be doubted whether he was a man or a phantom, since, like a shade, he seemed rather to glide along than to walk on his feet. He vanished, as it were, from the sight of all, and then the whole resplendent procession was silent, the singing died down, the music ceased, and the throng of dancers suddenly and unexpectedly grew rigid. Laughter was mixed with grief, and lamentation took the place of extremes of joy.'[1] The spectators were horror-

[1] *Joannis de Fordun Scottichronicon*, ed. W. Goodall, Edinburgi, 1759 II, p. 128.

struck and regarded the event as a portent. 'Omina sunt aliquid'. These superstitious fears must have seemed well grounded, because five months later the King died suddenly by a fall from his horse. Shortly after, his granddaughter, the Maid of Norway, also perished under tragic circumstances, and these were but the first of a long series of disasters and calamities that befell the Kingdom of Scotland.

The exact nature of the entertainment provided at Jedburgh is not easy to determine, but certain facts emerge from the vague narrative. The Latin word *ludus*, which is used to describe it, is the usual term for 'a play', but it may also be employed in a more general sense. Both in classical and mediaeval Latin it often means any kind of amusement or game. It was evidently a form of diversion to which the Scottish audience was not accustomed. From this circumstance, one concludes that it was brought to Scotland from France by Yolande of Dreux. Furthermore, Death was the chief character. The phrase 'military dance' (choream militarem) suggests that armed men took part and from the words 'resplendent procession' (processio phainatica) we infer that some of the actors wore the regalia of princes or nobles. It was a pageant or a dramatic performance; it was a dance, and a dance of death. There is no mention of the clergy as taking part, nor is it clear whether the pageant was acted in dumb show or accompanied by spoken words.

Enough has been said to establish the fact of a Dance of Death drama and to prove its priority as compared with the pictures. The paintings at the Innocents may have been derived from such a source, but one does not wish to be dogmatic on the point. There are, after all, various other possibilities. Let us deal with them in turn.

One of the alternatives that deserves consideration is that the Dance developed out of an illustrated sermon, an object lesson. In a fifteenth century *exemplum*,[1] or moral tale, we read of a preacher who suddenly pulled out a skull which he had been holding under his cloak, in order to bring his point home to the congregation. When Friar Dietrich Coelde was engaged in putting an end to the deadly feud between the Hoeks and the Kabbeljaus at Amsterdam, he produced two skulls and asked his audience if they recognized to what parties the dead men had belonged.

Many of the picture cycles begin or end with the preacher in his pulpit. There is a distinct suggestion that the Dance is a kind of sermon. In the written versions the same kind of allusion is to be found. 'Often you have preached of Death,' says the Franciscan's

[1] Owst, *Preaching in Mediaeval England*, p. 349.

partner in the Paris *Danse macabre*. Lydgate amplifies this in his translation: 'Sir cordeler, to you my hand is stretched, to lead and convey you to this dance, who in your teaching have full oft taught how that I am most fearful for to dread, albe that folk take thereof no heed.' The Spanish *Danza* gives great prominence to the *predicador*. Is it not conceivable that a friar, or for that matter a secular priest, should have worked out a kind of sermon-drama, in which he called upon members of every class by name, then led them one by one to an erection that resembled a mortuary, or an open grave or a coffin, thus impressing on his hearers the inevitability of death? The dialogue form would strengthen the effect. Each person would bewail his fate, repent his sins, give voice to his emotions in accordance with the circumstances of the case.

We might next consider the theory that the Dance of Death is a further development of the *Legend of the Three Living and the Three Dead*. This hypothesis has been very adequately refuted, but it keeps on cropping up from time to time, like a hardy annual, either as a tentative suggestion or as an unshakable dogma. In her admirable book on Middle Scots Literature, Miss Janet Adam Smith, with commendable caution, draws a parallel between the Dance and the *Legend* without going so far as to derive one from the other. The subject is very complicated and involves many minor technical details, but it might be as well to touch on the main outlines here.

The poem with which we are now concerned originated in France. In the thirteenth century four French poets, Baudouin de Condé, Nicholas de Margival, and two anonymous authors, wrote versions which differ but little in detail. In its earliest phase the story is quite simple. Three corpses meet three living persons, who are terrified at the sight. The dead address the living, who are moved to repentance. The three living are nobles; one is a duke, another a count, the third is the son of a king. The dead relate that the first of them was a pope, the second a cardinal, the third the pope's notary. 'You will be as we are. Wealth, honour, power are of no worth; at the hour of death good works only will avail you.' This speech gives the content of the *Legend*.

The poem by Baudouin de Condé is illustrated by a miniature. The three living have come to an old cemetery beside a field. The dead are standing, as if awaiting them. In this older version the three nobles are on foot. In a later poem, which cannot be traced back beyond the fifteenth century, they are on horseback. In this second phase the story has been considerably amplified; it opens with a prologue spoken by a hermit and ends with a moralizing

epilogue. Thus the Legend appeared in 1486 in Guyot Marchant's edition of the *Danse macabre*.

The hermit begins: 'Open thy eyes, wretched creature; come and see the deeds of outrageous Death.' He has seen in a vision three corpses with decaying flesh on their bones, which he describes very realistically. He is still shaken by what he has seen, and says that those who are wise should think of death, because we shall all be like the dead later. He does not know whether the three apparitions had been in their lifetime kings, dukes, barons, or nobles, whether they had been beautiful or ugly. He only knows that they were once human. The hermit proceeds with his story: from the other direction came three handsome men on horseback; seeing the strange spectacle they were dumbfounded and full of fear. The dead spoke to the living and revealed to them the pain and horror of death: the living were so overwhelmed that they almost fell from their horses. One let loose his dog, and another his falcons.

Then comes the dialogue. The first dead tells the three noblemen that in spite of power, wealth, health and youth, all are subject to death, that it is so painful and bitter that the dead themselves would not wish to face it a second time. After death the bodies of the three nobles will rot in the grave and their souls will be delivered to a worse fate. 'We were once powerful men, and now we are what you see us to be. You will soon be likewise.' We notice, *en passant*, that there is no suggestion that the dead are the doubles of the living. The first dead addresses the three men collectively, and not his own opposite number. In the shorter version we are distinctly told that the dead had been clergymen; the living were laymen.

The second dead says that they will perish sooner than they think. For the sake of brief delight they will lose the joys of paradise and will be damned without reprieve. Life is full of suffering and adversity. Let them seek repose in heaven, for there is none on this earth; let them follow the counsel of the wise and lay up treasures in heaven.

The third dead upbraids the three living as foolish folk and ill-advised. They cover their rotten flesh with gay clothing, they indulge in vain pleasures while their serfs toil for them naked in the fields. The day of reckoning will surely come when they will have no time to do anything but cry for mercy. God is just and will reward everyone according to his deserts. The three noblemen are exhorted to do good now and not to wait till their dear ones do penance for them after their death, for many whom they count as their good friends are really their worst enemies.

The three living answer in turn. The first and second are con-

vinced of the truth of what they have heard, of the inevitability of death, the pangs thereof and the sufferings of the damned in hell. The third takes the initiative in proposing that they should choose the better part, and follow the path of salvation.

The epilogue sums up the message of what has gone before, by stating the two alternatives: the fleeting joys of this world coupled with damnation in the after life, or a little tribulation here and glory hereafter. In order to be certain of salvation a man must leave house and lands, father and mother, and all else, to serve God patiently. Nor is it safe to think that one can find leisure for repentance and sleep peacefully every night on a soft bed. Death will come suddenly with his dart and before one has time to say 'Peccavi', one will die without contrition and subject to divine judgment. The stress laid on leaving the world, and the implication that safety can only be found in conventual life, shows that the author was probably a monk or a friar.

In Marchant's book the story is illustrated by a woodcut. On the left hand side we see the three cavaliers. They have their characteristic emblems: one has his hounds, his companion's falcons are flying away. On the right are the three dead: the first has a scythe and the second a spade. These implements were taken from the illustrations of the *Danse macabre*. Below the three dead is the hermit, sitting outside his cell in a garden. Behind them is the cross at the cross-roads.

It is evident that the *Legend* has some features in common with the Dance of Death. Both have the didactic prologue, the dead who confront the living characters, and the division into classes, though on a very different scale. But in their fundamental idea the two works diverge considerably. The keynote of the *Danse macabre* is, to put it quite simply: 'Sir, join the dance, thy hour has struck,' whereas in the *Dis des trois morts et des trois vifs*, the dominant note is: 'As I am, so thou shalt be. Therefore repent, before it is too late.' In one case it is the immediate impact of death that is depicted, in the other a future contingency is envisaged. Moreover, one of the essential features of the Dance of Death is the procession or dance, of which there is no trace whatever in the *Legend*. This or that text of the *Legend* occasionally provided a detail in some version of the Dance of Death, and *vice versa*. The two works are often portrayed together, as at Paris and Kermaria, but they rest on different conceptions.

It was Peignot and Douce who first drew attention to the Legend *Des trois morts et des trois vifs*. They contented themselves with establishing a parallel between this work and the Dance of Death,

and refrained from dogmatism. Other scholars pursued the theme. Three Frenchmen, Jubinal, Fortoul and Dufour, with varying degrees of emphasis, sought the inspiration or the source of the Dance of Death in the *Legend*. Their arguments were not without influence on Mâle. In 1905 and 1908 two German scholars, P. Kupka and Karl Künstle, asserted that the Dance of Death developed out of the *Legend*.

Künstle was a historian of art, who had a wide knowledge of German mediaeval painting. With the help of copious material he demonstrated the wide popularity of the Legend of the *Three Living and the Three Dead* in France, Germany and Italy. Of the numerous examples in the British Isles he only mentions two mural paintings and a poem by Walter Map. No such poem exists and this error is due to a passage in Douce which Künstle evidently misunderstood. He showed that the *Legend* is sometimes found in conjunction with the Dance of Death in pictorial representations, as at Kermaria and Paris. He maintained that some versions of one work have features in common with some versions of the other.

It is certain that we find here and there in the literary examples of the Dance of Death passages that look like reminiscences of the *Legend*, but it is equally true that in the evolution of the *Legend* the influence of the Dance can be traced. The same thing holds good for the pictures. But in spite of sporadic action and reaction, the two works led a separate existence. We cannot exclude the possibility of a common source for some of the generalities about death that occur in both poems.

In the oldest known example of the Dance of Death, namely that of the Innocents, there were thirty characters. If this is a later development of the *Legend*, in which there were three men only, how is it that no intervening phase has ever been discovered? Künstle was aware of the hiatus in his chain of reasoning and he endeavours to explain it by referring to the frescoes at Clusone. This example has already been described, and it will be remembered that it combines a Triumph of Death, which has a motive borrowed from the *Legend*, and a Dance of Death. Künstle triumphantly concludes: 'The Dance of Death grows out of the Legend' (Der Totentanz wächst aus der Legende heraus).

The argument would be cogent if it could be proved (1) that the Dance of Death originated in Northern Italy: (2) that Clusone antedated the Innocents. Neither Künstle, nor anyone else, has ever made these claims. With regard to the first point he says emphatically: 'We must start out from the pictures, and in fact from that cycle which shows the most ancient form. That is, however, quite

certainly the Dance of Death of Kermaria.' He asserts that the Kermaria example was made in the fourteenth century at the latest. He follows Italian writers in placing the Clusone frescoes in the late fifteenth century (aus dem Ende des 15 Jahrhunderts). At Kermaria we see both the *Danse macabre* and the *Legend*. At Clusone which, according to Künstle, is a century later, 'the Dance of Death grows out of the *Legend*'.

There is a second objection to Künstle's thesis. If the *Legend* is the primitive form of the Dance of Death, how did the dance motive find its way into the *Legend*? None of the various versions of the latter contain anything even remotely connected with music or dancing, and yet these are fundamental characteristics of the Dance of Death. Künstle attempts to overcome this difficulty by surmising (1) that the motives of dancing and playing musical instruments came into the Dance of Death from outside; (2) that at Kermaria the living are not really dancing at all; (3) that Kermaria is the oldest form of the Dance of Death; (4) that the dance and music motives came from South Germany. All this is pure speculation, except for the second point, in which there is some truth.

In the Paris *Danse macabre* the idea of a dance is very fully and frequently expressed, and it must according to Karl Künstle be considered a later product, while the Kermaria example is an earlier type. He gives three reasons for this opinion: (1) the crudeness of the workmanship at Kermaria; (2) the architectural style of the adjacent parts of the church; (3) the absence of seven figures found at Paris. Kermaria is, in his view, the primitive form which was expanded by later additions at the Innocents. But, as I have already endeavoured to show, Breton workmanship is apt to be naïve and rough-hewn. There is no evidence that the choir, as Künstle maintained, is of the fourteenth century: it may be as late as the sixteenth.[1] In any case the dating of a small Breton chapel is a matter of some uncertainty. Régule placed the pictures in the late fifteenth century and this seems a reasonable conclusion.

As regards the third point, I have given elsewhere[2] my reasons for thinking that the canon, merchant, lawyer, physician, parish priest, clerk and hermit were omitted at Kermaria, not added at Paris. What was the motive for the omission? Soleil, who discovered and described the paintings at Kermaria, suggested lack of space. Künstle, who does not appear to have seen the work at all, disagrees. Künstle frankly admits that he has never read Soleil's

[1] For this and other details about Kermaria, I am indebted to M. Grosperrin of Perros-Guirec.

[2] See pp. 30, 32.

book on the *Danse macabre* of Kermaria (Leider ist mir die Schrift nicht zugänglich). But he has read another work by Soleil, which he does not think very much of. This is an argument *ad hominem* rather than *ad rem*. Künstle does not explain one curious circumstance. On the south side of the nave there are nine figures, each with his *mort*: pope, emperor, cardinal, king, patriarch, constable, archbishop, knight, bishop. The same nine characters commenced the *Danse macabre* at Paris; clergyman and layman alternate. Above the north arcade of the nave are eight characters: Carthusian, sergeant, monk, usurer (and poor man), lover, minstrel, labourer. The last four are all laymen. Are we to assume that this is the original list? Why is the regular sequence broken? Did the Paris artist decide to introduce three clerics to fill up the gaps? For at Paris the order was: usurer, physician, lover, advocate, minstrel, parish priest, labourer. The physician and advocate are always reckoned as clergy. Is it not much more reasonable to suppose that the work at the Innocents was the original? At Kermaria the village chapel had much less space than the vast Parisian cemetery. When the south side of the nave and part of the north had been painted, it became obvious that some figures would have to be missed out. The abridgement was done in the clumsy way that characterizes the whole production.

The seven omitted characters all occur in the Spanish *Danza de la muerte*, which Künstle places 'in the beginning of the fifteenth century' (aus dem Anfang des 15 Jahrhunderts). The Spanish poem is a translation or adaptation of 'the same Old French original of the fourteenth century, from which the Lübeck text is derived'. If this is true, it follows that the seven missing characters were also in the 'Old French original', and are therefore older than the *Danse macabre* of the Innocents. What is still more surprising is that Lydgate's poem contains all the seven missing persons. Künstle is quite emphatic as to the antiquity of the English translation: 'The French text appears in the oldest form once in the six stanzas which have been preserved in Kermaria, and then in a translation made soon after 1425 by the monk Lydegate (sic).'

Now, in the first place the Kermaria text is slightly corrupt and inferior to that of Paris. Künstle did not seem to be aware that two Paris manuscripts contain excellent transcripts of the version at the Innocents, otherwise he would not have attached so much importance to Lydgate's translation. In the second place Lydgate adds four new persons, not found either at Paris or Kermaria, namely 'Master John Rikill, Tregetour' (the jester of Henry V, and therefore a historical character), the princess, abbess, and gentlewoman.

His text is therefore inferior to that of the two Paris manuscripts and also to Guyot Marchant's version, quite apart from the fact that Lydgate, as he tells us himself, only attempts a very free rendering. The two manuscripts give us a trustworthy text and confirm the correctness of the printed edition of 1485.

The verses written under the pictures at the Innocents were composed by a poet and scholar of no mean order. A poem which has been attributed to the cultured Gerson could scarcely have come into being in a remote corner of Brittany. The glaring contrast between the polished verse and the barbaric pictures can only be explained in one way: Kermaria is a copy of Paris. The text was fairly well transcribed; the pictures were clumsily imitated by a rustic artist. In a word, most of the assumptions on which Künstle's theory is built up are devoid of foundation.

Another explanation of the origin of the Dance of Death is more plausible, although it cannot be accepted in all its implications. There is a short Latin poem written in France in the late thirteenth or early fourteenth century. This poem has come down to us in two chief versions. The first begins with a prologue which tells of the inevitability of death, and the Fall of man as its cause. Adam brought death into the world; now prince and pauper alike are subject to the same universal fate, the *lex moriendi*. Then follow ten distichs, each spoken by one person, each beginning and ending with the words *Vado mori*, which is the title given by later editors to the whole poem.

In the oldest French text there are only eleven characters: king, pope, bishop, knight, physician, logician, young man, old man, rich man, poor man, fool. They are all on their way to death, and make their complaint as they go. The prelate announces: 'I, a bishop, am about to die; whether I will or no, I must leave my crosier, sandals and mitre.' The knight has been victorious in many a battle, but has not learnt to conquer death. The physician complains: 'I, a physician, am about to die; no physic can save me, whatever the doctor's potion avails, I must die.' The logician has taught others to argue, but death swiftly convicts him of error. The rich man says: 'I, a rich man, am about to die; neither in gold nor abundance of possessions can I take refuge.' The poor man alone finds comfort in the thought that Christ loved the poor. The extreme terseness of the Latin is a pleasant contrast to the verbosity of the average vernacular moralist.

In the second version the number of persons has been increased to twenty-three in one manuscript and more in others; the prologue is missing. The *Vadomori* poem shares with the Dance of

H C.D.D.

Death the division of the characters into classes, with the descending order of precedence. In both works the Church and the State have an approximately equal representation; both have the speeches to Death. But in the *Vadomori* poem Death does not appear at all. There is no reply to the speeches of the doomed; they do not confront their opponent. The introductory passage of the first version, linking up the Fall with man's mortality, reminds us of a corresponding scene at La Chaise-Dieu, Amiens, and Rouen. Holbein's woodcuts also include the Fall, preceded, however, by the Creation.

The Italian *Ballo de la Morte* begins with two lines that may have been taken direct from the *Vadomori*. There is one line in the Paris *Danse macabre* that directly recalls the Latin poem. The usurer says: 'Je vois (i.e. vais) mourir, la mort mavance.' This looks very much like a reminiscence of the phrase *vado mori*. The Latin version of the *Danse macabre* by Pierre Desrey (1490) contains a large part of the *Vadomori* poem interpolated in the Latin translation of the lines inscribed at the Innocents.

Yet, however numerous the connecting links are between the two works, we are hardly justified in saying that the *Vadomori* was the germ out of which the Dance of Death sprang. It is not likely that one poem developed out of the other by slow and gradual transitions. With one possible exception, the intermediate phases do not exist. One *Vadomori* text is in dialogue form.[1] Besides the remarks of the human actors, there are replies, but whether they were spoken by Death, or by some commentator, say a preacher, standing by the characters, is a debatable point. But this is the only example, and it is questionable whether we can consider it as a potential Dance of Death. There is a wide gap between the scanty framework of the *Vadomori* and the elaborate production of the Innocents. So many of the ideas common to both, such as the hierarchial arrangement, and the Death motive, were in the air at the time.

It has been stated from time to time that the Mendicant friars were specially associated with the Dance of Death.[2] Whatever the original form may have been, there is no doubt that, quite early in its evolution, we find it in the hands of the clergy. The didactic tone, the precedence given to the clerics over the laity, the absence of women in the older versions, all alike demonstrate this. That it had a close connection with men whose function it was to preach is proved by the frequent occurrence, both in the pictures and the text, of the preacher and his pulpit. We find him at Paris, La Chaise-Dieu,

[1] Edited by E. P. Hammond, *Latin Texts of the Dance of Death*, pp. 2-3.
[2] E.g. Largajolli, p. 37.

Grossbasel (probably also at Kleinbasel),[1] Berlin, Metnitz, Strasbourg, in the block-books and Quatrain poem. He is more than a mere allegorical figure. When discussing the Paris series, we quoted the passage which related that Friar Richard the famous Franciscan preacher, used as his pulpit a high scaffolding erected in the cemetery of the Innocents, near the place of the *Danse macabre*.

In the Latin version of the Upper German Quatrain poem, the prologue takes the form of a short sermon. Then comes the rubric: 'Also another doctor is depicted preaching on the opposite side concerning the contempt of the world.' This readily recalls to our mind a sentence in the *Little Flowers of St. Francis*: 'Then St. Francis mounted the pulpit and began to preach so wondrously of the contempt of the world.'[2]

The *Danza de la muerte* contains a reference in the Prologue to the 'wise preachers'. Death concludes his introductory harangue by saying:

> If you do not see the friar who preaches this,
> Mark what he says of his great wisdom.

Next comes an address by the preacher, in which the essence of the whole poem is concentrated. In the second speech of Death there is a further mention of the preacher, and once more he is designated as a friar:

> Since the friar has preached to you
> That you should all go to do penance.

Not content with opening the proceedings, the friar actually appears as one of the *dramatis personae*, and in his short speech he points the moral of the whole. Death shows him some deference but cannot refrain from sneering at him. There is a distinct bias against the secular clergy in the poem. The archbishop confesses his unworthiness:

> But I was ever a lover of the world;
> I know well that hell is prepared for me.

The cardinal trembles at the approach of Death and thinks with misgivings of the benefices he has bestowed on his hirelings. The bishop has heaped up treasures on earth and neglected his spiritual duties. His life has been spent in noble palaces, among pomp and ceremony. He is sternly rebuked by Death. With what contemptuous words the abbot is summoned from his useless life: 'Dance, fat abbot with your tonsure.' The nobles are also lashed with the

[1] See Massmann, pp. 61-63.
[2] I quote from the late Professor Okey's translation (Everyman's Library).

whip of satire. Who but a friar, who had nothing to gain and nothing to lose, would have dared to attack wickedness in high places both in church and state, with such astonishing vigour? He spares neither the ecclesiastical hierarchy nor the nobility and does not stop before the Crown itself.

In the *Danse macabre* of the Innocents, the friar is also among the number of the actors in the awe-inspiring drama. Here again, Death is respectful:

> Souvent aves preschie de mort,
> Si vous devez moins merveillier.

The friar, whom both the rubric and the pictures describe as a Franciscan, replies to the effect that life is a vain thing and death comes soon:

> Mendicite point ne massure,
> Des meffais fault paier lamende.
> En petite heure dieu labeure:
> Sage est le pecheur qui samende.

It is curious that both in the Spanish and the French poems, Death and the friar have similar roles and use the same kind of language, except that the friar indulges in generalities, while Death addresses individuals. In other words, Death is the mouthpiece of the friar.

It is assuredly no mere coincidence that many of the mural paintings were to be found in Dominican or Franciscan convents, or in the graveyards attached to them. The Dominican friars of Strasbourg, Basel, Berne, Constance and Landshut, and the Beguines of Klingenthal, all had their Dance of Death. The Minorites were responsible for the representations at Berlin, Hamburg, and Gandersheim, and there are strong reasons for adding to this list Fribourg in Switzerland. In Italy we find a similar connection between the Dance of Death and the friars. The Dominicans seem to have ordered the frescoes at Pisa.[1] The *Ballo della morte* bears the stamp of Franciscan inspiration.

The Augsburg Dance of Death came from a Franciscan convent. The blockbook *Der Doten dantz* was clearly written under Minorite influence, because the good monk is a Franciscan, and the bad one a Dominican. The well-known reference to a drama performed at Besançon in 1453 shows that it was produced at the Provincial Chapter of the Friars Minor. But Künstle is mistaken in thinking that the church of the Innocents at Paris belonged to the Dominicans. Many versions of the Dance of Death are typical Franciscan ser-

[1] André Michel, *Histoire de l'Art*, Paris, 1906, t. II, 2ᵉ partie, p. 898.

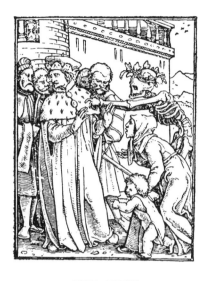

THE DUKE

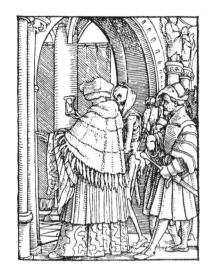

THE CANON

THE MERCHANT

THE CHILD

mons in miniature. They are permeated by love of poverty, charity towards the poor and afflicted, uncompromising hostility to those who oppress and exploit the poor: the usurer, the greedy abbot, the lawyer, the lawless man-at-arms. Vice is ruthlessly laid bare, the most drastic methods are employed to bring obstinate sinners to repentance. It is evident that the Mendicant Orders played a notable part in the diffusion, perhaps also in the creation, of the Dance of Death. But we must not push our conclusions too far. If the Franciscan was well treated at Paris, in the *Danse macabre*, so was the Carthusian. John Lydgate, the translator of the *Dance of Death at St. Paul's*, was a Benedictine monk.

If the friar is the master of cermonies in the *Danza de la muerte*, he is not immune from derisive remarks, and Death is more courteous to the Benedictine monk. Ideas passed so quickly from one order to another that it is not easy to decide who first promulgated them. Violent satire was not by any means confined to the clergy or religious in the Middle Ages.

In the middle of the fifteenth century the friars no longer had the monopoly of the Dance of Death, even if they had had it previously. Other circles had adopted it and modified it to suit their own purposes. It was painted on the walls of parish churches and cathedrals, reproduced in books of devotion. When transplanted into these new surroundings it quickly lost much of its ascetic and didactic character. Satire of the secular clergy would have been strangely out of place in a church; violent attacks on the powers that be would have alienated that particular reading public on which the printers of the time depended for a livelihood.

A visitor to the Innocents saw in the cloisters a long line of paintings in which the whole of human society, from the pope to the humble friar, and from the emperor to the labourer, was portrayed. Each of the living characters was paired off with a partner who was half skeleton and half corpse. We now come to one of the most complicated problems presented by our enigmatic subject. Who are the emissaries from the grave, and what is the significance of their dance with the living? The most obvious solution is that the dance is simply an allegory of death: to join the dance means to die. Is not this implied in the words spoken to the pope: 'Vous qui vivez certainnement Quoy quil tarde ainsi danceres. Mais quant, dieu le scet seulement'? Does not this mean: 'You will dance thus (i.e. die), but God alone knows when'? If we accept this view, the equality of all in death is the theme, with the further conclusion that man must repent before it is too late. The grim companions who invite the living to dance with them, collectively symbolize death.

There is, however, another interpretation which has met with considerable support. It is that the partners are not types, but individuals: they do not signify death in the abstract, but the dead. Whichever theory we adopt, the ultimate message of the *Danse macabre* is the same; the only point at issue is the precise mode of expressing it, whether by a dance of death or a dance of the dead. The importance of this detail is seen when we investigate the origin of the allegory. Those who adhere to the second view lay particular stress on mediaeval superstitions.

They cite the popular belief that at certain times the dead rise from their graves and dance in the churchyard. They lure mortals to join their ranks, and those who do so suffer sickness or death. Goethe once heard a Bohemian folk-tale of this nature; he combined it with a second traditional theme and fashioned his ballad *Totentanz*. In the German blockbooks with woodcuts of the Dance of Death, the skeletons are seen climbing out of their graves, while their companions leap wildly in the air to the music of a ghostly orchestra equipped with various types of wind instruments and drums. It seems natural enough to conclude that old superstitions concerning churchyard revels lived on in the Dance of Death. But the German blockbooks are late in date: the oldest were printed towards the end of the fifteenth century, at a time when the pictorial representations of the *Danse macabre* in France had been in existence for half a century or more. Popular traditions may have left their trace on some versions of the Dance of Death, but they do not help to elucidate the problem of the origin of the *Danse macabre* at Paris, which was completed in 1425.

There are also stories of unseemly dances in the churchyard on the part of the living. The best known of these stories is that of the dancers of Kölbigk, which is recorded in the Nuremberg Chronicle. While a priest was saying mass at Kölbigk in the diocese of Magdeburg on Christmas Eve, a gathering of eighteen men and ten women created a disturbance by singing and dancing in the churchyard. The priest remonstrated with them, but they mocked him and continued their revels. Thereupon the priest prayed to God and to St. Magnus, the patron of the Church, that they might remain dancing for twelve months. At the expiration of this period the Archbishop of Magdeburg put an end to their penance. Three of the dancers died immediately on their release, and the others a short time afterwards. Popular tradition associated this story with St. Vitus' dance.[1]

[1] For the English version of the legend, see Robert of Brunne's *Handlynge Synne*, ed. F. J. Furnivall, London, 1903 (*Early English Text Society*, O.S. 123), Part II, p. 283, n. 2.

Many historians of the Dance of Death, and among them Francis Douce, here as so often the pioneer, Georges Kastner, Heinrich Fehse, and Wolfgang Stammler, have referred to the Kölbigk legend. It is certainly an example of graveyard superstitions, but the strange events recorded are placed in the time of the Emperor Henry II, who reigned from 1002 to 1024. Where is the missing link between the alleged event and the *Danse macabre* which took shape four centuries later? Until more reliable evidence is forthcoming, the churchyard dancers of ribald layfolk are not a fruitful field of enquiry. The revels of the dead in the cemetery are a more plausible, though scarcely a convincing explanation of the Dance of Death.

There is no clear and unambiguous trace of such superstitions in the *Danse macabre*. There is no hint that the pictures were based on a real occurrence, or a supposedly real occurrence; there is no suggestion that the dead actually rise from the grave and dance in visible form. After all, even if they did so, they would hardly be likely to meet the whole ecclesiastical hierarchy from the pope downwards, and all classes of secular society, at one time and in the same place. If, however, the procession of the living has a metaphorical and not a literal sense, if it stands for humanity in the mass, not individual men, why should we take the procession of the dead as a reality, rather than a symbol? Was it not created in an age of symbols?

This line of reasoning is countered by the assertion that the artist and author of the Paris *Danse macabre* had only a vague recollection of the original meaning of the dance. The old idea (dance of the dead) was fading away and is overlaid by the later conception, that it is Death who is depicted. It may be frankly admitted that the poem inscribed at the Innocents is not free from ambiguity. But was not this unavoidable? Did not confusion result from the very nature of the allegory, and in fact, of all allegory?

It has frequently been shown that the allegory in such works as the *Faerie Queen* or *Pilgrim's Progress* inevitably breaks down. It is questionable whether allegory can be consistent under the best of conditions. Let us take a case in point from Bunyan. In his work death is symbolized by the crossing of a river, which is clear and intelligible. Presumably then, Christian cannot die unless and until he reaches the river bank. But he is often threatened by death in the course of his journey to the river and when at a great distance from it. It is surely legitimate to infer that any inconsistency in the text at the Innocents was inherent in the idea itself and was not due to a confusion in the mind of the poet.

The stock argument put forward in favour of the superstition theory is that in the Paris verses the dead are called *le mort*, not *la mort*, 'the dead man', not 'death'. In the *Danse macabre des femmes* we have *la morte*. But we must remember that these words are taken from Marchant's printed edition, not from the original poem. They were just a rubric added by the printer and were not present at the Innocents. Moreover, in the speeches by *les morts*, and in the replies of their victims or prisoners, death is referred to as *la mort*, not as *le mort*. The one solitary exception is in the second verse of the prologue spoken by *L'acteur*, the author: 'Le mort le vif fait avancer.' But this is preceded in the first stanza by the observation: 'Mort nespargne (n'épargne) petit ne grant.' These are two ways of saying the same thing.

On the other hand Death tells the emperor that he carries off everyone: 'Jenmainne tout, cest ma maniere.' Surely it is not an individual that is speaking here, but Death in the abstract. In addition Death summons the sergeant with the words: 'Vous estes de mort appellez.' There is no ambiguity here. Both in the speech addressed to the archbishop and in his reply there is a clear reference to *la mort*. The canon says: 'Or est la mort plus que moy forte Qui tout emmainne, c'est sa guise.' The merchant uses similar words: 'Or ay ie assez; mort me contraint.' The bourgeois is even more explicit. He complains that Death forces him to leave his rents and possessions; all these things 'tu faiz, mort, telle est ta nature.' Here Death is directly addressed in the second person.

Another argument is based on the fact that the dead are dried-up bodies like mummified corpses, rather than skeletons. The inference is that they are the mortal remains of definite individuals and are not types. The true explanation is to be found in the state of anatomical studies in the Middle Ages. We have already had occasion to refer to this matter.[1] Again, much is made of the circumstance that the dead are provided with different emblems, such as a scythe, a spade, or a coffin lid. This, we are told, makes them individuals. At Kermaria some of the dead figures have animal heads. We might point out that Holbein also varies his emblems, but no one has ever suggested that he was not depicting Death.

If the dead are individuals, who are they? We are told that they are the counterparts or doubles of the living. There was an ancient belief that lingered on in France and other countries, that if someone wrote a magic formula in his own blood, he would be able to see himself in a mirror as he would be after death. Does not the 'acteur' in the second stanza of the *Danse macabre* observe: 'En ce

[1] See p. 63.

miroer chascun peut lire'? Does not Guyot Marchant designate his little book as a 'Miroer Salutaire'?

It is quite true that we find this kind of symbolism in the *Legend of the Three Living and the Three Dead*. The illustrations reveal that the three nobles meet their doubles. But it is only in isolated examples of the *Legend* that this occurs. In the great majority of cases there is no such suggestion. In the oldest version of the *Legend* the three living are noblemen and the three dead are prelates. In the second version, as printed by Guyot Marchant, the three dead declare that they had all been powerful men, but if they have already departed this life, they cannot be the image of the three nobles as they will later be. They cannot be the doubles of the living.

The great majority of examples of the Dance of Death yield very little grist that can be taken to this particular mill. The Spanish poem is called *La Danza de la Muerte* and is quite consistent in referring to death as 'La Muerte'. It has been, however, pointed out that in Germany and Switzerland the phrase *Totentanz* has been in use from the earliest times. This can only mean 'Dance of the Dead'. As long as it was held that Germany was the habitat of the Dance of Death the argument carried weight. But when the so-called Minden *Totentanz* was discovered to be no *Totentanz* at all and when the erroneous date of the Klingenthal example had been corrected, the whole thesis fell to the ground, as far as Germany is concerned.

Nor do we find much to support this contention in the *Danse macabre*. We need not attach much importance to the phrase 'Miroer Salutaire'. This meant nothing more than that the book had a salutary moral; it was a poem in which men could see the truth about human life and destiny. Guyot Marchant was a priest of unimpeachable orthodoxy and he was not likely to have countenanced relics of pagan magic and superstition. *Miroir*, or the Latin equivalent *speculum* was a very popular word in the late Middle Ages for any kind of didactic poem.[1] The Franciscans used it repeatedly. In English literature we have, *inter alia*, the *Mirror for Magistrates*.

Admittedly, the emperor in the *Danse macabre* says: 'Armer me fault de pic, de pelle Et dun linseul, ce mest grant painne.' The emperor's partner has a pick and a spade on his shoulder and he wears a shroud. What he (le mort) is now, the emperor will become later, so it is argued. The reasoning is ingenious, but not convincing. The doomed man must exchange the attributes of an emperor for those of Death; in death all are equal and all alike bear pick or spade. To say that he must assume these emblems is equivalent to

[1] For examples in Old French poetry see G. Kastner, p. 21.

saying that he must die. The bishop's partner has a scythe in his hand, the partners of the abbot and the astrologer have a spade. They are all interchangeable.

It cannot be denied that in Marchant's second edition of the *Dance macabre*, the figure who summons the legate to the other world holds in his hand the crosier which is the distinguishing mark of the legate's authority. This has been taken as a proof that 'le mort' is the legate's double. It is more reasonable to suppose that this just indicates that Death deprives the legate of his authority with his life. As a matter of fact this scene proves nothing, because the legate is a later addition. He was absent in the first edition and did not occur in the paintings at the Innocents.

John Lydgate's testimony is of value here. He had seen the pictures at the Innocents shortly after they were painted. He had discussed their meaning with a French clerk (or clerks). He had translated the entire inscription. He wrote the heading over the first speech thus: 'Death first speaketh to the Pope, and after to every degree as followeth.' At the end of the poem we read, 'Death speaketh to the Hermit,' and then: 'Death speaketh to the Hermit again.' There is no dubiety here. It is not the dead, but Death that addresses the living.

In short, this hypothesis is not sufficiently supported by the facts. The speeches of the living are those of separate persons; each speaks in accordance with his station in life, or his temperament, but there is an essential unity in the words spoken to the living. It is Death who claims his victims, not differentiated representatives of the grave who attach themselves to individual people. The multiplicity of the dead is due to the medium used by the artist. In a poem or a drama one character would suffice, but in a painting the same figure has to be repeated in every section or scene, in a printed book on every page. To avoid monotony this figure must be varied. It does not matter whether the emblem given is a scythe, a dart, a coffin lid, or a spade. The meaning is the same. The *Danse macabre* is a dance of death, not a dance of the dead.

So we return to our starting point. The simplest and most obvious explanation is the true one. In the Middle Ages the word 'dance' was often used figuratively. Johann Bischoff, a Viennese Franciscan who wrote about the year 1400, tells us that at Eastertide dancing was very popular among all classes of the people.[1] He proceeds to observe that there are twenty different kinds of dances. 'The first is that in which Christ leads His elect to eternal life, who have kept the Ten Commandments. The second dance is that of the Devil,

[1] *Vienna Nationatbibliothek*, MS. No. 2827, fo. 252 r.

who leads his own to eternal suffering, who have been transgressors of the Ten Commandments.' Unfortunately the friar cuts his story short and omits the other eighteen types of dance. We can scarcely doubt that Death led one of them. Examples of the figurative use of 'dance' might be multiplied. The idea was a commonplace in the late Middle Ages. It is, therefore, unnecessary to postulate the influence of the churchyard superstitions. The dance is a symbol of death, nothing more. Poet and artist alike intended to portray in allegorical form the inevitability of death, and the equality of all men in death. The symbolism used may have been partly suggested by previous poems and pictures, such as the Legend and the *Vadomori* poem. The motive was at first didactic. John Lydgate put it in a nutshell: 'To shew this world is but a pilgrimage.'

APPENDIX A

COMPARATIVE DETAILS OF CHIEF EXAMPLES

I. CHRONOLOGICAL LIST OF PAINTINGS AND SCULPTURES

1424-5 Cemetery of the Innocents, Paris.*
c. 1430 Pardon Churchyard, St. Paul's, London.*
1436 Sainte Chapelle, Dijon.
c. 1440 Klingenthal Convent, Basel.*
1450 Dominican Church, Strasbourg.
c. 1450 Coventry Cathedral (formerly St. Michael's Church).
c. 1450 Rosslyn Chapel, near Edinburgh.
c. 1460 Hungerford Chapel, Salisbury Cathedral.*
1460-1470 (?) Abbey of La Chaise-Dieu, Auvergne.
1460-1470 Marienkirche, Berlin.*
1460-1500 Kermaria Parish Church, Brittany.*
1463 Marienkirche, Lübeck.*
c. 1480 Dominican Cemetery, Basel.*
1480-1500 Church of San Lazzaro, near Como.
c. 1485 Church of the Disciplini, Clusone.
1490-1500 Cemetery of Metnitz, Austria.
c. 1499 Church of San Benedetto, Ferrara.
c. 1500 Hexham Priory.
1508-1520 St. Mary Magdalene's Church, Newark.
1515-1520 Dominican Cemetery, Berne.*
1519 Church of San Stefano, Rendena, South Tyrol.
1520 Palazzo della Ragione, Ferrara.
1525 Anneburg, Saxony.
1527-1529 Cemetery of S. Maclou, Rouen.
c. 1530 Montivilliers Cemetery.
1535 Palace, Dresden.[1]
1543 Bishop's Palace, Chur, Switzerland.[2]
1625-1635 Spreuerbrücke, Lucerne.
1704 Kukuksbad, Bohemia.

Those marked with an asterisk have, or had, an explanatory text.

[1] Eighteenth century verses added later.
[2] Now in the Rhätisches Museum; a mural painting copied from Holbein's engravings.

II. LISTS OF PERSONS

BASEL

Klingenthal Convent (Kleinbasel)

[Preacher] Mortuary; (1) Pope; (2) Emperor; (3) Empress; (4) King; (5) Cardinal; (6) Patriarch; (7) Archbishop; (8) Duke; (9) Bishop; (10) Count; (11) Abbot; (12) Knight; (13) Jurist; (14) Advocate; (15) Canon; (16) Physician; (17) Nobleman; (18) Noblewoman; (19) Merchant; (20) Abbess; (21) Cripple; (22) Hermit; (23) Youth; (24) Usurer; (25) Maiden; (26) Piper; (27) Herold; (28) Mayor (Schulthes); (29) Judge (Blutvogt); (30) Fool; (31) Beguine; (32) Blind man; (33) Jew; (34) Turk; (35) Heathen Woman; (36) Cook; (37) Peasant; (38) Child; (39) Mother; [Preacher?].

Each of the scenes in this series, from No. 1 to No. 39, included the figure of Death, and the accompanying text was a dialogue, but in the above list the human characters only are enumerated. This also applied to the following lists.

Dominican Cemetery (Grossbasel)

Preacher; Mortuary; (1) Pope; (2) Emperor; (3) Empress; (4) King; (5) Queen; (6) Cardinal; (7) Bishop; (8) Duke; (9) Duchess; (10) Count; (11) Abbot; (12) Knight; (13) Jurist; (14) Councillor; (15) Canon; (16) Physician; (17) Nobleman; (18) Noblewoman; (19) Merchant; (20) Abbess; (21) Cripple; (22) Hermit; (23) Youth; (24) Usurer; (25) Maiden; (26) Piper; (27) Herold; (28) Mayor; (29) Judge; (30) Fool; (31) Pedlar; (32) Blind man; (33) Jew; (34) Heathen; (35) Heathen woman; (36) Cook; (37) Peasant; (38) Mother and child; (39) Painter;[1] [Preacher?].

This was the state of affairs when Merian made his engravings. In Büchel's time the last two scenes (38, 39) had been painted over by a representation of the Garden of Eden.

BERLIN

Preacher; Musician with two bagpipes; (1) Sacristan; (2) Chaplain (?); (3) Official (of bishop); (4) Austin Friar; (5) Preacher; (6) Parish Priest; (7) Carthusian; (8) Physician; (9) Monk; (10) Canon; (11) Abbot; (12) Bishop; (13) Cardinal (14) Pope; Crucifixion Scene (15) Emperor; (16) Empress; (17) King; (18) Duke; (19) Knight; (20) Burgomaster; (21) Usurer; (22) Squire; (23) Merchant; (24) Craftsman; (25) Peasant; (26) Innkeeper's wife; (27) Fool; (28) Mother and child.

DANSE MACABRE (edited Marchant, 1485)

Author; (1) Pope; (2) Emperor; (3) Cardinal; (4) King; (5) Patriarch; (6) Constable; (7) Archbishop; (8) Knight; (9) Bishop; (10) Squire;

[1] With two skeletons.

(11) Abbot; (12) Bailiff; (13) Astrologer; (14) Bourgeois; (15) Canon; (16) Merchant; (17) Carthusian; (18) Sergeant; (19) Monk; (20) Usurer; (21) Physician; (22) Lover; (23) Advocate; (24) Minstrel; (25) Parish Priest; (26) Labourer; (27) Franciscan; (28) Infant; (29) Clerk; (30) Hermit; Dead king; Master.

In the second edition (Lyons, 1486) the following were added: (5) Legate; (6) Duke; (19) Schoolmaster with pupil; (20) Man-at-arms; (31) Promoter (prosecutor in ecclesiastical court); (32) Gaoler; (33) Pilgrim; (34) Shepherd; (39) Halbadier; (40) Fool.

DANZA DE LA MUERTE (Spanish Poem)

(1) Pope; (2) Emperor; (3) Cardinal; (4) King; (5) Patriarch; (6) Duke; (7) Archbishop; (8) Constable; (9) Bishop; (10) Knight; (11) Abbot; (12) Squire; (13) Dean; (14) Merchant; (15) Archdeacon; (16) Advocate; (17) Canon (18) Physician; (19) Parish Priest; (20) Labourer; (21) Monk; (22) Usurer; (23) Friar; (24) Royal porter; (25) Hermit; (26) Accountant; (27) Deacon; (28) Messenger; (29) Subdeacon; (30) Sacristan; (31) Rabbi; (32) Arab magistrate (Alfaqui); (33) Custodian of sanctuary (Santero); (34) Those without a name.

DER DOTEN DANTZ MIT FIGUREN (Blockbook)

(1) Pope; (2) Cardinal; (3) Bishop; (4) Abbot; (5) Doctor; (6) Official; (7) Canon; (8) Parish Priest; (9) Chaplain; (10) Good Monk; (11) Bad Monk; (12) Friar; (13) Nun; (14) Physician; (15) Emperor; (16) King; (17) Duke; (18) Count; (19) Knight; (20) Young noble; (21) Squire; (22) Burgomaster; (23) Councillor; (24) Citizen; (25) Advocate; (26) Scribe; (27) Usurer; (28) Robber; (29) Gambler; (30) Thief; (31) Artisan; (32) Landlord of Bingen; (33) Youth; (34) Infant; (35) Citizen's wife; (36) Maiden; (37) Merchant; (38) Of all classes.

This is the order in the blockbook printed by Meydenbach at Mainz, c. 1492. Another blockbook ascribed to Zainer of Ulm, printed about 1488, has the same cuts in a slightly different order.

HANS HOLBEIN. FIRST EDITION. LYONS, 1538

(1) The Creation of all things; (2) Adam and Eve in Paradise; (3) Expulsion of Adam and Eve; (4) Adam tills the soil; (5) Bones of all men; (6) Pope; (7) Emperor; (8) King; (9) Cardinal; (10) Empress; (11) Queen; (12) Bishop; (13) Duke; (14) Abbot; (15) Abbess; (16) Nobleman; (17) Canon; (18) Judge; (19) Advocate; (20) Senator; (21) Preacher; (22) Parish Priest; (23) Monk; (24) Nun; (25) Old woman; (26) Physician; (27) Astrologer; (28) Rich man; (29) Merchant; (30) Seaman; (31) Knight; (32) Count; (33) Old man; (34) Countess; (35) Lady; (36) Duchess; (37) Pedlar; (38) Ploughman; (39) Child; (40) Last Judgment; (41) Escutcheon of Death.

In the first series of proof impressions the Astrologer (No. 27) is missing. In the second series he has been added. There are reasons for

thinking that in the proof impressions the clergy originally came before the laity, as is the case at present in the Basel and Vienna sets.

FIFTH EDITION. LYONS, 1545

Nos. 1 to 39 as above.

(40) Soldier; (41) Gambler; (42) Drunkard; (43) Fool; (44) Robber; (45) Blind man; (46) Waggoner; (47) Sick man; (48) to (51) Putti or boys; (52) Last Judgment; (53) Escutcheon of Death.

In the 1562 Lyons edition the Bride and Bridegroom and three further groups of boys are added.

HOLBEIN'S LITTLE DANCE OF DEATH, OR ALPHABET OF DEATH

A	Bones of all man.	N	Rich man.
B	Pope.	O	Monk.
C	Emperor.	P	Warrior.
D	King.	Q	Nun.
E	Cardinal.	R	Fool.
F	Empress.	S	Courtesan.
G	Queen.	T	Drunkard.
H	Bishop.	V	Knight.
I	Duke.	W	Hermit.
K	Count.	X	Gambler.
L	Canon.	Y	Infant.
M	Physician.	Z	Last Judgment.

According to Anatole de Montaiglon, the characters in the second half of the Alphabet, that is from M onwards, are not arranged in order of precedence, but according to the initial letter of their names in Latin. Thus, M is the physician (*medicus*), N is the banker (*numerarius*), O the fat monk (*obesus monachus*), P the mercenary (*praeliator*). This sounds fairly plausible, but what follows is much less convincing: R (the fool) is *ridens* or *ridiculus fatuus*, T is *tibulans homo*, V is *velox homo*, W (the hermit) is *wetustissimus* (sic) *homo*, X (the Gambler) is *xyphophantes*, Y stands for *ynfans* (that is, *infans*) and Z, the last letter, for the Last Judgment. This is fanciful conjecture, without any solid foundation in fact. We might just as well say that the initials of the German names were intended, O for *Ordensbruder* (monk), T for *Trinker*, W for *Waldbruder* (hermit), and so on.

KERMARIA

South Side of Nave

(1) Pope; (2) Emperor; (3) Cardinal; (4) King; (5) Patriarch; (6) Constable; (7) Archbishop; (8) Knight; (9) Bishop; (10) Missing; (11) Squire; (12) Abbot; (13) Bailiff; (14) Astrologer; (15) Bourgeois.

North Side of Nave

(16) Carthusian; (17) Sergeant; (18) Monk; (19) Usurer and poor man; (20) Lover; (21) Minstrel; (22) Labourer; (23) Franciscan Friar.

There is no trace of: Canon, Merchant, Physician, Advocate, Parish Priest, Clerk, Hermit, Dead King, Preacher.

LA CHAISE-DIEU

According to Langlois, II, 157

(1) Le pape; (2) l'empereur; (3) le cardinal; (4) le roi; (5) le patriarche; (6) le duc; (7) l'évêque; (8) le chevalier; (9) l'écuyer (?); (10) l'homme d'église; (11) le bourgeois, ou le bailli; (12) la chanoinesse; (13) le marchand; (14) la religieuse; (15) le sergent; (16) la vieille; (17) l'amoureux; (18) l'avocat, ou le procureur; (19) le ménetrier; (20) l'avocat; (21) le laboureur; (22) le moine; (23) l'enfant; (24) le clerc.

NOTES

No. (6): Both Paris and Kermaria have the constable here, not the duke. At both these places he is followed by the archbishop, not the bishop.

No. (16): It is doubtful whether this figure really represents a woman. We should expect the physician here, but the figure does not look like a physician. Miss E. C. Williams suggests a lay-brother.

Nos. (18) and (20): It is unlikely that the advocate came twice. Paris has the parish priest after the advocate.

No. (22): This is not the usual place for the monk. At Paris and Kermaria the labourer is followed by the Franciscan friar.

LONDON. ST. PAUL'S

The Translator; Author;

(1) Pope; (2) Emperor; (3) Cardinal; (4) King; (5) Patriarch; (6) Constable; (7) Archbishop; (8) Baron; (9) Princess; (10) Bishop (11) Squire; (12) Abbot; (13) Abbess; (14) Bailiff; (15) Astronomer (addressed 'master'); (16) Burgess; (17) Canon secular; (18) Merchant; (19) Carthusian; (20) Sergeant; (21) Monk; (22) Usurer and poor man; (23) Physician; (24) Amorous squire; (25) Gentlewoman; (26) Man of law; (27) Mr. John Rikill, Tregetour; (28) Person (i.e. parson); (29) Juror (French: advocat); (30) Minstrel; (31) Labourer; (32) Friar Minor; (33) Child; (34) Young clerk; (35) Hermit. King eaten of worms; Machabre the doctour; Translatour.

Nos. 9, 25, 27, 29 were not to be found at the Innocents, and are additions of Lydgate.

Lübeck, Marienkirche

(1) Pope; (2) Emperor; (3) Empress; (4) Cardinal; (5) King; (6) Bishop; (7) Duke (missing since 1799); (8) Abbot; (9) Knight; (10) Carthusian; (11) Nobleman; (12) Canon; (13) Burgomaster; (14) Physician; (15) Usurer; (16) Chaplain; (17) Merchant; (18) Sacristan; (19) Craftsman (Amtmann); (20) Hermit; (21) Peasant; (22) Youth; (23) Maiden; (24) Child in cradle.

This was the original arrangement, but owing to renovation the panels were replaced in the wrong order and Nos. 11-13 were transposed. They therefore ran: (11) Burgomaster; (12) Canon; (13) Nobleman. The original order is retained in the Blockbook of 1489, which adds four additional characters. The Blockbook of 1520 has 30 figures in all. (See Seelmann, pp. 35-36.)

Paris. Cemetery of the Innocents

According to the Epitaphier de Paris:

Acteur; (1) pape; (2) empereur; (3) cardinal; (4) roi, (5) patriarche; (6) connétable; (7) archevêque; (8) chevalier; (9) évêque; (10) écuyer; (11) abbé; (12) bailli; (13) maître (i.e. astrologien); (14) bourgeois; (15) chanoine; (16) marchant; (17) chartreux; (18) sergent; (19) moine; (20) usurier, pauvre homme; (21) médecin; (22) amoureux; (23) avocat; (24) ménestrel; (25) curé; (26) laboureur; (27) cordelier; (28) enfant; (29) clerc; (30) hermite; roi mort; un maître.

See also Danse macabre, above.

Upper German Quatrain Poem

Preacher; (1) Pope; (2) Emperor; (3) Empress; (4) King; (5) Cardinal (6) Patriarch; (7) Archbishop; (8) Duke; (9) Bishop; (10) Count; (11) Abbot; (12) Knight; (13) Jurist; (14) Canon; (15) Physician; (16) Nobleman; (17) Noblewoman; (18) Merchant; (19) Nun; (20) Beggar; (21) Cook; (22) Peasant; (23) Child; (24) Mother; Preacher.

The texts inscribed at Basel were an expanded version of this poem, with additional characters.

APPENDIX B

THE ETYMOLOGY OF MACABRE

For over a century the derivation of *macabre* has exercised the ingenuity of experts and amateurs. A Paris librarian, Van Praet, suggested an Arabic etymology. This was supported by a German scholar Ellissen. There is an Arabic word *maqābir*, meaning 'graves', 'cemetery'. Much that has been written in this connection is irrelevant or uncritical. Thus, the French word *machabé* used in slang to mean 'corpse', looks like a derivative of *Danse macabre*, rather than an old form. There is no evidence to connect the Arabic root with the Paris cemetery. There are said to have been some strange hieroglyphics on one of the portals of Les Innocents, and in the 1486 edition of the *Danse macabre* there is an engraving of a negro blowing a horn. But to connect all these things together is just guess-work and unconvincing.

In the fourteenth and fifteenth centuries *Macabré* existed as a surname in France. Gaston Paris assumed that it was the name of the painter of the *Danse macabre*.[1] Others think that *Macabré* was the name of the poet who wrote the verses at Paris. This was evidently the view of John Lydgate, as of Pierre Desrey, who translated the French verse into Latin in 1490. But the evidence is not adequate to prove this. The third theory is that *Macabre* is derived from *Maccabees*. In support of this theory it has been urged *inter alia*, that in Holland the Dance of Death was known as *Makkabeusdans*. Here again there is a distinct possibility but nothing more. The remaining etymologies: the Low Latin *masca*, a witch, Greek μακάριος blessed, Latin *macresco*, to get thin, *Macarius*, the name of a saint, and so forth, are merely historical curiosities and cannot be taken seriously by anyone who has the slightest acquaintance with philology.

[1] In *Romania*, XXIV (1895), p. 129; see also p. 588. A fuller account of this whole question will be published in the second Fascicule of the *Archivum Linguisticum*, which appears under the auspices of Glasgow University.

BIBLIOGRAPHY

A comprehensive bibliography of the Dance of Death would fill a volume and would of necessity include many books and articles that are compilations of ascertained facts rather than original investigations. This list is selective and is intended to serve a double purpose: that of giving fuller details of works quoted by author or name only, and that of acknowledging my principal indebtedness. Further references will be found in the footnotes.

AMADOR DE LOS RIOS, JOSE. Historia crítica de la literatura española. Madrid, 1863.
AUBERT, O. L. La Chapelle de Kermaria-Nisquit. St. Brieuc. [Without date of publication.]
BAROTTI, CESARE. Pitture e scolture . . . di Ferrara. Ferrara, 1770.
BÉGULE. La Chapelle de Kermaria Nisquit et sa danse macabre. Paris, 1909.
BRUNEREAU, AIMÉ. La Danse macabre de la Chaise-Dieu. La Chaise-Dieu (Haute-Loire), 1923.
BUCHHEIT, GERT. Der Totentanz. Seine Entstehung und Entwicklung. Leipzig, 1926.
BURCKHARDT-WERTHEMANN, DANIEL. Kunstgeschichtliche Basler Sagen und ihr Kern. Basel, 1936. [Festschrift zur Eröffnung des Basler Museums.]
CANÇONER de las obretes en nostra lengua materna mes divulgadas durant los segles XIV, XV e XVI recullit e ordenat per Marian Aguilo y Fuster. Barcelona, 1900. [Text of Catalan Dance of Death.]
CHAMBERLAIN, A. B. Hans Holbein the Younger. London, 1913.
CHATTO, W. A. Treatise on Wood Engraving. London, 1861.
CHRISTOFFEL, ULRICH. Hans Holbein der Jüngere. Berlin, 1926.
CITTADELLA. Notizie relative a Ferrara. Ferrara, 1864.
——Documenti risg. la storia artistica ferrarese. Ferrara, 1868.
DANCE OF DEATH. Ed. Henry Green. London, 1869. [The Holbein Society Reprints, Vol. I.]
DANSE MACABRE. La Grande Danse Macabre des hommes et des femmes, etc. Paris (no date, but after 1862). [Text of the first edition of 1486.]
——La grant danse Macabre des hommes et des femmes, etc. Paris, 1700.
——La Danse Macabré des Charniers des Saints Innocents. Ed. Edward F. Chaney. Manchester, 1945.
DANZA GENERAL. Ed. Carl Appel. Festschrift. Breslau, 1927.
DÖRING-HIRSCH, E. Tod und Jenseits im Spätmittelalter. Berlin, 1927
DOTEN DANTZ MIT FIGUREN. Clage und Antwort schon von allen staten der welt. Ed. Albert Schramm. Leipzig, 1922. [Facsimile edition.]

DOUCE, FRANCIS. The Dance of Death, painted by J. Holbein, and engraved by W. Hollar. (Without date or name of author.) London, 1794(?).
——The Dance of Death Exhibited in Elegant Engravings on Wood, etc. London, 1833. [Reprinted in 1858. References in the present work are to the 1833 edition.]

DUFOUR, VALENTIN. Recherches sur la Dance Macabre peinte en 1425 au cimetière des Innocents. Paris, 1873.
——La Dance macabre des SS. Innocents de Paris. Paris, 1874. [Text of poem and reproductions of first edition.]

DÜRRWÄCHTER, ANTON. Die Totentanzforschung. Kempten und München, 1914.

EMBLEMS OF MORTALITY; representing in upwards of fifty cuts, Death seizing all ranks and degrees of people, etc. to which is prefixed a copious preface. London, 1789. [By J. D. Hawkins.]

FEHSE, WILHELM. Der Ursprung der Totentänze. Halle, 1907.
——Der oberdeutsche vierzeilige Totentanztext, in Zeitschrift für deutsche Philologie, 40 (1908), 67-92. [Latin and German text of Quatrain poem.]
——Das Totentanzproblem, loc. cit., 42 (1910), 261-286.

FIORILLO, J. D. Geschichte der zeichnenden Künste in Deutschland und den Niederlanden, Band IV, 119-174. Hannover, 1820.

FORTOUL, M. H. Etudes d'archéologie. Paris, 1854.

GANZ, PAUL. Holbein. Stuttgart und Berlin, 1919.
——Handzeichnungen von Hans Holbein dem Jüngeren, Berlin, 1926.

GOETTE, ALEXANDER. Holbeins Totentanz und seine Vorbilder. Strassburg, 1897.

HAMMOND, ELEANOR P. Latin Texts of the Dance of Death, in Modern Philology, Vol. 8 (1911), 399-410. [Vadomori poem.]
——English Verse between Chaucer and Surrey. London, 1927. Pp. 124-142, 418-435. [Editions of Lydgate's Dance of Death and the French original, with copious notes.]

HAWKINS, J. D. See Emblems of Mortality.

HEYSE, CARL GEORG. Der Lübecker Totentanz von 1463. Berlin, 1937. [Zeitschrift des deutschen Vereins für Kunstwissenschaft, Band 4, Heft 4.]

H. HOLBEINS INITIAL-BUCHSTABEN MIT DEM TODTENTANZ. Nach Hans Lützelburgers Original-Holzschnitten im Dresdner Kabinet zum ersten Mal treu copirt von Heinrich Loedel. Mit erläuternden Denkversen und einer geschichtlichen Abhandlung über die Todtentänze von Dr. Adolf Ellissen. Göttingen, 1849.

HILSCHER, PAUL CHRISTIAN. Beschreibung des Todten-Tanzes an H. Georgens Schlosse in Dresden. Leipzig, 1705.
——Beschreibung des sogenannten Todten-Tanzes, wie selber in Dresden an Herzog Georgens Schlosse als ein kurioses Denkmal menschlicher Sterblichkeit zu finden. Dresden, 1718.

HODGES, CHARLES CLEMENT. The Abbey of St Andrews, Hexham. Hexham, 1888.

HUIZINGA, J. The Waning of the Middle Ages. London, 1924. [English Translation.]

HUMPHREYS, H. E. Hans Holbein's Dance of Death. London, 1868.

BIBLIOGRAPHY 123

JACOBI, J. G. SCHULTZ. De Nederlandsche Doodendans. Utrecht, 1849.

JUBINAL, ACHILLE. Explication de la danse des morts de la Chaise-Dieu, fresque inédite du XVe siècle, etc. Paris, 1841.

——Danse des morts. Roll. [British Museum.]

KASTNER, GEORGES. Les Danses des Morts. Paris, 1852.

KEYSER, C. E. A List of Buildings in Great Britain and Ireland having mural and other painted decorations etc. (Science and Art Department of the Committee of Council on Education, South Kensington Museum), London, 1883.

KÜNSTLE, KARL. Die Legende der drei Lebenden und der drei Toten und der Totentanz. Freiburg im Breisgau, 1910.

KURTZ, LEONARD P. The Dance of Death and the Macabre Spirit in European Literature. [Publications of the Institute of French Studies, Inc., Columbia University] New York, 1934.

LANGLOIS, E. H., A. POITTIER, ALFRED BAUDRY. Essai historique philosophique et pittoresque sur les Danses des Morts, suivi d'une lettre de M. C. Leber et d'une note de M. Depping sur le même sujet. Rouen, 1851.

LARGAJOLLI, DIONIGI. Una Danza dei Morte del secolo XVI nelli alto Trentino. Trento. 1886. (Offprint from Archivo Trentino, Anno V, fascicolo 11.)

LIPPMANN, F. The Dance of Death by Hans Holbein. London, 1886.

MÂLE, ÉMILE. L'Art religieux de la fin du moyen áge en France. Paris, 1908. [Passage relative to Dance of Death also in Revue des deux Mondes, t. 32, pp. 647-679.]

MANTELS, WILHELM. Zwiegespräch zwischen dem Leben und dem Tode, in Jahrbuch des Vereins für niederdeutsche Sprachforschung, Jahrgang 1874, 54-56, Jahrgang 1876, 131-133.

MASSMANN, H. F. Die Baseler Todtentänze. Stuttgart, 1847. [With an Atlas, containing reproductions of the two series at Basel, after Büchel, and of the 1465 Blockbook.]

——Ausführliche Beschreibung und Abbildung des Todtentanzes in der St. Marienkirche zu Lübeck. Lübeck, 1863. [Both High and Low German texts are given, with illustrations in colour.]

MERIAN, MATTHIEU. Todten-tanz, wie derselbe in der löblichen und weitberühmten Stadt Basel, als ein Spiegel menschlicher Beschaffenheit gantz künstlich gemahlet und zu sehen ist. Frankfurt, 1696. [Engravings of paintings at Grossbasel.]

MONTAIGLON, ANATOLE DE. The Celebrated Hans Holbein's Alphabet of Death. Paris, 1856.

MORRIS, J. E. Northumberland. London, 1933.

PEIGNOT, GABRIEL. Recherches historiques et littéraires sur les danses des morts, etc. Dijon, 1836.

PELLEGRINI, ASTORRE. Nuove illustrazioni del Trionfo o Danza della Morte a Clusone. Bergamo, 1878.

POEMAS CASTELLANOS ANTERIORES al siglo XV. Ed. Tomas Antonio Sanchez, Pedro Jose Pidal, Florencio Janer. Madrid, 1864. [Text of Spanish Dance of Death.]

POINSIGNON, A. Der Totentanz in der St. Michaelskapelle auf dem alten Friedhof zu Frieburg im Breisgau. Freiburg i.B., 1891.

POOLE, BENJAMIN. Coventry. Its History and Antiquities. London, 1870.

PRÜFER, THEODOR. Der Todtentanz in der Marien-Kirche zu Berlin. Berlin, 1873.

ROUS, FRANCIS PEYTON. The Modern Dance of Death. [Linacre Lecture.] Cambridge, 1929.

SCHMID, HEINRICH ALFRED. Hans Holbein der Jüngere. Sein Aufstieg zur Meisterschaft und sein englischer Stil. Basel, 1945-47. [3 vols.]

SCHREIBER, W. L. Die Totentänze, in Zeitschrift für Bücherfreunde II (1898-99), 341.

SCHRÖER, K. J. Totentanzsprüche, in Germania, XII (1867), 284-309.

SEELMANN, WILHELM. Die Totentänze des Mittelalters. Norden und Leipzig, 1893.

SILVESTRE, GARCIA. Historia Sumaria de la Literatura Catalana. 1932.

SOLEIL, FÉLIX. La Danse macabre de Kermaria-en-Isquit. Saint-Brieuc, 1882.

SPRENGER, R. Der Berliner Totentanz, in Jahrbuch des Vereins für niederdeutsche Sprachforschung, Jahrgang 1878, 105-106.

STAMMLER, WOLFGANG. Die Totentänze. Leipzig, 1922. [Bibliothek der Kunstgeschichte, Band 47.]
——Totentänze des Mittelalters. München, 1922. [Einzelschriften zur Bücher- und Handschriftenkunde, Band IV.]
——Der Totentanz. Entstehung und Deutung. München, 1948.

STEGEMEIER, HENRI. The Dance of Death in Folk-song. Chicago, 1939.

STEIN, WILHELM. Holbein. Berlin, 1929.

STORCK, WILLY F. Das 'Vado mori', in Zeitschrift für deutsche Philologie, 42 (1910), 422-428.

TICKNOR, GEORGE. History of Spanish Literature. London, 1849. [Text of Spanish Dance of Death.]

TODTENTANZ, DER. Gemälde auf der Mühlenbrücke in Luzern. Luzern, 1889.
——Gemälde auf der Mühlenbrücke in Lucern. Getreu nach den Originalien lithographiert und herausgegeben von Gebr. Eglin. Luzern, 1867. [With a lengthy and useful introduction by J. Schneller.]

TOTENTANZ, DER. Blockbuch von etwa 1465, etc. Mit einer Einleitung von W. L. Schreiber. Leipzig, 1900. [Facsimile of Heidelberg Blockbook.]
——in der Marienkirche zu Lübeck. Nach einer Zeichnung von C. J. Milde. Lübeck, 1868.

VALLARDI, GIUSEPPE. Trionfo e Danze della Morte o danza macabra a Clusone, Dogma della morte a Pisogne, con osservazioni storiche ed artistiche. Milano, 1859.

VIGO, PIETRO. Le Danze macabre in Italia. Bergamo, 1901. 2nd. edition. [General account of the Dance of Death in Italy in art and literature.]

WACKERNAGEL, WILHELM. Der Totentanz. [Kleinere Schriften, I, 302-375.] Leipzig, 1872.

WAETZOLDT, WILHELM. Hans Holbein der Jüngere. Werk und Welt. Berlin, 1938.

WARREN, FLORENCE AND WHITE, BEATRICE. The Dance of Death edited from MSS. Ellesmere 26/A.13 and B.M. Lansdowne 699. Early English

Text Society, 181. London, 1931. [Text of Lydgate's translation and of the Danse macabre from a London MS.]

WARTHIN, A. S. The Physician of the Dance of Death. New York, 1931.

WEBER, F. P. Aspects of Death and Correlated Aspects of Life in Art, Epigram and Poetry. London, 1922.

WEIGEL, T. O., ZESTERMANN, AD. Die Anfänge der Buchdruckerkunst in Bild und Schrift. Leipzig, 1866. [Reproduction and explanation of Lübeck Blockbook of 1498.]

WOLF, FERDINAND. Ein spanisches Frohnleichnamsspiel vom Todtentanz. Wien, 1852.

WOLTMANN, ALFRED. Holbein und seine Zeit. Leipzig, 1874-76.

WILLIAMS, ETHEL CARLTON. The Dance of Death in Painting and Sculpture in the Middle Ages, in Journal of the British Archaeological Association, 3rd Series, I (1937), pp. 229-257. [A very useful survey, including Holbein and later examples.]

WORNUM, R. N. Some Account of the Life and Works of Hans Holbein. London, 1867. [Contains much material, but to be used with caution, as it is largely out-of-date.]

ZARDETTI, C. Danza della morte dipinta a fresco sulla facciata della chiesa di San Lazzaro fuori di Como. Milano, 1845.

INDEX

HOW THE ANCIENTS
REPRESENTED DEATH

G[otthold] E. Lessing

INTRODUCTION.

THE indisputable fact that nearly all Lessing's works owe
their existence to some personal impetus has gained him
the undesirable reputation of being a kind of philosophical
Ishmaelite. But this is not absolutely the case. Lessing
did not attack his contemporaries for the pure pleasure of
aggression, but because as Heine so well expresses it " he
was the living critique of his period." Polemics were
his delight in so far as he hoped to rectify what was
erroneous and hence when he saw himself or others
unjustly attacked, he at once flew to his pen. But it
was not fighting for fighting's sake, but for the sake of
what he held to be the truth. After the publication of the
'Laokoon,' a certain Klotz, Professor of the University of
Halle, published a very unwarrantable attack upon its
accuracy and scholarship, and among other matters, he
accused Lessing of having been guilty of "an unpardon-
able fault." Such an accusation from such a quarter
highly exasperated Lessing, who was moreover in an
irritable state at the time, owing to the failure of his
scheme with the Hamburg theatre. This induced him
to write his 'Antiquarian Letters,' which were true
polemics, but it also led him to write his little essay
'How the Ancients represented Death,' which he was

very desirous should not be confounded with the circumstances that gave it birth, though it had also been prompted by a remark of Klotz's. Klotz had averred, in reply to Lessing's assertion in a note of the 'Laokoon' that the ancients never represented death as a skeleton, that they constantly thus represented it and referred to figures of skeletons found on gems and reliefs. Klotz had here confounded two distinct ideas, and Lessing, attracted by the theme, wrote this short essay to prove his theory. The result was that his idea of the genius with a reversed torch as a personification of death was eagerly accepted by his contemporaries, who were glad to banish the grinning skeleton of Christian and mediæval art. Goethe in 'Wahrheit und Dichtung' expresses the joy with which the essay was greeted. A few archæologists differed from Lessing in his interpretation of Pausanias, concerning the crossing of the feet, among them Heyne suggested that " bent outwardly " may be intended in lieu of "crossed," but agreed with Lessing that "crooked" could never have been meant. Such philological niceties do not detract from the excellence of the whole, and this little investigation has become a classic among Lessing's works, praised even by Goeze in the very midst of their bitter feud.

HOW THE ANCIENTS REPRESENTED DEATH.

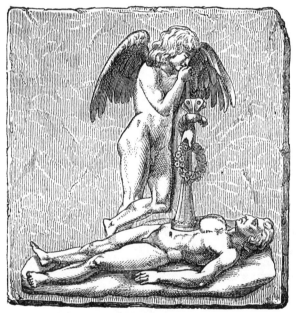

Part of a SARCOPHAGUS. (From Bellori, see p. 183.)
"Nullique ea tristis imago." [1]—STATIUS.

PREFACE.

I SHOULD be sorry if this disquisition were to be estimated according to the circumstance that gave it occasion. This is so despicable, that only the manner in which I have used it can excuse me for having used it at all.

[1] Theb. 10, 105: " And to none does this shape seem sorrowful."

Not indeed that I do not consider our present public to be too delicately averse to all that is called polemics, or resembles it. It seems as though it wished to forget that it owes the elucidation of many an important point to mere contradiction, and that mankind would be of one mind on no subject in the world if they had as yet never wrangled about anything.

"Wrangled," for so politeness names all discussion. Wrangling has become something so unmannerly that we must be less ashamed of hatred and calumny than of controversy.

If however the greater part of the public, which will not hear of controversial writings, consisted of authors, then it might perhaps be something else than mere politeness that was intolerant of a polemical tone. It is so displeasing to egotism and self-conceit! It is so dangerous to the sur-reptitious reputation!

And truth, they say, so rarely gains thereby.—So rarely? Granted that as yet truth has been established through no contest; yet nevertheless truth has gained by every controversy. Controversies have stimulated the spirit of investigation, have kept prejudice and authority in constant convulsion; in brief, have hindered gilded untruth from taking root in the place of truth.

Neither can I share the opinion that controversies are only demanded by the most important truths. Importance is a relative idea, and what is very unimportant in one respect may become very important in another. As a constituent of our cognition one truth is therefore as important as another; and whoever is indifferent in the most trifling matter to truth and untruth, will never persuade me that he loves truth merely for the sake of truth.

I will not impose my way of thinking concerning this matter on any one. But I may at least beg him who differs from me most widely, if he intends to speak publicly of this investigation, to forget that it is aimed at any one. Let him enter upon the subject and keep silence concerning the personages. To which of these the art critic is most inclined, which he holds in general to be the best writer, nobody demands to know from him. All that is desired to learn from him is this, whether he, on his part,

has aught to place in the scale of the one or the other
which in the present instance would turn, or further
weight the scales. Only such extra weight, frankly
accorded, makes him that which he wishes to be; but he
must not fancy that his mere bold enunciation would be
such an extra weight. If he be the man who overtops
us both, let him seize the opportunity to instruct us
both.

Of the irregularity which he will soon perceive in
my work, he may say what likes him best. If only he
does not let the subject be prejudiced thereby. I might
certainly have set to work more systematically; I might
have placed my reasons in a more advantageous light; I
might still have used this or that rare or precious book;
indeed what might I not have done!

It is moreover only on long-known monuments of
ancient art on which I have been enabled to lay the
foundations of my investigation. Treasures of this kind
are daily brought to light, and I myself should wish to be
among those who can first satiate their thirst for know-
ledge. But it would be singular if only he should be
deemed rich who possesses the most newly minted money.
It is rather the part of prudence not to have too much to
do with this before its true value has been established
beyond question.

The antiquarian who, to prove a new assertion, refers us
to an ancient work of art that only he knows, that he has
first discovered, may be a very honest man, and it would
be sad for research if this were not the case with seven-
eighths of the confraternity. But he, who grounds his
assertion only on that which a Boissard or Pighius has
seen a hundred or more years before him, can positively
be no cheat, and to discover something new in the old, is
at least as laudable, as to confirm the old through the
new.

GEM. (From Licetus, see p. 200.)

THE CAUSE.

HERR KLOTZ always thinks he is at my heels. But always when I turn to look after him at his call, I see him wandering in a cloud of dust, quite at one side on a road that I have never trodden. "Herr Lessing," so runs his latest call of this nature,[1] "will permit me to assign to his assertion that the ancient artists did not represent death as a skeleton ('Laokoon,' ch. xi. note,) the same value as to his two other propositions, that the ancients never represented a fury, or a hovering figure without wings. He cannot even persuade himself that the recumbent bronze skeleton which rests with one arm on a cinerary urn in the Ducal Gallery at Florence, is a real antique. Perhaps he would be more easily persuaded, if he looked at the engraved gems on which a complete skeleton is portrayed (see Buonarotti, 'Oss. sopr. alc. Vetri,' t. xxxviii. 3, and Lippert's 'Daktyliothek,' 2nd 1000, n. 998). In the Museum Florentinum this skeleton to which an old man

[1] In the preface to the second part of Caylus's treatises. [For the controverted statements in 'Laokoon,' see above, pp. 15 *note* and 51 *note* 1, 65 *note* 3, and especially 73, *note* 1.]

in a sitting attitude is playing something on the flute is likewise to be seen on a gem. (See 'Les Satires de Perse, par Sinner,' p. 30.) But engraved stones belong to allegory, Herr Lessing will say. Well then I refer him to the metallic skeleton in the Kircherian Museum (see 'Ficoroni Gemmas antiq. rarior.' t. viii.). If he is not yet satisfied, I will over and above remind him that Herr Winckelmann, in his 'Essay on Allegory,' p. 81, has already taken notice of two ancient marble urns in Rome on which skeletons stand. If my numerous examples are not tedious to Herr Lessing, I will still add ' Sponii Miscell. Antiq. Erud.' sect. i. art. III., especially No. 5. And since I have once taken the liberty to note some things against him, I must refer him to the splendid collection of painted vases possessed by Mr. Hamilton, to show him another fury on a vase (Collection of Etruscan, Grecian, and Roman antiquities from the cabinet of the Hon. Wm. Hamilton, No. 6)."

It is, by Heaven, a great liberty, forsooth, to contradict me! And whoever contradicts me must I suppose be very careful whether he is tedious to me or no!

Unquestionably a contradiction such as Herr Klotz charges me with, is enough at any rate, to put the coolest, calmest man out of temper. If I say " it is not yet night," then Herr Klotz says, " but it is long past noon." If I say "seven and seven do not make fifteen," then he says, " but seven and eight do make fifteen." And this is what he calls contradicting me, confuting me, convicting me of unpardonable errors.

I beg of him for one moment to have rather more recourse to his understanding than to his memory.

I have asserted that the ancient artists did not repro sent Death as a skeleton, and I assert it still. But is to say that the ancient artists did not represent Death as a skeleton the same thing as saying that they never represented a skeleton at all? Is there absolutely no difference between these two sentences, so that he who proves the one must needs prove the other? that he who denies the one must needs deny the other?

Here is an engraved gem, and a marble urn, and there a brazen image; all are undoubtedly antique, and all

represent a skeleton. Very good. Who does not know this?
Who can help knowing this if there is nothing amiss with
his fingers and eyes, as soon as he wishes to know it?
Must antique works of art be always construed alle-
gorically?

These antique works of art represent skeletons; but do
these skeletons represent Death? Must a skeleton of neces-
sity represent Death, the personified abstraction of Death,
the deity of Death? Why should not a skeleton simply
represent a skeleton? Why not even something else?

INQUIRY.

HERR KLOTZ'S acumen goes far! I need not answer him
more, but yet I will do more than I need. Since some
other scholars more or less share Herr Klotz's perverse
idea, I will establish two things for their benefit.

Firstly: that the ancient artists really represented Death,
the deity of Death, under quite another image than that
of a skeleton.

Secondly: that the ancient artists, when they repre-
sented a skeleton, meant by this skeleton something quite
different from Death as the deity of Death.

I. The ancient artists did not portray Death as a skeleton,
for they portrayed him according to the Homeric idea,[1]
as the twin brother of Sleep, and represented both Death
and Sleep, with that likeness between them which we
naturally expect in twins. On a chest of cedarwood in
the temple of Juno at Elis, they both rested as boys in
the arms of Night. Only the one was white, the other
black; the one slept, the other seemed to sleep; both with
their feet crossed.[2]

Here I will invoke a principle to which, probably, very
few exceptions will be found, namely this, that the ancients
faithfully retained the sensuous representation which had
once been given to an ideal being. For even though such
representations are arbitrary, and every one has an equal
right to conceive them thus or thus, yet the ancients held

[1] Il. xvi. 681, 2. [2] Pausanias, Eliac. cap. xviii. p. 422.

it good and needful that the late comers should waive this right and follow the first inventor. The cause is clear: without this general uniformity no general recognition is possible.

Consequently this resemblance of Death to Sleep, once accepted by the Greek artists, will, according to all likelihood, have been always observed by them. It showed itself indubitably on the statues which these two beings had at Lacedæmon, for they reminded Pausanias[3] of Homer's representation of them as brothers.

Now what most distant resemblance with Sleep can be conceived, if Death stood beside him as a mere skeleton?

"Perhaps," writes Winckelmann,[4] "Death was thus portrayed by the inhabitants of Gades, the modern Cadiz, who among all peoples were the only one who worshipped Death."

Now Winckelmann had not the faintest reason for this "perhaps." Philostratus[5] only says of the Gaditani "that they were the only people who sang pæans to Death." He does not even name a statue, not to mention that he gives us no reason whatever to presume that this statue represented a skeleton. Finally, what has the representation of the Gaditani to do with the matter? It is a question of the symbolical pictures of the Greeks, not of those of the barbarians.

I observe, by the way, that I cannot concur with Winckelmann in rendering the words of Philostratus, τὸν θάνατον μόνοι ἀνθρώπων παιανίζονται, as "the Gaditani were among all peoples the only one who worshipped Death." *Worshipped* says too little for the Gaditani, and denies too much of the other peoples. Even among the Greeks Death was not wholly unreverenced. The peculiarity of the Gaditani was only this, that they held the deity of Death to be accessible to entreaty, that they believed that they could by sacrifices and pæans mollify his rigour and delay his decrees. For pæans mean in their special sense, songs sung to a deity to avert some evil. Philostratus seems to refer to the passage in Æschylus, where it is

[3] Laconic. cap. xix. p. 253. [4] Allego. p. 83.
[5] Vita Apoll. lib. v. c. 4.

said of Death, that he is the only one among the gods who regards no gifts and hence has no altars, to whom no pæans are sung :

$$\text{Οὐδ' ἔστι βωμὸς, οὐδὲ παιωνίζεται.}$$

Winckelmann himself mentions in his 'Essay on Allegory' regarding Sleep,[6] that on a gravestone in the Palazzo Albani, Sleep is represented as a young genius resting on a reversed torch, beside his brother Death, "and just so represented these two genii may be found on a cinerary urn in the Collegio Clementino in Rome." I wish he had recollected this representation when dealing with Death itself. Then we should not miss the only genuine and general representation of Death where he furnishes us only with various allegories of various modes of dying.

We might also wish that Winckelmann had described the two monuments somewhat more precisely. But he says very little about them, and this little is not as definite as it might be. Sleep leans upon a reversed torch ; but does Death do so too? and exactly in the same way? Is there not any distinction between both genii? and what is it? I do not know that these monuments have been much known elsewhere where one might find an answer for oneself.

However they are, happily, not unique of their kind. Winckelmann did not notice anything on them that was not noticeable on others that had been known long before him. He saw a young genius with a reversed torch and the distinct superscription *Somno ;* but on a gravestone in Boissard[7] we see the same figure, and the inscription *Somno Orestilia Filia* leaves us as little in doubt as to its meaning. It often occurs in the same place without inscription, indeed on more than one gravestone and sarcophagus it occurs in duplicate.[8] Now what in this exactly similar duplication can the other more fitly be than the twin-brother of Sleep, Death, if the one be a picture of Sleep?

It is surprising that archæologists should not know this, or if they knew it should forget to apply it in

[6] p. 76. [7] Topograph. parte iii. p. 48. [8] Parte v. pp. 22, 23.

their expositions. I will only give a few examples of this.

Before all others I remember the marble sarcophagus which Bellori made known in his 'Admiranda,'[9] and has explained as relating to the last fate of man. Here is shown among other things a winged youth who stands in a pensive attitude beside a corpse, his left foot crossing his right, his right hand and his head resting on a reversed torch supported on the breast of the corpse, and in his left hand which grasps the torch, he holds a wreath with a butterfly.[10] This figure, says Bellori, is Amor, who is extinguishing the torch, that is to say the affections, on the breast of the dead man. And I say, this figure is Death.

Not every winged boy or youth need be an Amor. Amor and the swarm of his brothers had this formation in common with various spiritual beings. How many of the race of genii were represented as boys?[11] And what had not its genius? Every place, every man, every social connexion of mankind, every occupation of men from the lowest to the highest,[12] yes I might say, every inanimate thing, whose preservation was of consequence, had its genius. If this had not been a wholly unknown matter, to Herr Klotz among others also, he would surely not have spared us the greater part of his sugary story of Amor on engraved gems.[13] With the most attentive fingers this great scholar searched for this pretty little god through all engraved books, and wherever he only saw a little naked boy, there he cried: Amor! Amor! and registered him quickly in his catalogue. I wish him much patience who will scrutinize these Klotzian Amors. At each moment he will have to eject one from the ranks. But of this elsewhere.

Enough that not every winged boy or youth must necessarily be an Amor; for then this one on the monument of Bellori need least of all be so.

And absolutely cannot so be! For no allegorical figure

[9] Tab. lxxix. [10] [See illustration, p. 175.]
[11] Barthius ad Kutilii lib. i. v. 327, p. 121. [12] Ibid. p. 128.
[13] Über den Nutzen und Gebr. der alt. geschnitt. St. pp. 194-224.

may be contradictory to itself. This however an Amor
would be whose work it is to extinguish the affections
in the breast of man. Such an Amor is just on this
account no Amor.

Rather everything that is about and on this winged
youth speaks in favour of the figure of Death.

For if it had only been proved of Sleep that the
ancients represented him as a young genius with wings,
this alone would sufficiently justify us in presuming the
same of his twin brother, Death. " Somni idolum senile
fingitur." Barth wrote in a happy-go-lucky way [14] to
justify his punctuation of a passage in Statius :

" Crimine quo merui, juvenis placidissime divûm,
Quove errore miser, donis ut solus egerem
Somne tuis?——"

the poet implored Sleep, and Barth would have that the
poet said *juvenis* of himself, not of Sleep.

" Crimine quo merui juvenis, placidissime divûm," &c.

So be it, because at a pinch so it might be, but the reason
is nevertheless quite futile. Sleep was a youthful deity
with all poets, he loved one of the Graces, and Juno, in
return for an important service, gave him this Grace to wife.
And yet artists are declared to have represented him as
an old man ? That could not be credited of them, even
if the contrary were no longer visible on any monument.

But not only Sleep, as we see, but another Sleep, that
can be no other than Death, is to be beheld on the less
known monuments of Winckelmann, and on those more
familiar of Boissard, as a young genius with reversed
torch. If Death is a young genius there, why could not
also a young genius be Death here ? And must he not so
be, since, besides the reversed torch, all his other attri-
butes are the most beautiful, most eloquent attributes of
Death ?

What can more distinctly indicate the end of life than
an extinguished, reversed torch ? If it is Sleep, this short
interruption to life, who here rests on such a torch, with
how much greater right may not Death do so ?

[14] Ad Statium, Silv. v. 4.

The wings too are even more fitly his than Sleep's.
His assault is even more sudden, his passage more
rapid.

" ——Seu me tranquilla Senectus
 Expectat, seu Mors atris circumvolat alis "

—says Horace.[15] And the wreath in his left hand? It is the mortuary
garland. All corpses were wreathed among the Greeks
and Romans; wreaths were strewn upon the corpse by
surviving friends; the funeral pile, urn and monument
were decked with wreaths.[16]

Finally, the butterfly above this wreath? Who does
not know that a butterfly is the emblem of the soul, and
especially of the departed soul?

To this must be added the entire position of the figure,
beside a corpse and leaning upon this corpse. What
deity, what higher being could and might take this posi-
tion, save Death himself? A dead body, according to the
idea of the ancients, polluted all that approached it, and
not only the mortals who touched it or did but behold it,
but even the gods themselves. The sight of a corpse was
absolutely forbidden to all of them.

——ἐμοὶ γὰρ οὐ θέμις φθιτοὺς ὁρᾶν

Euripides[17] makes Diana say to the dying Hippolytus.
Yes, to avoid this spectacle they had to withdraw as soon
as the dying man drew his last breath. For Diana con-
tinues thus:

οὐδ᾽ ὄμμα χραίνειν θανασίμοισιν ἐκπνοαῖς·
ὁρῶ δέ σ᾽ ἤδη τοῦδε πλησίον κακοῦ·

—and therewith departs from her favourite. For the same
reason Apollo says in the same poet [18] that he must now
depart from the cherished abode of Admetus because
Alkestis nears her end.

ἐγώ δε, μὴ μίασμά μ᾽ ἐν δόμοις κίχῃ,
λείπω μελάθρων τῶνδε φιλτάτην στέγην.

[15] Lib. ii. Sat. i. v. 57, 58.
[16] Car. Paschalii Coronarum, lib. iv. c. 5.
[17] Hippol. v. 1437. [18] Alc. v. 22, 23.

I consider this circumstance, that the gods might not pollute themselves by the sight of a corpse, as very cogent in this place. It is a second reason why it cannot be Amor who stands beside the corpse, and is also a reason against all the other gods, the one god alone excepted who cannot possibly pollute himself by regarding a corpse, Death himself.

Or is it thought that perchance yet another deity is to be excepted, namely, the especial genius, the especial guardian spirit of man? Would it then be something preposterous, it might be said, if a man's genius stood mourning beside his body, since its vital extinction forces him to separate from it for ever? Yet even though this idea would not be preposterous, it would be wholly opposed to the ancient mode of thought, according to which even a man's guardian spirit did not await his actual death, but parted from him before the total separation of body and soul ensued. This is manifestly attested by several passages,[19] and consequently this genius cannot be the especial genius of the just departed mortal on whose breast he is resting his torch.

I must not pass over in silence a peculiarity in his position. I seem to find in it a confirmation of a conjecture which I advanced in the same part of the Laokoon.[20] This conjecture encountered objections; it may now be seen whether on good grounds.

When namely Pausanias describes the representation on a sarcophagus in the temple of Juno at Elis, above named, where among other things there appears a woman who holds in her right arm a white sleeping boy, and in her left a black boy, καθεύδοντι ἐοίκοτα, which may equally mean " who resembles the sleeping boy" as " who seems to sleep," he adds: ἀμφοτέρους διεστραμμένους τοὺς πόδας. These words are rendered by the Latin translator as *distortis utrinque pedibus*, and by the French as *les pieds contrefaits*. I asked to what purpose the crooked feet here? How come Sleep and Death by these unshapely limbs? What are they meant to indicate? And, at a loss for an

[19] Wonna, Exercit. iii. de Geniis, cap. 2, § 7. [20] See above, p. 73 note.

answer, I proposed to translate διεστραμμένους τοὺς πόδας not by "crooked" but by "crossed feet," because this is the usual position of sleepers, and Sleep is thus represented on ancient monuments.

It will be needful first to quote the whole passage in its connected form, because Sylburg deemed an emendation necessary in those very words. πεποίηται δὲ γυνὴ παῖδα λευκὸν καθεύδοντα ἀνέχουσα τῇ δεξιᾷ χειρί, τῇ δὲ ἑτέρᾳ μέλανα ἔχει παῖδα καθεύδοντι ἐοίκοτα, ἀμφοτέρους διεστραμμένους τοὺς πόδας. Sylburg deemed διεστραμμένους objectionable, and thought that it would be better to read διεστραμμένον instead, because it is preceded by ἐοίκοτα, and both refer to παῖδα.[21] Now this change would not only be superfluous, but also quite false. Superfluous, because why should this διαστρέφεσθαι refer just to παῖδα, since it may as well refer to ἀμφοτέρους or πόδας? False, because thus ἀμφοτέρους could only belong to πόδας, and we should have to translate "crooked in both feet," while it still refers to the double παῖδα, and we must translate "both with crooked feet." That is to say, if διεστραμμένος here means crooked and can mean crooked at all!

Now I must confess that when I wrote the passage in the 'Laokoon,' I knew of no reason why Sleep and Death should be depicted with crooked feet. Only afterwards I found in Rondel [22] that the ancients meant to denote by these crooked feet, the ambiguity and fallaciousness of dreams. But on what is this action founded? and what does it mean? What it should explain, it would only half explain at best. Death surely is dreamless, and yet Death has the same crooked feet. For, as I have said, ἀμφοτέρους must needs refer to the preceding double παῖδα, else ἀμφοτέρους taken with τοὺς πόδας would be a very shallow pleonasm. If a being has crooked feet at all, it follows of itself that both feet are crooked.

But if some one only on this account submitted to Sylburg's reading (διεστραμμένον for διεστραμμένους) in order to be able to give the crooked feet to Sleep alone? Then

[21] Rectius διεστραμμένον, ut antea ἐοίκοτα, respiciunt enim accusativum παῖδα.

[22] Expos. Signi veteris Tolliani, p. 294. Fortuitorum Jacobi Tollii.

let this obstinate man show me any antique Sleep with such feet. There are enough statues as well as *bas-reliefs* extant, which archæologists unanimously recognise as Sleep. Where is there one on which crooked feet can as much as be suspected?

What follows hence? If the crooked feet of Death and Sleep cannot be satisfactorily interpreted; if crooked feet assigned to the latter are not in any antique representation, then I think nothing follows more naturally than the presumption that the crooked feet here are a mere conceit. They are founded on the single passage in Pausanias, on a single word in that passage, and this word is over and above capable of quite another meaning.

For διεστραμμένος from διαστρέφειν does not mean only "crooked," "bent," as "distorted" in general, "brought out of its direction"; not so much *tortuosus*, *distortus*, as *obliquus*, *transversus*, and πόδας διεστραμμένοι can be translated as well by transverse, obliquely placed feet, as by crooked feet; indeed it is better and more accurately rendered by the former than by the latter.

But that διεστραμμένος could be thus translated would be little to the point. The apparent meaning is not always the true one. The following is of greater weight and gives a complete turn to the scale; to translate πόδας διεστραμμένοι as I suggest by "with crossed feet" is, in the case of Death as well as of Sleep, not only most beautiful and appropriate in meaning, but is also often to be seen on ancient monuments.

Crossed feet are the natural attitude of a sleeper when sleeping a quiet healthful sleep. This position has unanimously been given by the ancient artists to every person whom they wished to depict in such sleep. Thus the so-called Cleopatra sleeps in the Belvedere; thus sleeps the Nymph on an old monument in Boissard; so sleeps, or is about to sink into sleep, the Hermaphrodite of Dioskurides. It would be superfluous to multiply such examples. I can only at present recall one ancient figure sleeping in another posture. (Herr Klotz is still very welcome to run quickly over pages of his books of engravings and show me several more.) But this single figure is a drunken faun too overtaken in wine for a quiet

sleep.[23] The ancient artists observed this attitude down to sleeping animals. The two antique lions of yellowish marble among the royal antiquities at Berlin sleep with their fore-paws crossed and rest their heads on them. No wonder therefore that Sleep himself has been represented by them in the attitude so common to sleepers. I have referred to Sleep in Maffei[24] and I might equally well have referred to a similar marble in Tollius. Maffei also mentions two smaller ones, formerly belonging to Constable Colonna, little or in no respect different.

Even in waking figures the posture of crossed feet is a sign of repose. Not a few of the half or wholly recumbent figures of river gods rest thus on their urns, and even in standing persons one foot crossing the other is the actual attitude of pause and quiescence. Therefore Mercuries and Fauns sometimes appear in this position, especially if we find them absorbed in their flute-playing or some other recreation.

Now let all these probabilities be weighed against the mere downright contradictions with which it has been endeavoured to dispose of my explanation. The profoundest is the following, from a scholar to whom I am indebted for more important admonitions. "The Lessing explanation of διεστραμμένους τοὺς πόδας," says the author of the 'Kritischen Wälder,' [25] "seems to contradict linguistic usage; and if we are to venture conjectures, I could just as well say 'they slept with crossed feet,' i.e. the foot of the one stretched over the foot of the other, to show the relationship of Death and Sleep," &c.

Against linguistic usage? How so? Does διεστραμμένος mean anything else but related? and must all that is related be necessarily crooked? How could tho one with crossed feet be named more exactly and better in Greek than διεστραμμένον (κατὰ) τοὺς πόδας? or διεστραμμένους τοὺς πόδας, with ἔχοντα understood? I do not know in the least what there is herein against the natural meaning of words or opposed to the genuine construction of the

[23] In Maffei (t. xciv.) where we must resent the taste of this commentator who desires perforce to turn such an indecent figure into a Bacchus. [24] Tabl. cli. [25] [Herder, Tr.]

language. If Pausanias meant to say "crooked," why did he not use the usual word σκολιός?

There is undoubtedly much room for conjecture. But does a conjecture, which has nothing but mere possibility in its favour, deserve to be opposed to another that wants little of being an established truth? Nay, I can scarcely allow the conjecture that is opposed to mine to be even possible. For the one boy rested in the one arm, the other in the other arm of Night; consequently the entwinement of the feet of the one with the feet of the other can scarcely be understood.

Finally, assuming the possibility of this enlacement, would διεστραμμένους, which is meant to express it, then not also mean something quite different from crooked? Would not this meaning be also opposed to customary usage? Would not the conjecture of my opponent be exposed to the difficulty to which he thinks mine is exposed, without having a single one of the recommendations which he cannot deny to mine?

To return to the plate in Bellori's collection. If it is proved, from what I have hitherto adduced, that the ancient artists represented Sleep with crossed feet; if it is proved that they gave to Death an exact resemblance to Sleep, they would in all probability not have omitted to depict Death with crossed feet. And how, if this very illustration in Bellori were a proof of this? For it really stands with one foot crossing the other, and this peculiarity of attitude can serve as well, I think, to confirm the meaning of the whole figure, as the elsewhere demonstrated meaning of the latter would suffice to establish the characteristic point of this particular attitude.

But it must be understood that I should not form my conclusions so rapidly and confidently if this were the only ancient monument on which the crossed feet are shown on the figure of Death. For nothing would be more natural than to object to me : " If the ancient artists depicted Sleep with crossed feet, then they only portrayed him as recumbent, as himself a sleeper ; from this position of Sleep in sleep little or nothing can be deduced as to his attitude when erect, or still less as to the corresponding posture of his counterpart, Death, and it may be a mere

accident that Death once happens to stand in the manner
in which we generally see Sleep sleeping."

This objection could only be obviated by the production
of several monuments showing that which I think I dis-
cover in the figure engraved by Bellori. I hasten therefore
to indicate as many of these as are sufficient for the induc-
tion, and believe that it will be deemed no mere superfluous
ornamentation if I produce some of the most remarkable
of these in illustration.

(i.) Monument. (From Boissard.)

First, therefore, appears the above-named monument in
Boissard. Since the express superscription of these figures
leaves no room for a misapprehension of their meaning, it
may be regarded as the key to all the rest. How does the
figure show itself which is here called Somno Orestilia
Filia? As a naked youth who casts a mournful look
sideways to earth, who leans on a reversed torch, and crosses
one foot over the other.

I ought not to omit to mention that there is also a

drawing of this very same monument amongst the papers
of Pighius in the Royal Library at Berlin, from which
Spanheim has incorporated the single figure of Sleep in
his commentary on Kallimachus.[26] That it must be identi-
cally the same figure from the same monument given by
Boissard is indisputable from the identity of the super-
scription. But so much more is one astonished at seeing
such remarkable differences in the two. The slender
grown-up form in Boissard is in Pighius a plump sturdy
boy; the latter has wings, the former none; to say
nothing of smaller differences in the turn of the head and
the position of the arms. How it was that these differ-
ences escaped being noticed by Spanheim is conceivable:
Spanheim knew the monument only through Gruter's
Inscriptions, where he found only the words without any
engraving. He did not know or did not remember that
the engraving was already published in Boissard, and thus
thought that he was imparting something quite unknown,
when he furnished it in part from Pighius's papers. It is
less easy to excuse Gravius, who in his edition of Gruter's
Inscriptions added the design from Boissard,[27] and at the
same time did not notice the contradiction between this
design and Gruter's verbal description. In the latter the
figure is *Genius alatus, crinitus, obesus, dormiens, dextra manu
in humerum sinistrum, a quo velum retrorsum dependet, posita;*
while in the former it appears frontwise as we see here,
and altogether different—not winged, not with really
copious hair, not fat, not asleep, and not with the right hand
upon the left shoulder. Such discrepancy is scandalous,
and cannot but awaken the reader's mistrust, especially
when he does not find a word of warning in respect to it.
Meanwhile it proves thus much, that the two drawings
cannot both be immediately copied from the monument;
one of them must necessarily have been drawn from
memory. Whether this is Pighius's design or Boissard's
can only be decided by one who has opportunity of com-
paring therewith the monument itself. According to the
account of the latter it was to be found in Card. Cesi's
palace in Rome. But this palace, if I am correctly

[26] At ver. 234 of Hymn. in Delum. Ed. Ern. p. 524. [27] P ccciv.

informed, was utterly destroyed in the sack of 1527.
Several of the antiquities which Boissard there saw might
now be in the Farnese Palace; this I assume is the case
in respect to the Hermaphrodite and the supposed Head of
Pyrrhus.[28] Others I believe I have found again in other
cabinets—in short, they are scattered, and it would be
difficult to discover the monument of which we are
speaking even if it is still in existence. On mere suppo-
sition I would just as little declare in favour of Boissard's
drawings as of Pighius's. For if it is certain that Sleep
can have wings it is just as certain that he need not
necessarily have wings.

D. M.

QVIETORIVM
CLYMENES
ET
LIBERTORVM
ET RAPHIS

(ii.)—MONUMENT. (From Boissard.)

The second illustration shows the monument of a cer-
tain Clymene, also taken from Boissard.[29] One of these

[28] "Hermaphroditus nudus, qui involutum palliolo femur habet—
Caput ingens Pyrrhi regis Epirotarum, galeatum, cristatum, et armato
pectore." Topogr. parte i. pp. 4, 5; Winckelmann's Anmerk. üb. d.
Gesch. d. Kunst, p. 98. [29] Par. vi. p. 119.

figures has so much resemblance to the before named, that this resemblance and the place it occupies can no longer leave us in doubt on its account. It can be nothing else but Sleep, and this Sleep, also leaning on a reversed torch, has the feet placed one over the other. It is also without wings, and it would indeed be singular if Boissard had forgotten them here a second time, but as I have said, the ancients may often have represented Sleep without wings. Pausanias does not give any to Sleep in the arms of Night; neither do Statius nor Ovid accord him such in their detailed description of this god and his habitation. Brouckhuysen has been much at fault when he says that the latter poet actually gave Sleep two pairs of wings, one at his head and one at his feet. For although Statius says of him—

"Ipse quoque et volucrem gressum et ventosa citavit
 Tempora " [30]

—this is not in the least to be understood of natural wings, but of the winged petasus and the talaria, which the poets bestow not only on Mercury, but frequently also on other deities when they wish to represent them in extraordinary haste. But I am not at all concerned with the wings but the feet of Sleep, and I continue to show the διεστραμμένον of the same on various monuments.

Our third illustration shows a Pila or a sarcophagus, which is again taken from Boissard.[31] The inscription also occurs in Gruter,[32] where the two genii with reversed torches are called two Cupidines. But we are already too conversant with this figure of Sleep to mistake it here. And this Sleep also stands both times with feet crossed. And why is this same figure repeated twice here? Not so much repeated, as doubled; to show image and counter-image. Both are Sleep; the one the transient, the other the long-enduring Sleep; in a word, they are the resembling twin brothers, Sleep and Death. I may conjecture

[30] Ad Tibullum, lib. ii. Eleg. i. v. 89 : "Et sic quidem poetæ plerique omnes, videlicet ut alas habuerit hic deus in humeris. Papinius autem, suo quodam jure peculiari, alas ei in pedibus et in capite adfingit." L. 10, Theb. v. 131.

[31] Par. v. p. 115. [32] Pag. DCCXII.

SER. VALERIVS
SEVERIANVS
FILIO DVLCISSIMO
B.
M.
FEC. VIX AN. XI.

(iii.)—SARCOPHAGUS. (From Boissard.)

that as we see them here, so and not otherwise, they will appear on the monuments mentioned by Winckelmann; on the sepulchral stone of the Palazzo Albani and on the cinerary urn of the Collegium Clementinum. We must not be misled by the bows that here lie at their feet; these may belong to the floating genii just as well as to the standing ones, and I have seen on various monuments an unstrung or even a broken bow, not as the attribute of Amor, but as an image totally unconnected with him, of spent life in general. How a bow could be the image of a good housewife I do not know, and yet an old epitaph, made known by Leich from the unpublished Anthology,[33] says that so it has been:—

Τόξα μὲν αὐδάσει τὰν εὔτονον ἄγετιν οἴκου·

And from this it is at least apparent that it need not of necessity be the weapon of Amor, and that it may mean more than we can explain.

I append a fourth illustration. This is a monument found by Boissard in Rome in St. Angelo ("in Templo Junonis quod est in foro piscatorio"), and where beyond doubt it may still be found.[34] Behind a closed door stands on either side a winged genius, half of whose body projects, and who points with his hand to the closed door. The representation is too expressive not to recall the *domus exilis Plutonia*,[35] from whence no release can be hoped; and who could more fitly be the warders of this eternal prison than Sleep and Death? In the position and action in which we see them no reversed torch is needed to define them more accurately; but the artist has given them the crossed feet. Yet how unnatural this posture would be in this place if it were not expressly meant to be characteristic!

Let it not be thought that these are all the examples I could adduce on my side of the question. Even from Boissard I could bring forward several more, where Death, either as Sleep, or together with Sleep, exhibits the same position of the feet.[36] Maffei too would furnish me with a

[33] Sepulc. Car. xiv. [34] Parte v. p. 22.
[35] Tollii Expos. Signi vet. p. 292.
[36] For instance part iii. p. 69, and perhaps also part v. p. 23.

complete harvest of figures such as appear on the first plate.[37]

But to what end this superfluity? Four such monuments, not reckoning that in Bellori, are more than enough to obviate the presumption that that could be a

(iv.)—SEPULCHRAL MONUMENT. (From Boissard.)

mere insignificant accident which is capable of such a deep meaning. At least such an accident would be the most extraordinary that can be imagined! What a coincidence, if certain things were accidentally thus on more than one undoubted antique monument. exactly as I have said that according to my reading of a certain

[37] Museo Veron, tab. cxxxix.

passage, they must be; or if it were a mere accident that this passage could be so construed as if it had been written with a real view to such monuments. No, chance is not so consistent, and I may maintain without vanity, that consequently my explanation, although it is only *my* explanation, little as may be the credit attaching to it merely on my authority, is yet as completely proved as ever anything of this nature can be proved.

Consequently I think it is hardly worth while to clear away this or that trifle which might perhaps occur to a sceptic who will not cease doubting. For instance the lines of Tibullus :—[38]

" Postque venit tacitus fuscis circumdatus alis
Somnus et incerto somnia vara pede."

It is true that express mention is here made of Dreams with crooked legs. But Dreams! And if the legs of Dreams were crooked why must Sleep's needs be the same? Because he is the father of Dreams? An excellent reason! And yet that is not the only answer that here occurs to me. For the real one is this : the adjective *vara* is certainly not Tibullus's own, it is nothing but an arbitrary reading of Brouckhuysen's. Before this commentator all editions read either *nigra* or *vana*. The latter is the true one, and Brouckhuysen can only have been misled to reject it by the facility of foisting a foreign idea upon his author by altering a single letter. For if the ancient poets often represent Dreams as tottering upon weak uncertain feet, namely deceptive, false dreams; does it follow thence that they must have conceived of these weak uncertain feet as crooked? Why must weak feet needs be crooked, or crooked feet, weak? Moreover the ancients did not regard all dreams as false and deceptive, they believed in a species of very veracious dreams, and Sleep with these, his children, was to them *Futuri certus* as well as *pessimus auctor*.[39] Consequently crooked feet, as the symbol of uncertainty, could not in their apprehension belong to Dreams in general, still less to Sleep, as the universal father of Dreams. And yet I admit all these petty reasons

[38] Lib. ii. Eleg. i. v. 89, 90. [39] Seneca Herc. Furens, v. 1070.

might be pushed aside if Brouckhuysen, beside the mis-
understood passage of Pausanias, had been able to indicate
a single one in favour of the crooked feet of Dreams and
Sleep. He explains the meaning of *varus* with twenty
superfluous passages, but to prove *varus* an epithet of
dreams, he adduces no example, but has to make one, and
as I have said, not even the single one of Pausanias gives
it but it is made out from a false rendering of Pausanias.
It is almost ludicrous, when, since he cannot find a bandy-
legged Sleep, he tries to show us at least a genius with
crooked feet in a passage of Persius,[40] where *genius* means
nothing but *indoles* and *varus*, hence nothing more than
standing apart.

". Geminos, horoscope, varo
 Producis genio"

This digression concerning the διεστραμμένους of Pau-
sanias would have been far too long had it not afforded
me an opportunity of bringing forward at the same time
various antique representations of Death. For let it be
as it may with the crossed feet of Death and his brother;
may they be held as characteristic or no; so much is
unquestionable from the monuments I have adduced, that
the ancient artists always continued to fashion Death
with an exact resemblance to Sleep, and it was only that
which I wanted to prove here.

For, completely as I myself am convinced of the
characteristic element that is contained in this attitude of
the feet, I will not therefore insist that no image of Sleep
or Death can be without it. On the contrary I can easily
conceive an instance in which such an attitude could be
at variance with the meaning of the whole and I think I
can show examples of such instances. If namely one foot
crossing the other is a sign of repose, it can then only
duly belong to death that has already taken place; death
on the other hand that has still to occur will for that
very reason demand another attitude.

In such another attitude, announcing its approach, I
think that I recognise Death on a gem in Stephanonius

[40] Sat. vi. v. 18.

or Licetus.[41] A winged genius who holds in one hand a
cinerary urn, seems to be extinguishing with the other a
reversed but yet burning torch, and looks aside mourn-
fully at a butterfly creeping on the ground. The out-
stretched legs are either to show him in the act of
advancing, or denote the posture involuntarily assumed
by the body when about to throw back one arm with
violence. I do not like to detain myself with a refutation
of the highly forced explanation which both the first
poetical exponent of the Stephanonian gem and the hiero-
glyphical Licetus gave of this representation. They are
both founded on the assumption that a winged boy must
needs be an Amor, and as they contradict each other, so
they both fall to the ground as soon as the foundation of
this assumption is examined. This genius is therefore
neither Amor who preserves the memory of departed
friends in a faithful heart ; nor Amor who renounces love
out of vexation because he can find no requital; he is
nothing but Death and even approaching Death, in the
act of extinguishing his torch, upon which, when extin-
guished, we have already seen him leaning.

I have always been reminded of this gesture of extin-
guishing the torch, as an allegory of approaching death,
as often as the so-called brothers, Castor and Pollux, in
the Villa Ludovici have been brought before my eyes.[42]
That they are not Castor and Pollux has been evident to
many scholars, but I doubt whether Del Torre or Maffei
have therefore come any nearer the truth. They are two
undraped, very similar genii, both in a gently melancholy
attitude, the one embraces the shoulder of the other, who
holds a torch in each hand ; the one in his right, which
he seems to have taken from his playfellow, he is about to
extinguish upon an altar that stands between them, while
the other in his left, he has dashed over his shoulder to
extinguish it with violence ; behind them stands a smaller
female figure, not unlike an Isis. Del Torre saw in this
group two figures worshipping Isis ; while Maffei pre-
ferred to regard them as Lucifer and Hesperus. Good as
the reasons may be which Maffei brings against the ex-

41 Schemate, vii. p. 123. [See p. 178 above.] 42 Maffei, tab. cxxi.

planation of Del Torre, his own idea is equally unhappy.
Whence can Maffei prove to us that the ancients represented
Lucifer and Hesperus as two distinct beings? They
were to them only two names for the same star and for
the same mythical personage.[43] Pity that one should ven-
ture to guess the most intimate thoughts of antiquity and
not know such generally familiar matters! But the more
needful must it be to excogitate a new explanation of this
excellent work of art; and if I suggest Death and Sleep,
I desire to do nothing more than to suggest them. It is
palpable that their attitudes are not those of sacrificers;
and if one of the torches is to light the sacrifice what
means the other in the background? That one figure
extinguishes both torches at once, would be very signifi-
cant according to my conjecture, for in reality Death
makes an end to both waking and sleeping. And then,
according to this theory the diminutive female figure
might not unjustly be interpreted as Night, as the mother
of Sleep and Death. For if the kalathus on the head of
an Isis or Cybele makes her recognisable as the mother
of all things, I should not be astonished to see here
Night—

θεῶν γενέτειρα—ἥ δε καὶ ἀνδρῶν,

as Orpheus names her, also with the kalathus.

What besides appears most manifestly from the figure
of Stephanonius combined with that of Bellori, is this,
that the cinerary urn, the butterfly, and the wreath are
those attributes by which Death was distinguished from
his counterpart Sleep, where and when this was needful.
The particular mark of Sleep was on the other hand un-
questionably a horn.

Some light might be thrown on this by quite another
representation on the gravestone of a certain Amemptus,
a freed-man of I know not which empress or imperial
princess.[44] See the accompanying plate [p. 202]. A male
and female Centaur, the first playing on a lyre, the other
blowing a double tibia, each bearing a winged boy on

[43] Hyginus, Poet. Astr. lib. ii. cap. 42.
[44] Boissardus, par. iii. p. 144.

its back, of whom each is blowing a flute; under the upraised foot of the one Centaur lies an urn, under that

MONUMENTAL STONE. (From Boissard.)

of the other a horn. What can this allegory import? What was it to mean here? A man like Herr Klotz, it is true, whose head is full of love-gods, would soon be ready with his answer. These are a pair of Cupids, he would say, and the wise artist has here again shown the triumph of love over the most untamable creatures, a triumph effected by music. Well, well, what could have been more worthy the wisdom of the ancient artists than ever to dally with love, especially in the way that these gentlemen knew love? Meanwhile it still could be possible that even an ancient artist, to speak after their manner, sacrificed less to love and the graces and was in this instance a hundred miles away from thinking of love! It might be possible

that what to their eyes resembles Amor as one drop of
water the other, is nothing more playful than Sleep and
Death.

In the guise of winged boys the two are no longer
strange to us, and the vase on the side of the one and the
horn beside the other seems to me not much less expres-
sive than their actual written names would be. I know
well that the vase and the horn might only be drinking
vessels, and that in antiquity the Centaurs were no mean
topers, wherefore on various works they appear in the train
of Bacchus and even draw his car.[45] But why in this
capacity did they require to be indicated by attributes?
and is it not far more in keeping with the place to explain
this vase, this horn as the attributes of Sleep and Death
which they had of necessity to throw aside in order to
manage their flutes?

If however I name the vase or urn as the attribute of
Death, I do not mean thereby the actual cinerary urn, the
Ossuarium or *Cinerarium*, or however else the vase was
called in which the remains of the cremated bodies were
preserved. I include under it also the λήκυθοι, the vessels
of every kind that were placed in the earth with the dead
bodies that were buried entire, without entering upon the
question what may have been contained in these bottles.
A corpse about to be buried among the Greeks was as
little left without such a vessel as without a wreath,
which is very clearly shown in various passages of
Aristophanes among others,[46] so that it is quite intelli-
gible how both became attributes of Death.

There is still less doubt regarding the horn as an attri-

[45] Gemme antiche colle sposizioni di P. A. Maffei, parte iii. p. 58.

[46] Especially in the Ecclesiazusæ, where Blepyrus scolds his Praxa-
gora for having got up secretly at night and gone out in his clothes
(l. 537-8)—

ᾤχου καταλιποῦσ᾽ ὡσπερεὶ προκείμενον,
Μόνον οὐ στεφανώσασ᾽, οὐδ᾽ ἐπιθεῖσα λήκυθον.

The scholiast adds thereto: Εἰώθασι γὰρ ἐπὶ νεκρῶν τοῦτο ποιεῖν. Com-
pare in the same play the lines 1022-27, where the Greek funeral
customs are to be found together. That such vessels (λήκυθοι) which
were placed beside the dead, were painted, and that it was not pre-
cisely the great masters who occupied themselves with this branch
of the art is clear from lines 987-88. Tanaquil Faber seems to have

bute of Sleep. The poets refer to this horn in innumerable passages. Out of a full horn he pours his blessing over the eyelids of the weary—

> " Illos post vulnera fessos
> Exceptamque hiemem, cornu perfuderat omni
> Somnus ; "

with an emptied horn he follows departing Night into his grotto—

> " Et Nox, et cornu fugiebat Somnus inani."

And as the poets beheld him the artists depicted him.[47] Only the double horn, wherewith the extravagant imagination of Romeyn de Hooghe has overburdened him, is known neither by the one nor the other.[48]

Granted therefore that it might be Sleep and Death who here sit on the Centaurs, what would be the meaning of their combined representation? If I have happily guessed a part, must I therefore be able to explain the whole? Perhaps however the secret is not very profound. Perhaps Amemptus was a musician especially skilled in the instruments we here behold in the hands of these subterrene beings; for Centaurs also had their abode at the gates of Hades according to the later poets—

> " Centauri in foribus stabulant "

—and it was quite common to place on the monument of an artist the implements of his art, which here would not have been devoid of a delicate complimentary significance.

believed that they were not really painted vessels that were buried with the dead, but that such vessels were painted round about them, for he notes at the last place : "Quod autem lecythi mortuis appingerentur, aliunde ex Aristophane innotuit." I wish he would have given his reference for this *aliunde*.

[47] Servius ad Æneid. vi. v. 233: "Somnum cum cornu novimus pingi. Lutatius apud Barthium ad Thebaid. vi. v. 27. Nam sic a pictoribus simulatur, ut liquidum somnium ex cornu super dormientes videatur effundere."

[48] Denkbilder der alten Völker, p. 193, German translation.

I cannot however express myself otherwise than hesitatingly concerning this monument in general. For I see myself once again perplexed as to how far Boissard may be relied upon. The drawing is Boissard's, but before him Smetius had published the inscription with an additional line,[49] and had appended a verbal description of the figures surrounding it. Smetius says of the principal figures: "Inferius Centauri duo sunt, alter mas, lyncea instratus, lyram tangens, cui Genius alatus, fistula, Germanicæ modernæ simili, canens insidet; alter fœmina, fistulis duabus simul in os insertis canens, cui alter Genius fœmineus alis papilionum, manibus nescio quid concutiens, insidet. Inter utrumque cantharus et cornu Bacchicum projecta jacent." All is exact, except the genius borne by the female Centaur. According to Smetius this one should also be of female sex, and have butterfly wings and strike something together with her hands. According to Boissard this figure is no more winged than its companion, and instead of cymbals or perhaps of a Crotalum, he plays upon the same kind of wind instrument as the other. It is sad to notice such contradictions so often. They must from time to time make antiquarian studies very repugnant to a man who does not willingly build on quicksand.

Nevertheless even if Smetius saw more correctly than Boissard, I should not therefore wholly abandon my explanation. For then the female genius with butterfly wings would be a Psyche, and if Psyche is the picture of the soul, then we must here see instead of Death the soul of the dead. To this also the attribute of the urn would be appropriate, and the attribute of the horn would still indicate Sleep.

I imagine moreover that I have discovered Sleep elsewhere than on sepulchral monuments, and especially in a company where one would scarcely have expected to find him. Among the train of Bacchus, namely, there appears not rarely a boy or genius with a cornucopia, and I do not know that any one has as yet thought it worth

<hr />

[49] Which names those who erected this monument to Amemptus, LALVS ET CORINTHVS. L. V. Gruteri Corp. Inscr. p. dcvi. edit. Græc.

his while to identify this figure. It is, for instance, on
the well-known gem of Baggaris, now in the collection
of the King of France, the explanation of which Casaubon
first gave, and it was noticed by him and all subsequent
commentators,[50] but not one of them knew what to say
of it beyond what is obvious to the eye, and a genius
with a cornucopia has remained a genius with a cornu-
copia. I venture to pronounce him to be Sleep. For as
has been proved, Sleep is a diminutive genius, the attri-
bute of Sleep is a horn, and what companion could an
intoxicated Bacchus desire rather than Sleep? That it
was usual for the ancient artists to couple Bacchus with
Sleep, is shown by the pictures of Sleep with which
Statius decked his palace.[51]

" Mille intus simulacra dei cælaverat ardens,
　Mulciber. Hic hæret lateri redimita voluptas,
　Hic comes in requiem vergens labor. Est ubi Baccho,
　Est ubi Martigenæ socium pulvinar amori
　Obtinet. Interius tectum in penetralibus altis,
　Et cum Morte jacet: nullique ea tristis imago."[52]

Nay, if an ancient inscription may be trusted, or rather
if this inscription is ancient enough, Bacchus and Sleep
were even worshipped in common as the two greatest and
sweetest sustainers of human life.

It is not in place here to pursue this trace more keenly.
Neither is the present occasion opportune for treating
more amply my special theme and seeking far and wide for
further proofs of the ancients having depicted Death as
Sleep, and Sleep as Death, now alone, now together, now
with, now without certain attributes. Those instanced,
even if others could not be hunted out, sufficiently con-
firm what they are designed to confirm, and I may pass
on without scruple to the second point which contains
the refutation of the one single counter-proposition.

[50] See Lippert's Dakt. i. 366.
[51] Thebaid. xv. 100. Barth need not have been so chary as to omit
commenting on these lines because they are omitted in some of the
best MSS. He has spent his learning on worse verses.
[52] Corp. Inscript. p. lxvii. 8.

II. I say : the ancient artists, when they represented a skeleton, meant thereby something quite different from Death, as the deity of Death. I prove therefore (1) that they did not thereby mean Death, and show (2) what they did mean.

1. It never occurred to me to deny that they represented skeletons. According to Herr Klotz's words I must have denied it, and denied it for the reason that they refrained in general from portraying ugly or disagreeable objects. For he says, I should beyond question resolve the examples thereof on engraved gems into allegory, which thus relieves them from the higher law of beauty. If I needed to do this, I need only add, that the figures on gravestones and cinerary urns belong no less to allegory, and thus of all his cited examples there would only remain the two brazen figures in the Kircherian Museum and the gallery at Florence, which can really not be reckoned among works of art as I understand that term in the 'Laokoon.'

But wherefore these civilities towards him ? As far as he is concerned I need simply deny the faults of which he accuses me. I have nowhere said that the ancient artists represented no skeletons, I only said that they did not depict Death as a skeleton. It is true, I thought that I might doubt the genuine antiquity of the bronze skeleton at Florence ; but I added : "It cannot at any rate be meant to represent Death because the ancients depicted him differently." Herr Klotz withholds this additional sentence from his readers, and yet everything depends upon it. For it shows that I will not exactly deny that of which I doubt. It shows that my meaning has only been this : if tho image in question is to represent Death, as Spence maintains, it is not antique, and if it is antique, then it does not represent Death.

I was already acquainted with several skeletons or antique works and now I know of several more than the luckless industry or the boastful indolence of Herr Klotz has been able to produce.

For in fact those which he cites, all except one, are already to be found in Winckelmann [53] and that he here

[53] Allegorie, p. 81.

only copied from him is apparent from an error common to them both. Winckelmann writes: "I here note that skeletons are only extant on two ancient monuments and urns of marble in Rome, the one is in the Villa Medici, the other in the Museo of the Collegio Romano. Another with a skeleton is to be found in Spon, but is no longer in Rome." He refers to Spon concerning the former of those skeletons which still stands in the Villa Medici (Spon, *Rech. d'Antiq.* p. 93) and concerning the third, which is no longer extant in Rome, to the same scholar's *Miscell. Ant.* p. 7. Now this and that with Spon are one and the same, and if that which Spon cites in his *Recherches* still stands in the Villa Medici, then that in his *Miscellanées* is certainly also still in Rome and is to be seen in the same villa on the same spot. Spon however, I must remark, did not see it in the Villa Medici, but in the Villa Madama.

As little therefore as Winckelmann can have compared the two quotations from Spon, as little has Herr Klotz done so, else he would not have referred me, to excess, as he says, to the two marbles quoted by Winckelmann in his essay on allegory and immediately after have also named the monument in Spon. One of these is, as I have said, counted twice over, and this he must permit me to deduct.

In order however that he may not be annoyed at this subtraction, I will at once place half a dozen other skeletons at his service in lieu of the one I have taken away. It is game that I myself do not preserve, that has only accidentally strayed into my domains, and with which I am consequently very liberal. To begin with, I have the honour to bring before him three all together. They are upon a stone from the Daktyliotheca of Andreini in Florence to be found in Gori.[54] The fourth this same Gori will exhibit to him on an old marble likewise in Florence.[55] The fifth he will encounter, if my information is not at fault, in Fabretti,[55] and the sixth upon the

[54] Inscript. antiq. quæ in Etruriæ urbibus exstant, par. i. p. 455.

[55] *Ibid.* p. 382: "Tabula, in qua sub titulo sculptum est canistrum, binæ corollæ, fœmina cornu mensa tripode in lectisternio decumbens, Pluto quadriga vectus animam rapiens, præeunte Mercurio retasato et caduceato, qui rotundam domum intrat, prope quam jacet sceletus."

[56] Inscript. cap. i. n. 17, quoted by Gori from the above.

second of the two gems of Stosch of which he only brings forward one out of Lippert's [57] impressions.

What a wretched study is the study of antiquity if its subtlety depends on such knowledge; when the most learned therein is he who can most easily and exhaustively count up such trivialities on his fingers!

But it seems to me it has a more dignified side, this study. An antiquarian is one thing and an archæologist another! The former has inherited the fragments, the latter the spirit of antiquity. The former scarcely thinks with his eyes; the latter sees even with his thoughts. Before the former can say "Thus it was," the latter already knows whether it could be so.

The former may pile together yet seventy and seven more such artistic skeletons out of his rubbish heap, to prove that the ancients represented Death as a skeleton; the latter will shrug his shoulders at this short-sighted industry and will continue to say what he said before he knew all this baggage; either they are not as old as they are thought to be, or they are not that which they are proclaimed.

Putting the question of age aside as not decided or as not capable of decision, what reason have we for saying that these skeletons represent Death?

Because we moderns represent Death as a skeleton? We moderns still in part depict Bacchus as fat and paunchy. Was this therefore also the representation which the ancients gave of him? If a bas-relief were found of the birth of Hercules and we saw a woman with folded hands, *digitis pectinatim inter se implexis* sitting before a door, should we perhaps say this woman is praying to Juno Lucina that she may aid Alkmene to a quick and happy deliverance? But do not we pray in this manner? This reasoning is so wretched that one feels ashamed to attribute it to any one. Moreover too the moderns do not portray Death as a mere skeleton; they give him a scythe or something of the kind in his hand, and this scythe it is that converts the skeleton into Death.

If we are to believe that the ancient skeletons represented Death, we must be convinced, either by the repre-

[57] Descript. des Pierres gr. p. 517, n. 241.

sentation itself or by the express testimony of ancient writers. But neither the one nor the other are forthcoming. Not even the faintest, the most indirect testimony can be adduced for this.

I call indirect testimonies the references and pictures of the poets. Where is there the faintest trace in any Greek or Roman poet which could ever allow us to suspect that he found Death represented as a skeleton or so thought of it himself?

Pictures of Death are frequent among the poets and often very terrible. He is the pale, pallid, sallow Death ; [58] he roams abroad on black wings ; [59] he bears a sword ; [60] he gnashes hungry teeth ; [61] he suddenly opens a voracious jaw ; [62] he has bloody nails with which he indicates his destined prey ; [63] his form is so large and monstrous that he overshadows a whole battlefield,[64] that he hurries off with entire cities.[65] But where in all this is there even a suspicion of a skeleton? In one of Euripides' tragedies he is even introduced among the acting personages; and there too he is the sad, terrible, inexorable Death. Yet even there he is far removed from appearing as a skeleton, although we know that the mechanism of the ancient stage did not hesitate to terrify the spectators with yet more horrible figures. There is no apparent trace of his being indicated otherwise than by his black vesture,[66] and by the steel with which he cut off the hair of the dying, thus dedicating them to the infernal gods.[67] Perhaps he may have had wings.[68]

[58] " Pallida, lurida Mors."
[59] " Atris circumvolat alis," Horat. Sat. ii. i. v. 58.
[60] " Fila sororum ense metit," Statius, Theb. i. v. 633.
[61] " Mors avidis pallida dentibus," Seneca, Her. Fur.
[62] " Avidos oris hiatus pandit," Idem, Œdipo.
[63] " Præcipuos annis animisque cruento ungue notat," Statius, Theb. viii. v. 380.
[64] "Fruitur cœlo, bellatoremque volando campum operit," Ibid. viii. v. 378.
[65] " Captam tenens fert manibus urbem," Ibid. lib. i. v. 633.
[66] Alcest. v. 843, where Hercules names him Ἄνακτα τὸν μελάμπεπλον νεκρῶν.
[67] Ibid. v. 75, 76, where he says of himself—

ἱερὸς γὰρ οὗτος τῶν κατὰ χθονὸς θεῶν,
ὅτου τόδ᾽ ἔγγος κράτος ἁγνίσει τρίχα.

[68] If the πτέρωτος ᾅδας in the 261st line is to be understood of him.

But may not some of these shots recoil on myself? If it be admitted to me that in the pictures of the poets nothing is seen of this skeleton; must I not in return admit that they are nevertheless far too terrible to exist together with that image of Death which I believe that I have discovered among the ancient artists? If a conclusion drawn from that which is not to be found in the poet's pictures be valid for the material pictures of art; will not a similar conclusion drawn from that which is found in these pictures be valid also?

I answer, No; this conclusion is not as entirely valid in this case as in the other. Poetical pictures are of immeasurably wider range than the pictures of art: and especially in the personification of an abstract idea, art can only express that which is general and essential to it. It must renounce all the accidents which would form exceptions to this universality, which stand in opposition to this essential quality, for such accidents in the thing itself would make the thing itself unrecognisable, and to be recognised is its aim above all things. The poet, on the contrary, who elevates their personified abstract idea into the class of acting personages, can allow him to act up to a certain point contrary to this idea and can introduce him in all the modifications that any especial case offers, without our losing sight in the least of his actual nature.

Hence, if art wishes to make the personified idea of Death recognisable by us, by what must she, by what else can she do so, than by that which is common to Death in all possible cases? And what else is this but the condition of repose and insensibility? The more she would desire to express contingencies which in a single case might banish the idea of this rest and insensibility, the more unrecognisable her picture must necessarily become, unless she resorts to the addition of some word, or some conventional sign, which is no better than a word and will thus cease to be pictorial art. The poet need not fear this. For him language has already elevated abstract ideas to the rank of independent beings, and the same word never ceases to awaken the same idea, however many contradictory contingencies he may unite with it. He may describe Death as never so painful, so terrible, so

cruel, we do not therefore forget that it is only Death,
and that such a horrible shape does not belong to him
essentially, but only under similar circumstances.

The condition of being dead has nothing terrible, and in
so far as dying is merely the passage to being dead, dying
can have nothing terrible. Only to die thus and thus, at
this moment, in this mood, according to the will of this
or that person, to die with shame and agony, may be terri-
ble and becomes terrible. But is it then the dying, is it
Death, which has caused the terror? Nothing less; Death
is the desired end of all these horrors, and it is only to be
imputed to the poverty of language if it calls both condi-
tions, the condition which leads unavoidably to Death, and
the condition of Death itself, by one and the same name.
I know that this poverty can often become a source of
pathos and that the poets thus derive advantage from it,
but still that language unquestionably merits the prefer-
ence that despises a pathos which is founded on the
confusion of such diverse matters, and which itself
obviates such confusion by distinctive appellations. Such
a language it appears was the ancient Greek, the lan-
guage of Homer. Κήρ is one thing to Homer and
θάνατος another; for he would not so frequently have
combined θάνατος and κήρ if both were meant to express
only one and the same thing. By κήρ he understands
the necessity of dying, what may often be a sad, an early,
violent, shameful, inopportune death; by θάνατος natural
death, which is preceded by no κήρ, or the condition of
being dead without any reference to the preceding κήρ.

The Romans too made a distinction between *lethum*
and *mors*.

> " Emergit late Ditis chorus, horrida Erinnys,
> Et Bellona minax, facibusque armata Megæra,
> Lethumque, Insidiæque, et lurida Mortis imago "

—says Petronius. Spence thinks it is difficult to under-
stand this distinction; but that perhaps by *lethum*
they understood the general principle or the source
of mortality, which they supposed to have its proper
residence in Hell, and by *mors* or *mortes* the imme-
diate cause of each particular instance of mortality

on our earth.[69] I, for my part, would sooner take that
lethum is to denote rather the manner of dying, and *mors*
Death originally and in general, for Statius says : [70]

"Mille modis lethi miseros Mors una fatigat."

The modes of dying are endless ; but there is only one
Death. Consequently *lethum* would completely answer
to the Greek κήρ, and *mors* to θάνατος, without prejudice
to the fact that in the one language as well as in the
other, both words became confounded in time and were
finally employed as entirely synonymous.

However I will here also imagine to myself an oppo-
nent who contests every step of the field. Such a one
might say : "I will allow the distinction between κήρ
and θάνατος, but if the poets, if language itself have
distinguished between a terrible death and one that is
not terrible, why then may not Art be permitted to have
a similar double image for Death? The less terrible
image may have been the genius who rests on his
reversed torch, with his various attributes ; and conse-
quently this genius was a θάνατος. How stands it with
the image of Κήρ? If this had to be terrible, then
perhaps it was a skeleton, and we should then still be
permitted to say, that the ancients represented Death,
i.e. violent death, for which our language lacks a name,
by means of a skeleton.

It is certainly true that the ancient artists also
accepted the abstraction of Death from the terrors that
precede it and represented the latter under the especial
image of Κήρ. But how could they have chosen for their
representation something which only ensues long after
death? A skeleton would have been as unsuitable for this
as possible. Whosoever is not satisfied with this reasoning,
let him look at the fact. Fortunately Pausanias has

[69] Polymetis, p. 261 : "The Roman poets sometimes make a distinc-
tion between Lethum and Mors, which the poverty of our language
will not allow us to express. Perhaps he meant by Lethum, that
general principle or source of mortality, which they supposed to have
its proper residence in hell ; and by Mors, or Mortes (for they had
several of them) the immediate cause of each particular instance of
mortality on our earth." [70] Thebaid. ix. v. 280.

preserved for us the image under which this Κήρ was depicted. It appeared as a woman with horrible teeth and crooked nails, like to a wild beast. Thus was she represented upon the cist of Kypselus in which Death and Sleep rested in the arms of Night, behind Polyneikes when his brother Eteokles attacks him. τοῦ Πολυνείκους δὲ ὄπισθεν ἕστηκεν ὀδόντας τε ἔχουσα οὐδὲν ἡμερωτέρους θηρίου, καὶ οἱ καὶ τῶν χείρων εἰσὶν ἐπικαμπεῖς οἱ ὄνυχες· ἐπίγραμμά δε ἐπ' αὐτῇ εἶναί φασι Κῆρα.[71] A substantive seems wanting in the text before ἕστηκεν, but it would be a mere quibble if we affected to doubt that it must be γυνή. Anyway it cannot be σκελετός, and that is enough for me.

Herr Klotz has already once before wanted to employ this image of Κήρ against my assertion as to the manner in which Death was depicted by the ancients,[72] and now he knows what I could have replied to him. Κήρ is not Death, and it is mere poverty in those languages where it has to pass for it by a circumlocution and with the addition of the word Death. So distinct an idea ought to have a word for itself in all languages. And yet Herr Klotz should not have praised Kulmius for translating κήρ by *mors fatalis*. It would be more correct and exact to say *fatum mortale, mortiferum*, for in Suidas κήρ is explained by θανατηφόρος μοῖρα, not by θάνατος πεπρωμένος.

Finally I will remind my readers of the euphemisms of the ancients and their delicacy in exchanging such words as might immediately awaken disagreeable, sad, horrible ideas for less shocking ones. If in consequence of this euphemism they did not distinctly say "he is dead" but rather "he has lived, he has been, he has gone to the majority"[73] and such like; if one of the reasons of this delicacy consisted in avoiding as far as might be words of evil omen; then there can be no doubt that the artists too

[71] Lib. v. cap. 19, p. 425, ed. Kuhn.

[72] Ad Litt. vol. iii. p. 288: "Considerem quasdam figuras arcæ Cypseli in templo Olympico insculptas. Inter eas apparet γυνὴ, ὀδόντας, κ.τ.λ. Verbum κῆρα recto explicat Kuhnius mortem fatalem, eoque loco refutari posse videtur Auctoris opinio de minus terribili forma morti ab antiquis tributa, cui sententiæ etiam alia monimenta adversari videntur."

[73] Gattakerus, de novi Instrumenti stylo, cap. xix. [London, 1648].

would tone down their language to this gentler pitch.
They too would not have presented Death under an
image unavoidably calling up before the beholder loath-
some ideas of decay and corruption, the image of the
ugly skeleton; for in their compositions too the unex-
pected sight of such an image could have become as ominous
as the unexpected hearing of the actual word. They too
therefore will rather have chosen an image, which leads
us to that of which it is emblematic by an agreeable by-
path; and what image could be more suited to this, than
that whose symbolic expression language itself likes to
employ as the designation of Death, the image of Sleep?

" Nullique ea tristis imago."

But euphemism does not banish words from a language,
does not necessarily thrust them out of usage because it
exchanges them for gentler ones. It rather employs
these repulsive and therefore avoided words, instead of
the less offensive ones, on a more terrible occasion. Thus,
for example, it says of him who died quietly, that he
no longer lives, so it would say of him who had been
murdered under the most horrible tortures, that he had
died; and in like manner, Art will not wholly banish
from her domain those images by which she might
indicate Death but which on account of their horrors she
does not willingly employ, but will rather reserve them
for such occasions in which they are the more appropriate,
or even the only serviceable ones.

Therefore, since it is proved that the ancients did not
represent Death by a skeleton; and since nevertheless
skeletons are to be seen on ancient monuments; what
are they then, these skeletons?

Without circumlocution these skeletons are *Larvæ;*
and that not inasmuch as *Larva* itself means nothing else
but a skeleton, but inasmuch as under *Larvæ* a kind of
departed souls was understood.

The ordinary pneumatology of the ancients was as
follows. Besides the gods, they believed in an innumer-
able race of created spirits, whom they named Dæmons.
Among these Dæmons they also reckoned the departed
souls of men, which they comprehended under the general
name of *Lemures* and of which there could not well be

otherwise than two kinds ; departed souls of good and of bad men. The good became peaceful, blissful household gods for their posterity and were named *Lares*. The bad, in punishment of their crimes, wandered like restless fugitives about the earth, an empty terror to the pious, a blighting terror to the impious, and were named *Larvæ*. In the uncertainty whether a departed soul were of the first or second kind, the word *Manes* [74] was employed.

And I say, that such *Larvæ*, such departed souls of bad men were represented as skeletons. I am convinced that this remark is new from the point of view of art and has not been used by any archæologist in explanation of ancient monuments. People will therefore require to see it proved, and it might not be sufficient if I referred to a commentary of Herr Stephanus, according to which in an old epigram οἱ σκελετοί is to be explained by *Manes*. But what this commentary only lets us guess, the following words will place beyond doubt. Seneca says : [75] " Nemo tam puer est, ut Cerberum timeat, et tenebras, et Larvarum habitum nudis ossibus cohærentium ;" or as our old honest and thoroughly German Michael Herr translated : " Es ist niemands so kindisch, der den Cerberus förcht, die Finsterniss und die todten Gespenst, da nichts dann die leidigen Bein an einander hangen " [76] (" No one is so childish as to fear Cerberus, darkness and dead spectres hanging together by nothing but bare bones "). How could a

[74] Apuleius, de Deo Socratis (p. 110, edit. Bas. per Hen. Petri): " Est et secundo signatu species dæmonum, animus humanus exutus et liber, stipendiis vitæ corpore suo abjuratis. Hunc vetere Latina lingua reperio Lemurem dictitatum. Ex hisce ergo Lemuribus, qui posterorum suorum curam sortitus, pacato et quieto numine domum possidet. Lar dicitur familiaris. Qui vero propter adversa vitæ merita, nullis bonis sedibus incerta vagatione, ceu quodam exilio punitur, inane terriculamentum bonis hominibus, cæterum noxium malis, hunc plerique Larvam perhibent. Cum vero incertum est quæ cuique sortitio evenerit, utrum Lar sit an Larva, nomine Manium deum nuncupant, et honoris gratia Dei vocabulum additum est."

[75] Epist. xxiv.

[76] Sittliche Zuchtbücher des hochberühmten Philosophen Seneca, Strasburg 1536, in folio. A later translator of Seneca, Conrad Fuchs (Frankfort 1620) renders the words " et Larvarum habitum nudis ossibus cohærentium " by " und der Todten gebeinichte Companey." Very elegant and mad !

skeleton. a framework, be more distinctly indicated, than by *nudis ossibus cohærens?* How could it be more emphatically expressed that the ancients were accustomed to conceive and to figure their haunting spirits as skeletons?

If such an observation affords a more natural explanation for misunderstood representations, this is unquestionably a new proof of their justice. Only a single skeleton on an ancient monument might certainly be Death if it had not been proved on other grounds that he was not so depicted. But how, when many such skeletons appear? May we say that, even as the poet knew various Deaths—

" Stant Furiæ circum, variæque ex ordine Mortes "

—so it must also be permitted to the artist to represent various forms of death as a separate Death? And if even then no sound sense can be made of such a composition consisting of various skeletons? I have referred above to a stone in Gori [77] on which three skeletons are to be seen ; the one drives on a biga drawn by fierce animals, over another prostrate on the ground, and threatens to drive over a third that stands in its way. Gori calls this representation the triumph of Death over Death. Words without sense. But happily this gem is of bad workmanship and filled up with characters intended to pass for Greek, but which make no sense. Gori therefore pronounces it the work of a Gnostic, and people have taken leave from all time to lay as many absurdities as they do not care to explain to their account. Instead of seeing Death triumphing over himself, or over a few rivals envious of his dominion, I see nothing but departed souls, in the form of *Larvæ*, who still cling in the other life to those occupations which were so pleasant to them in this. That this was the case was a commonly received opinion with the ancients, and Virgil has not forgotten the love of racing among the examples he gives of this [78]

"——quæ gratia currûm
Armorumque fuit vivis, quæ cura nitentes
Pascere equos, eadem sequitur tellure repostos."

[77] See above, p. 208. [78] Æneid. vi. v. 653.

Therefore nothing is more common on monuments and urns and sarcophagi than genii, who exercise—

"——aliquas artes, antiquæ irritamina vitæ,"

and in the very work of Gori, in which he adduces this gem, a marble occurs of which the gem might be almost called the caricature. The skeletons that on the gem drive and are driven over, are, on the marble, genii.

Now if the ancients did not conceive of the *Larvæ*, *i.e.* the departed souls of wicked men otherwise than as skeletons, then it was quite natural that finally every skeleton, even if it was only a work of art, should be called *Larva*. Hence *Larva* was also the name of that skeleton which appeared at solemn banquets, to stimulate a more hasty enjoyment of life. The passage in Petronius concerning such a skeleton is well known,[79] but the conclusion it might be sought to deduce, that it is a representation of Death, would be very precipitate. Because a skeleton reminded the ancients of Death, was a skeleton therefore the received image of Death? The saying which Trimalcus utters rather distinguishes expressly the skeleton and Death:

" Sic erimus cuncti, postquam nos auferet Orcus."

That does not mean, " This one will soon carry us off," " In this form Death will claim us," but " This is what we must all become, and skeletons we shall all be when Death has claimed us."

And thus I think that I have proved in all ways what I promised to prove. But I still wish to show that I have not taken this trouble only against Herr Klotz. To put Herr Klotz alone right might seem to most readers an equally

[79] "Potentibus ergo, et accuratissimas nobis lautitias mirantibus, larvam argenteam attulit servus sic aptatam, ut articuli ejus verte-bræque laxatæ in omnem partem verterentur. Hanc quum super mensam semel iterumque abjecisset, et catenatio mobilis aliquot figuras exprimeret Trimalcio adjecit—

Heu, heu, nos miseros, quam totus homuncio nil est!
Sic erimus cuncti, postquam nos auferet Orcus.
Ergo vivamus, dum licet esse bene."

(Edit. Mich. Hadr. p. 115.)

easy and useless occupation. It is something different if he has gone astray along with the whole flock. Then it is not the hindermost bleating sheep, but the flock that puts the shepherd or his dog in motion.

PROOF.

I WILL therefore glance at better scholars who, as I have said, share more or less in the erroneous imaginations of Herr Klotz, and will commence with a man who is all in all to Herr Klotz, his departed friend, Count Caylus. What lovely souls those must be who at once declare as their friend, one with whom they have exchanged a few compliments at the distance of a hundred miles! It is only a pity that we can just as easily become their enemy!

Among the subjects recommended to artists out of Homer, by Count Caylus, was that of Apollo delivering the purified and embalmed corpse of Sarpedon to Death and Sleep.[80]

The Count says: " It is only vexatious that Homer did not enter upon the attributes that were at his time accorded to Sleep. To designate this god, we only know his actions and we crown him with poppies. These ideas are modern, and the first, which is altogether of minor use, cannot be employed in the present instance, in which even flowers seem to me quite unsuitable, especially for a figure that is to group with Death." [81] I will not repeat here what I have said in the 'Laokoon,' concerning the want of taste of the Count who demands from Homer that he should deck the creatures of his mind with the attributes of the artists. I will only note here how little he himself knew these attributes, and how inexperienced he was in the actual representation of both Death and Sleep. As to the first it is incontrovertibly shown from his words that he believed Death could and must be represented as nothing else but a skeleton. He would not otherwise have observed complete silence concerning its figure, as

[80] Iliad. π. v. 681. [81] Tableaux tirés de l'Iliade, &c.

on a subject that was self-evident; still less would he have remarked that a figure crowned with flowers could not be well assorted with the figure of Death. This apprehension could only arise from the fact that he had never dreamed of the resemblance of both figures, having pictured Death to himself as an ugly monster, and Sleep as a gentle genius. Had he known that Death was a like gentle genius, he would surely have reminded his artists of this, and could only have discussed with them, whether it be well to give these allied genii distinctive attributes and which would be the most becoming. But in the second place, he did not even know Sleep as he should have known him. It is rather too much ignorance to say, that except by his action he only indicates this deity by baleful poppies. He indeed justly notes that both these symbols are modern, but he not only does not say what were the old genuine symbols, but he also totally denies that such have been handed down to us. He therefore knew nothing of the horn which the poets so often ascribe to Sleep, and with which he was depicted according to the express testimony of Servius and Lutatius. He knew nothing of the reversed torch; he did not know that a figure with such a reversed torch was extant from ancient times, which was announced as Sleep, not by a mere conjecture, but by its own undoubted superscription. He had not found this figure either in Boissard, or Gruter, or Spanheim, or Beger, or Brouckhuysen,[82] and heard nothing of it in any quarter: Now let us imagine the Homeric picture, as he would have it with a Sleep, as if it was the awakened sleep of Algardi; with a Death, a very little more graceful than he bounds about in old German Death-Dances. What is ancient, Greek, Homeric in this? What is there that is not fanciful, Gothic, and French? Would not this picture of how Homer thought, according to Caylus, bear the same likeness to the original as Hudart's translation? Still it would only be the fault of the

[82] Brouckhuysen has incorporated it in his Tibullus from Spanheim, but Beger, as I should have noted above, p. 192, has made known the whole monument, out of which this single figure is taken. This he has done from the papers of Pighius in his Spicilegio Antiquitatis, p. 106. Beger as little refers to Spanheim, as Spanheim to Beger.

artist's adviser, if he became so offensively and romantically modern, whereas he might be so simple and suggestive, so graceful and great, in the true spirit of antiquity. How he should feel allured to put forth all his powers upon two such advantageous figures as winged genii, to make what is similar different, and what is different similar, alike in growth, form, and mien; yet as unlike in hue and flesh as the general tone of his colouring will allow. For according to Pausanias the one of these twins was black, the other white. I say, the one and the other, because it is not actually clear from the words of Pausanias, which was the white one and which the black. And though I should not marvel if an artist made the black one to be Death, yet I could not therefore assure him that he must be in unquestioned agreement with antiquity. Nonnus, at least, calls Sleep μελανόχρουν, when Venus shows herself inclined not to force such a black spouse upon the white Pasithea;[83] and it is quite possible that the ancient artists gave the white hue to Death, thus to indicate that he was not the more terrible Sleep of the two.

Truly, Cayius could learn little if at all better from the well-known iconological works of a Ripa, a Chartarius and however their copyists may be called.

Ripa,[84] it is true, knew the horn of Sleep, but how erroneously he decks him out in other respects! The shorter white tunic over a black dress which he and Chartarius[85] give to him, belongs to Dreams and not to Sleep. Ripa knew the passage in Pausanias concerning the resemblance of Death and Sleep, but without making the least use of this for his picture. He proposes three kinds, and none of these are such as a Greek or Roman would have recognised. Nevertheless only one of them, the invention of Camillo da Ferrara, is a skeleton; but I doubt whether Ripa means to say by this that it was this Camillo who first painted Death as a skeleton. I do not however know this Camillo.

Those who have made most use of Ripa are Giraldus and Natalis Comes.

[83] Lib. xxxiii. v. 40. [84] Iconolog. p. 464, edit. Rom. 1603.
[85] Imag. Deorum, p. 143, Francof. 1687.

They copied the error about the white and black dress
of Sleep from Giraldus,[86] and Giraldus can only have
looked at a translation, instead of at Philostratus himself.
For it is not Ὕπνος but Ὄνειρος, of whom Philostratus
says : [87] ἐν ἀνειμένῳ τῷ εἴδει γέγραπται, καὶ ἐσθῆτα ἔχει λευκὴν
ἐπὶ μελαίνῃ τὸ, οἶμαι, νύκτωρ αὐτοῦ καὶ μεθ᾽ ἡμέραν. It
is incomprehensible to me how even the latest translator
of Philostratus' works, Gottfried Olearius, who assures
us that he has given us an almost wholly new rendering,
could have been so extremely careless with these words.
They run in Latin, with him as : " Ipse somnus remissa
pictus est facie, candidamque super nigra vestem habet,
eo, ut puto, quod nox sit ipsius, et quæ diem excipiunt."[87]
What does this mean : "et quæ diem excipiunt"? Did
Olearius not know that μεθ᾽ ἡμέραν means "interdiu," and
νύκτωρ "noctu"? It might be said in his defence that one
grows weary of purging the old miserable translations.
He should then at least not have desired to excuse or
refute any one out of an untested translation. But as it
further runs, "Cornu is (Somnus) manibus quoque tenet,
ut qui insomnia per veram portam inducere soleat," he
appends in a note : "Ex hoc vero Philostrati loco
patet optimo jure portas illas somni dici posse, qui scilicet
somnia per eas inducat, nec necesse esse ut apud Virgi-
lium (Æneid. vi. v. 562) somni dictum intelligamus
pro somnii, ut voluit Turnebus " (lib. iv. Advers. c. 14).
But Philostratus himself does not speak of the portals of
Sleep, Somni, but of Dreams, Somnii, and it is also
Ονειρος, not Ὕπνος with him who admits dreams through
the true gates. Consequently Virgil can still only be
helped otherwise than by Turnebus's commentary, if he
absolutely must coincide with Homer in his conception
of these gates. Giraldus is entirely silent concerning
the form of Death.

Natalis Comes gives to Death a black garment strewn
with stars.[88] The black garment, as we saw above, is
founded on Euripides, but who put the stars upon it I do
not know. He has also dreams *contortis cruribus* and

[86] Hist. Deorum Syntag. ix. p. 311, edit. Jo. Jensii.
[87] Iconum, lib. i. 27. [88] Mythol. lib. iii. cap. 13.

assures us that Lucian made them roam about thus on his island of Sleep. But with Lucian they are mere shapeless dreams, ἄμορφοι, and the crooked legs are Natalis's own invention. Even according to him these crooked legs would not appertain to dreams in general as an allegorical distinction, but only to certain dreams.

To refer to other mythological compilers would scarcely repay the trouble. Banier alone may seem to merit an exception. But even Banier says nothing of the form of Death, and commits more than one inaccuracy respecting the form of Sleep.[89] For he too mistakes Dream for Sleep in this picture of Philostratus, and sees him there formed as a man, though he thinks that he can determine from the passage of Pausanias that he was represented as a child, and only as a child. He also copies a gross error from Montfaucon, which has been already condemned by Winckelmann and which should therefore have been familiar to his German translator.[90] Namely, both Montfaucon and Banier proclaim the Sleep of Algardi in the Villa Borghese as antique, and a new vase, that stands near it with various others, is declared to be a vessel filled with a somniferous potion, just because Montfaucon found it placed beside it on an engraving. This Sleep of Algardi itself, however exquisite the workmanship may be, is quite at variance with the simplicity and the dignity of the ancients. Its position and gesture are borrowed from the position and gesture of the sleeping Faun in the Palazzo Barberini, to which I have referred above.

Nowhere have I met with an author on this branch of knowledge, who has not either left the image of Death, as it existed amongst the ancients, totally undecided or has it incorrectly. Even those who were familiar with the monuments which I have named, or with others like them, have not therefore approached much nearer the truth.

Thus Tollius knew that various old marbles were extant, on which boys with reversed torches represented the eternal sleep of the dead.[91] But is this to recognise in one

[89] Erläuterung der Götterlehre, vol. iv. p. 147, German trans.
[90] Preface to Geschichte der Kunst, p. 15. [91] In notis ad Roudelli Expositionem, S. T. p. 292.

of them Death himself? Did he therefore comprehend that the deity of Death was never represented in another form by the ancients? It is a long step from the symbolical signs of an idea, to the well-defined establishment of this idea personified, and reverenced as an independent being.

Just the same may be said of Gori. Gori most expressly names two such winged boys on old sarcophagi "Genios Somnum et Mortem referentes,"[92] but this very "referentes" betrays him. And since at another place[93] he speaks of these as " Genii Mortem et Funus designantes"; since elsewhere, notwithstanding the meaning of Death which he grants to Buonarotti, he still sees in one a *Cupido*, since, as we have seen, he recognises the skeletons on old stones as *Mortes*; it is almost pretty well unquestionable that he was at least very undecided in himself concerning these matters.

The same holds good for Count Maffei. For although he held that the two winged boys with reversed torches seen on old monuments were meant for Sleep and Death, yet he declared such a boy, who stands on the well-known " Conclamation marble " in the Saloon of Antiquities at Paris, to be neither the one nor the other, but a genius, who shows by his reversed torch that the deceased person indicated died in the flower of youth, and that Amor and his kingdom mourn this death.[94] Even when Dom Martin bitterly controverted this first error, and incorporated the same marble in his Museum Veronese, he makes no attempt at its clearer identification, and leaves the figures on the 139th plate, which he could have used for this purpose, without any explanation.

But this Dom Martin scarcely deserved to be confuted. He would have the two genii with reversed torches found on ancient monuments and urns, to be held as the genii of the man and of his wife or for the united guardian spirits whom, according to some of the ancients, every one possessed.

He might and should have known, that at least one of

[92] Inscript. ant. quæ in Etruriæ urbibus exstant, parte iii. p. xciii.
[93] *Ibid.* p. lxxxi.
[94] Explic. de divers Monuments singuliers qui ont rapport à la Religion des plus anciens peuples, par le R. P. Dom **, p. 36.

these figures, in consequence of the express ancient super-
scription, must needs be Sleep, and just now I luckily hit
upon a passage in Winckelmann in which he has already
censured the ignorance of this Frenchman.

Winckelmann writes : " It occurs to me that another
Frenchman, Martin, a man who could dare to say Grotius
had not understood the Septuagint, announces with bold-
ness and decision that the two genii on the ancient urns
cannot be Sleep and Death, and yet the altar on which
they figure in this sense with the antique superscription
of Sleep and Death, is publicly exhibited in the courtyard
of the Palazzo Albani." I ought to have recalled this
passage above (p. 182), for Winckelmann here means the
same marble which I have there adduced from his Essay on
Allegory. What was not so clearly expressed there, is
the clearer here ; not only the one genius, but also the
other, are by the ancient inscription literally designated,
on this Albani monument, as what they are; namely
Sleep and Death. How much I wish that I could set a
final seal upon this investigation by this announcement !

Yet a word about Spence ere I close. Spence, who most
positively desires to force upon us a skeleton as the
antique image of Death, Spence opines, that the ordi-
nary representations of Death among the ancients, could
not well have been other than terrible and ghastly, because
the ancients generally entertained far darker and sadder
conceptions of his nature than we could now admit.[95]

Yet it is certain that that religion which first discovered
to man that even natural death was the fruit and the
wages of sin, must have infinitely increased the terrors of
death. There have been sages who have held life to be a
punishment, but to deem death a punishment, could not
of itself have occurred to the brain of a man who only
used his reason, without revelation.

From this point of view it would presumably be our
religion which has banished the ancient cheerful image
of Death out of the domains of art. Since however this
religion did not wish to reveal this terrible truth to drive
us to despair ; since it too assures us that the death of the

[95] Polymetis, p. 262.

righteous cannot be other than gentle and restoring; I do not see what should prevent our artists from banishing the terrible skeletons, and again taking possession of that other better image. Even Scripture speaks of an angel of Death; and what artist would not rather mould an angel than a skeleton?

Only misunderstood religion can estrange us from beauty, and it is a token that religion is true, and rightly understood, if it everywhere leads us back to the beautiful.

THE LITERATURE OF
DEATH AND DYING

Abrahamsson, Hans. **The Origin of Death:** Studies in African Mythology. 1951

Alden, Timothy. **A Collection of American Epitaphs and Inscriptions with Occasional Notes.** Five vols. in two. 1814

Austin, Mary. **Experiences Facing Death.** 1931

Bacon, Francis. **The Historie of Life and Death with Observations Naturall and Experimentall for the Prolongation of Life.** 1638

Barth, Karl. **The Resurrection of the Dead.** 1933

Bataille, Georges. **Death and Sensuality:** A Study of Eroticism and the Taboo. 1962

Bichat, [Marie François] Xavier. **Physiological Researches on Life and Death.** 1827

Browne, Thomas. **Hydriotaphia.** 1927

Carrington, Hereward. **Death:** Its Causes and Phenomena with Special Reference to Immortality. 1921

Comper, Frances M. M., editor. **The Book of the Craft of Dying and Other Early English Tracts Concerning Death.** 1917

Death and the Visual Arts. 1976

Death as a Speculative Theme in Religious, Scientific, and Social Thought. 1976

Donne, John. **Biathanatos.** 1930

Farber, Maurice L. **Theory of Suicide.** 1968

Fechner, Gustav Theodor. **The Little Book of Life After Death.** 1904

Frazer, James George. **The Fear of the Dead in Primitive Religion.** Three vols. in one. 1933/1934/1936

Fulton, Robert. **A Bibliography on Death, Grief and Bereavement:** 1845-1975. 1976

Gorer, Geoffrey. **Death, Grief, and Mourning.** 1965

Gruman, Gerald J. **A History of Ideas About the Prolongation of Life.** 1966

Henry, Andrew F. and James F. Short, Jr. **Suicide and Homicide.** 1954

Howells, W[illiam] D[ean], et al. **In After Days;** Thoughts on the Future Life. 1910

Irion, Paul E. **The Funeral:** Vestige or Value? 1966

Landsberg, Paul-Louis. **The Experience of Death:** The Moral Problem of Suicide. 1953

Maeterlinck, Maurice. **Before the Great Silence.** 1937

Maeterlinck, Maurice. **Death.** 1912

Metchnikoff, Élie. **The Nature of Man:** Studies in Optimistic Philosophy. 1910

Metchnikoff, Élie. **The Prolongation of Life:** Optimistic Studies. 1908

Munk, William. **Euthanasia.** 1887

Osler, William. **Science and Immortality.** 1904

Return to Life: Two Imaginings of the Lazarus Theme. 1976

Stephens, C[harles] A[sbury]. **Natural Salvation:** The Message of Science. 1905

Sulzberger, Cyrus. **My Brother Death.** 1961

Taylor, Jeremy. **The Rule and Exercises of Holy Dying.** 1819

Walker, G[eorge] A[lfred]. **Gatherings from Graveyards.** 1839

Warthin, Aldred Scott. **The Physician of the Dance of Death.** 1931

Whiter, Walter. **Dissertation on the Disorder of Death.** 1819

Whyte, Florence. **The Dance of Death in Spain and Catalonia.** 1931

Wolfenstein, Martha. **Disaster:** A Psychological Essay. 1957

Worcester, Alfred. **The Care of the Aged, the Dying, and the Dead.** 1950

Zandee, J[an]. **Death as an Enemy According to Ancient Egyptian Conceptions.** 1960